FRÉDÉRIC BAZILLE

FRÉDÉRIC BAZILLE

Prophet of Impressionism

MUSÉE
FABRE
MONTPELLIER

Translated and
Published by
THE
BROOKLYN
MUSEUM

Published on the occasion of the exhibition

FRÉDÉRIC BAZILLE

Pavillion du Musée Fabre — Montpellier
July 9–October 4, 1992

The Brooklyn Museum
November 13, 1992–January 24, 1993

The Dixon Gallery and Gardens, Memphis
February 14–April 25, 1993

LIBRARY OF CONGRESS
CATALOGING-IN-PUBLICATION DATA

Frédéric Bazille. English
Frédéric Bazille: prophet of impressionism/
Aleth Jourdan... [et al.].
 p. cm.
 Translation of: Frédéric Bazille: et ses amis impressionnistes.
 "Published on the occasion of the exhibition Frédéric Bazille:
prophet of impressionism, The Brooklyn Museum, November 13,
1992—January 24, 1993 — T.p. verso.
 Includes bibliographical references.
 ISBN 0-87273-129-4
 1. Bazille, Frédéric, 1841-1870 — Exhibitions. 2. Impressionism
(Art)—France—Exhibitions. I. Jourdan, Aleth. II. Brooklyn Museum. III. Title.
ND553.B43A4 1992
759.4—dc20 92-25633 CIP

Frédéric Bazille: Prophet of Impressionism has been organized by The Brooklyn Museum in association with The Dixon Gallery and Gardens, Memphis. It was developed from an exhibition of Bazille and his contemporaries entitled Frédéric Bazille et ses amis impressionnistes *organized by the City of Montpellier and the Musée Fabre.*

Frédéric Bazille: Prophet of Impressionism is made possible by a generous grant from the Iris and B. Gerald Cantor Foundation and supported by an indemnity from the Federal Council on the Arts and the Humanities. Federal Express Corporation is the official carrier for the exhibition. Support for the English edition of the catalogue was provided by the Iris and B. Gerald Cantor Foundation and the Andrew W. Mellon Foundation.

Translated by John Goodman

Published by The Brooklyn Museum
200 Eastern Parkway
Brooklyn, New York 11238

This catalogue was published in France by the Réunion des musées nationaux.
Copyright © 1992 Montpellier, musée Fabre
39, boulevard Bonne-Nouvelle
34000 Montpellier, France
Copyright © 1992 Éditions de la Réunion des musées nationaux,
49, rue Étienne-Marcel
75001 Paris, France

COVER
View of the Village
1868 (detail), Montpellier, Musée Fabre

Photography Credits
Atlanta, The High Museum of Art: cat. 9
Beaune-la-Rolande, Office of the Mayor: cat. 52
Cambridge, Harvard University Art Museums: cat. 25
Chicago, The Art Institute of Chicago: cat. 11, 42
Dallas, The Dallas Museum of Art: cat. 53
Detroit, The Detroit Institute of Arts: cat. 12
Geneva, Musée du Petit-Palais: fig. 57
Grenoble, Musée de Peinture et de Sculpture: cat. 22
Kansas City, The Nelson Atkins Museum of Art (photo
 William Rockhill, Nelson Trust): fig. 36
Lausanne, Musée Cantonal des Beaux-Arts: fig. 9, 10
Lausanne, Archives Bibliothèque des arts: cat. 54
Minneapolis, The Minneapolis Institute of Arts:
 fig. 1; cat. 46
Montpellier, Director of Communication: fig. 81, 99
Montpellier; Francis de Richemond: fig. 80
Montpellier, Musée Fabre (Frédéric Jaulmes): fig. 2, 4,
 5, 6, 7, 11, 15, 31, 37, 70, 71, 72, 77, 78, 79, 82,
 85, 86, 87, 100, 101; cat. 1, 2, 3, 4, 5, 8, 14, 16,
 20, 21, 26, 27, 34, 36, 37, 39, 40, 43, 45, 48, 49,
 50
Montpellier, O'Sughrue: fig. 84, 103
Moscow, Pushkin Museum: fig. 91
New York, The Metropolitan Museum of Art: fig. 35,
 98; cat. 15
Nîmes, F. Pervenchon: fig. 8, 89; cat. 28, 29, 30, 31,
 32, 33, 41, 51
Paris, Bibliothèque Nationale: fig. 22, 62, 88
Paris, Galerie Schmidt: fig. 38
Paris, Musée Marmottan: fig. 12
Paris, RMN: fig. 14, 16, 17, 18, 19, 20, 23, 24, 25, 26,
 27, 39, 40, 41, 42, 44, 45, 46, 47, 48, 49, 50, 51,
 52, 53, 54, 55, 56, 58, 59, 60, 61, 63, 64, 65, 66,
 68, 73, 74, 75, 76, 83, 92, 93, 94, 96, 97; cat. 10,
 17, 18, 24, 38, 44
Paris, Studio Visage de France: cat. 48
Pasadena, The Norton Simon Foundation (A.E.
 Dolinski): fig. 30
Richmond, The Virginia Museum of Fine Arts: cat. 13
San Francisco, The Fine Arts Museums: fig. 32
Tokyo, Museum of Western Art: fig. 34
Tokyo, The Mitsubishi Trust and Banking Corporation:
 cat. 47
Washington, National Gallery of Art: fig. 13, 28, 29,
 33, 46, 69; cat. 23, 35
Zurich, Rau Foundation for the Third World: cat. 19

English edition designed by
Karen Davidson, Exhibition Catalogues, New York

Printed by
Laffont à Avignon

Color separations by
La Photogravure à Marseille

Lenders to the Exhibition

ALGERIA

Algiers, Musée National des Beaux-Arts

FRANCE

Beaune-la-Rolande, Office of the Mayor

Grenoble, Musée de Peinture et de Sculpture

Paris, Musée du Louvre, Département des Arts Graphiques

Paris, Musée d'Orsay

JAPAN

Tokyo, The Mitsubishi Trust and Banking Corporation

SWITZERLAND

Zurich, Rau Foundation for the Third World

UNITED STATES

Atlanta, The High Museum of Art

Cambridge, Harvard University Art Museums

Chicago, The Art Institute of Chicago

Dallas, The Dallas Museum of Art

Detroit, The Detroit Institute of Arts

Minneapolis, The Minneapolis Institute of Arts

New York, The Metropolitan Museum of Art

Richmond, The Virginia Museum of Fine Arts

Washington, National Gallery of Art

As well as all those individuals who have preferred to remain anonymous.

In 1870, Montpellier received word of the death of Frédéric Bazille, the son of Gaston Bazille — assistant to the mayor and a respected figure — as news of a hero's death in combat. Yet, the first important exhibition of his work organized in the city would not take place until the centenary of 1941, when another war severely limited the attention it received.

On the present occasion I have the pleasure to introduce an artistic personality who, though still relatively little known to historians of Montpellier, played a role in the history of world art, specifically in early Impressionism.

Frédéric Bazille extended his hospitality to two of his colleagues from the Gleyre studio, Claude Monet and Auguste Renoir, acting as a surrogate family for the first when his real one refused financial support, and lodging the second over a more extended period. Bazille was also generous to others of his friends among the future Impressionists. His life in their circle, in Paris between 1862 and 1870, was one of painting, intellectual stimulation, and friendship; and it is to a discovery of this specific moment in the history of painting that I invite you.

This exhibition could not have taken place without the active participation of the Ministry of Culture, the Prefecture of Languedoc-Roussillon, and the regional office for cultural affairs, and the valuable cooperation of the newspaper *Midi libre*, along with the Southern and Eastern Salt-Works Company. I take pleasure in thanking the individuals who, whether in an official or a private capacity, provided the support necessary to ensure the realization of this project.

This exhibition was held in the Pavillon du Musée Fabre, which has been completely remodeled to provide the museum with a prestigious exhibition space. This remodeling received crucial support from M. Jacques Sallois, Director of French Museums, to whom I wish to express my gratitude, as well as to M. Jacques Imbert, Regional Director of Cultural Affairs for Languedoc-Roussillon.

I would also like to offer special thanks to Aleth Jourdan, curator of the Musée Fabre, for having convinced us of the originality and importance of this subject: the events of 1992 have vindicated her judgment. By her enthusiasm, professionalism, and cordiality, and with the assistance of her collaborators, especially Didier Vatuone, the assistant in charge of this exhibition, she managed to procure the cooperation of many important institutions, including the Musée d'Orsay and the Musée du Louvre in Paris, as well as great American museums such as The Metropolitan Museum of Art in New York, the National Gallery of Art in Washington, The Art Institute of Chicago, and the museums

of Atlanta, Cambridge, Dallas, Detroit, Minneapolis, and Richmond, along with the assistance of the researchers and academics who agreed to work with her on the project.

It is also with great pleasure and pride that we send this exhibition to two distinguished institutions in the United States: The Brooklyn Museum and The Dixon Gallery and Gardens in Memphis. It is our hope that Americans will enjoy the work of Bazille and come to appreciate the genius of this distinguished artist from Montpellier.

Georges Frêche

Mayor and Representative of Montpellier

Foreword

The Brooklyn Museum has had a strong commitment over the years to exhibiting French late nineteenth-century art, ranging from Caillebotte to Courbet and Vuillard. We are thus very pleased to be able to present this retrospective of the work of Frédéric Bazille on the occasion of the sesquicentennial of his birth. This occasion, celebrating Bazille's achievement all in the space of eight years, marks the inauguration of the special exhibition gallery in the newly renovated West Wing of The Brooklyn Museum.

This exhibition's American tour was curated by Elizabeth Easton, Associate Curator of European Painting and Sculpture. She received important advice and help from Sarah Faunce, Curator of European Painting and Sculpture, as the project developed. Discovering that the Musée Fabre in Montpellier was planning a retrospective, and that they were eager to collaborate with us, we embraced their offer. Traditionally, in the context of the last exhibition in Chicago in 1978, and again in Montpellier this year, Bazille has been grouped with his better-known contemporaries. For the American venues of the exhibition we chose to limit the scope exclusively to works by Bazille.

We are extremely grateful to the Iris and B. Gerald Cantor Foundation for their funding of the exhibition at The Brooklyn Museum. The continued support of Mr. and Mrs. Cantor on behalf of this institution is a model of generosity and commitment to the arts. In addition, we wish to acknowledge an important indemnity from the Federal Council on the Arts and the Humanities.

Mrs. Cantor, a Trustee at The Brooklyn Museum, suggested The Dixon Gallery and Gardens, Memphis, where she is also a Trustee, as a second possible American venue. The Dixon eagerly embraced the project, and we are delighted to present the exhibition in association with them.

No exhibition on Bazille can take place without the generoous cooperation of the Musée Fabre in Montpellier, which holds the body of Bazille's work as donations from his family. Not only were they gracious in inviting us to be collaborators on the project, but their former director, Aleth Jourdan, and her successor, Michel Hilaire, united in ensuring us the loan of all their works of art. In addition, Mlle Jourdan worked very hard to secure loans of works still in the Bazille family. We are also grateful to Madame Françoise Cachin, Director of the Musée d'Orsay, whose agreement to lend immeasurably enriched the show, and to our museum colleagues both here and abroad, as well as other private lenders. Thanks are also due to Georges Frêche, Mayor of Montpellier, and André Levy and Max Lévita of his staff for their steadfast conviction that this exhibition should travel to the United States.

With The Dixon Gallery and Gardens' focus on French Impressionism, an exhibition devoted to the art of Bazille finds a most sympathetic environment for presentation. The museum, with its collection of paintings assembled by its founders, Margaret and Hugo Dixon, has hosted numerous scholarly examinations of works by contemporaries of Bazille. Most importantly, this project brings for the first time to the mid-southern audience rare works of this outstanding artist who is less well known than his Impressionist friends but equally deserving of recognition. Brooklyn's and the Dixon's enthusiastic decision to bring Bazille into clearer focus for American audiences thus acknowledges the significance of the original exhibition begun in the artist's native city more than a century after his death.

All those who have supported this exhibition have enabled us to bring together a body of work that is impressive and inspiring and that, we hope, will enable a new generation to become familiar with this great artist's oeuvre.

Robert T. Buck
Director, The Brooklyn Museum

John E. Buchanan, Jr.
Director, The Dixon Gallery and Gardens

Contents

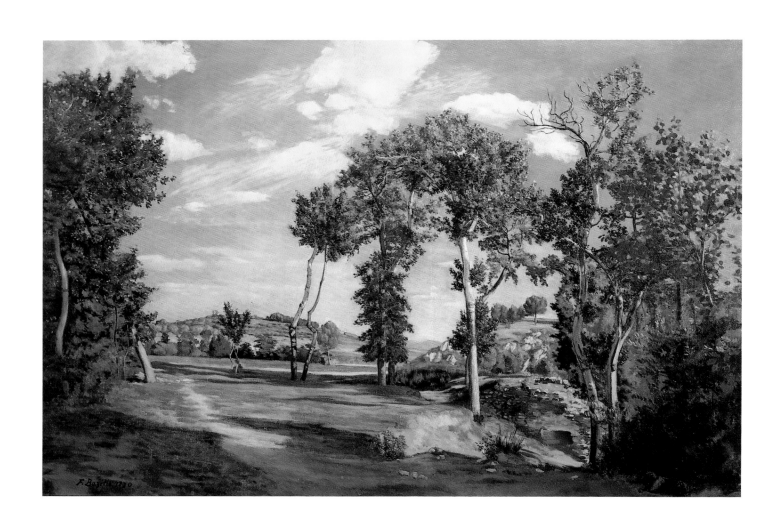

Introduction

As for myself,
I'm sure not to get killed,
I have too many things to do in this life.

Frédéric Bazille, November 1870[1]

eath annihilated this certitude. The artist, in his youthful presumption, already possessed a sense of history, and of his role in what would become, without his participation, the history of Impressionism. Thus the need to examine his true role in that history in an exhibition like the present one. For a myth does, in fact, exist. It was elaborated in the years since the turn of the century around the notion of Bazille as "one of the precursors of modern painting whom a heroic death prevented from becoming one of the masters of contemporary art."[2] And although this image is now obsolete, it has helped to serve as the foundation of this study of his life and work.

Defining Frédéric Bazille's place in the history of pre-Impressionism is a very different thing from seeking to determine what he wasn't or what he might have become.

Since 1974 and the celebration of Impressionism's centenary, the great monographic exhibitions devoted to the Impressionists, in France and elsewhere, have thrown considerable new light on this period. The present exhibition is intended to do likewise for a painter whose work and life were of short duration. The goal will not be to classify a body of visual work that is small but complex. Instead, we have set out to reveal the multiple facets of a figure who, between 1862 and 1870, was an important actor in a momentous decade: painter, collector, the devoted friend of Monet despite the often considerable demands this entailed, a man attentive to the obligations of modernity as well as sensitive to those imposed by official recognition. A more global overview of the generation of 1860–1870 will be provided by the 1994 exhibition "The Origins of Impressionism," to be held in Paris and New York.

The historiographic myth, perhaps rooted in Pissarro's characterization of Bazille as "one of the most gifted among us," was constructed around a work in its developmental phase. Had Bazille lived, would he have become one of the important artists of his generation, as the critics seem determined to have us think? Like all myths, such an assertion is neither entirely true nor entirely false. To assess it we must turn to the surviving evidence; not only the truncated body of work but his friendships, his relations with his family, his letters.

FIG. 1

Frédéric Bazille

The Banks of the Lez

1870

Les Bords du Lez

oil on canvas

h. 138; w. 202

The Minneapolis

Institute of Arts

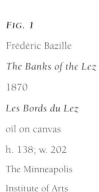

Bazille's correspondence, carried on with family and friends, was and remains today the principal documentary resource for study of the artist. All the extant publications devoted to him or discussing him in any way exploit this resource in only fragmentary, limited ways; errors have resulted, as Gabriel Sarraute pointed out in a letter addressed to the Musée Fabre in 1984.

Unfortunately, it has been impossible for us to consult Sarraute's personal archives, assembled over many years between the 1930s and his death in 1990. This archive includes a complete manuscript transcription of Bazille's correspondence, discovered by Edmond Maître in the artist's studio in December 1870 and sent to Montpellier at the same time as the remainder of his work. This important transcription was made prior to the dispersal of documents that has taken place in recent years. Deprived of access to this material, our knowledge of the letters from Camille Bazille to her son is incomplete. A happenstance of friendship, both generous and fortuitous, has made it possible for us to read the series of letters exchanged between Gabriel Sarraute and Jean Claparède, curator of the Musée Fabre between 1945 and 1965, which was brought to an end by the latter's death in 1989. This brilliant exchange concerning an artist largely misunderstood by the general public, unfolding over almost half a century, has often served as a spur to the writing of this catalogue, and to the reflections behind it.

The purchase of seven precious letters[3] in December 1991 by the artist's native city, along with the exceptional and generous loan of a hundred letters by an informed collector, has enabled us to base our research on the direct consultation of original documents — the first time this has been possible since the 1950s. Close comparative study of published documents — excerpts from letters, entire letters, letters typed by a family secretary — was a necessary preliminary task. With two exceptions, Frédéric's own missives are not dated, but in each case reference to some fact, either historical or familial, permitted us to establish its precise date. The letters from Gaston Bazille to his son, most of which are dated, provided us with important chronological reference points.

The careful determination of each letter's date enabled us to reconsider the correspondence from beginning to end and to reassess all previous assertions concerning Bazille. With this reliable factual basis in hand, we proceeded to reexamine the artist's life and production.

The first retrospective exhibition devoted to Bazille was held as part of the Salon d'Automne in 1910. It included twenty-three paintings and drawings. Marc Bazille, the painter's brother, went to see it with Claude Monet. Renoir, ill at the time, could not accompany them. He figured in the retrospective, however, with one of his works: *Bazille*

at His Easel, owned by Gaston Bazille from 1876 (fig. 14). Édouard Manet had given it to the artist's father in exchange for *Women in the Garden* by Monet (fig. 17). Between 1927 and 1959, several exhibitions — listed at the back of this catalogue — helped increase familiarity with Bazille's work. The most important of these took place in 1950, at the Wildenstein Gallery in Paris, on the initiative of Jean Claparède and Gabriel Sarraute. Sixty-seven paintings and drawings were assembled on that occasion, the last time such a grouping was seen in France. It was only with the exhibition at The Art Institute of Chicago, organized by Jean-Patrice Marandel in 1978, that the work of Frédéric Bazille reached an international public. Marandel published a substantial portion of the correspondence (ninety-eight documents) for the first time, and juxtaposed Bazille's paintings with those of his contemporaries. Finally, in 1984, the Musée Fabre presented an exhibition of works by Bazille still in private hands.

The 1992 retrospective, which originated in Montpellier, fills a genuine gap. No exhibition on this scale has been held there since the painter's death and it was a fitting homage to one who, prior to the 1910 Salon d'Automne, was known to his contemporaries only as a hero of the Franco-Prussian War. The Montpellier exhibition also encompassed Bazille's friendships and painterly affinities by presenting works by his Parisian contemporaries and friends. The artistic milieu of his native city, which shaped his early development, was also evoked there through the presence of the Bruyas collection, which Bazille visited frequently.

The exhibition will travel to America, where the works of Bazille will be shown for the first time in New York, at The Brooklyn Museum, and in the South, at The Dixon Gallery and Gardens, in Memphis, Tennessee. The American venues will exhibit the work of Bazille exclusively, in order to familiarize American audiences with the oeuvre of this great artist.

The oeuvre of Frédéric Bazille is unclassifiable. Incomplete as it is, it reveals something of the aims of an artist inspired by the modernist ideals of the 1860s: "I sought to paint as best I could a subject that's as simple as possible. Besides, in my view the subject matters little so long as what I've done is interesting as painting. I chose the modern period, because it's the one I understand best, and which I find to be the most vital for living beings, and that's exactly what will get me refused," Bazille wrote to his parents on the occasion of his first Salon submissions. Bazille's preoccupation with light and color is characteristic of his generation. And Zola confirmed the analogous interest in contemporary subject matter in his remarks concerning *The Family Gathering* (cat. 18): "One sees that the painter loves his own time, like Claude Monet, and that he thinks one can

be an artist even if one paints frock-coats." His friendships reinforced these proclivities, even though Bazille deviated from the preferences of Monet and Renoir in 1870, when he embarked on a biblical theme with *Ruth and Boaz* (private collection), his last painting (cat. nos. 28–32). The technique, lighting, and classicism of *The Banks of the Lez* (fig. 1) also underline the distance separating the vision of Monet and Renoir revealed in their 1869 depictions of *La Grenouillère*,[4] and the vision that produced this landscape, painted by Bazille in Montpellier a few months before his death.

Bazille's body of work is complex. In assembling the catalogue essays we have opted for inclusiveness, allowing for the juxtaposition of different art-historical approaches. This intentionally fragmentary approach should enable us to obtain a more encompassing view of both the artist's personality and his production. Both Dianne Pitman and Jean-Patrice Marandel accurately discern a certain ambivalence in the last paintings, especially those presented in the exhibition. Our intention in bringing together these fragments has been to reconstruct an image of Frédéric Bazille, but in such a way that our vision of the work itself does not become blurred.

The 1991 commemoration of the 150th anniversary of the artist's birth clarified the need to reveal the art-historical importance of Frédéric Bazille's oeuvre to a large public. On the initiative of M. Georges Frêche, deputy mayor of Montpellier, a "Bazille Year" was organized to provide a framework for the homage Montpellier sought to render the painter.

From the moment this project was announced, the assistance and capable support of Jean-Pierre Cuzin, Inspecteur Général des Musées Classés et Contrôlés, has been a decisive factor in bringing it to realization.

Several persons have been generous in aiding us in our research. We would particularly like to thank Guy Barral, Jean Nougaret, Béatrice de Parseval, and Jean-Louis Vaysettes. To Dominique Mendez we extend our gratitude for her remarkable patience and her warm support.

To M. Georges Frêche, Mayor of Montpellier, and to his assistant for cultural affairs, Professor André Lévy, we express our thanks for their endorsement of this project and for their confidence and support throughout the long period of its gestation.

The aid and committed involvement of Max Lévita, the municipal councillor for the plastic arts, have been essential to the success of the project from the beginning. Frédéric Bazille has established between us lasting ties of friendship and mutual esteem. And these are not the only such ties that developed in the course of this "Bazille Year." We would like to thank several others who have become the friends of Frédéric Bazille,

and who placed their talents, their skills, and their enthusiasm at his disposal: Brigitte, Marie, Bernard, and Jean-Claude.

And, finally, we would like to express our gratitude to Nathalie Brunet and Brigitte Portal. Their assistance and generosity were indispensable. In addition, we are grateful to Elizabeth Easton at The Brooklyn Museum, who is responsible for bringing the exhibition to America. Also, the enthusiasm of Robert T. Buck, Director of The Brooklyn Museum, and John E. Buchanan, Jr., Director of The Dixon Gallery and Gardens, made possible the international showing of Bazille's work.

> *Yesterday I won another kind of victory, this one through sheer brute*
> *strength. Two of my friends and I took the first prize in the Bougival regatta,*
> *as you'll see in the papers. The name of the boat is* The Jack-Pot,
> *unfortunately the names of the rowers won't be published.*
> Frédéric Bazille, July 17, 1865

Aleth Jourdan

Didier Vatuone

NOTES

1. Poulain, 1932, p. 194; Daulte 1952, p. 88.
2. Quote from the deliberations of the purchase committee of the Musée Fabre in Montpellier, March 27, 1918, page 83.
3. See Vatuone in *Bazille. Traces et Lieux de la création,* Montpellier, 1992, pp. 28–39.
4. In 1869, Renoir painted this subject four times, and Monet painted it twice. Cat. *Renoir*, London-Paris-Boston, 1985 (cat. 11 and 12, figs. 17–18, figs. 19–20).

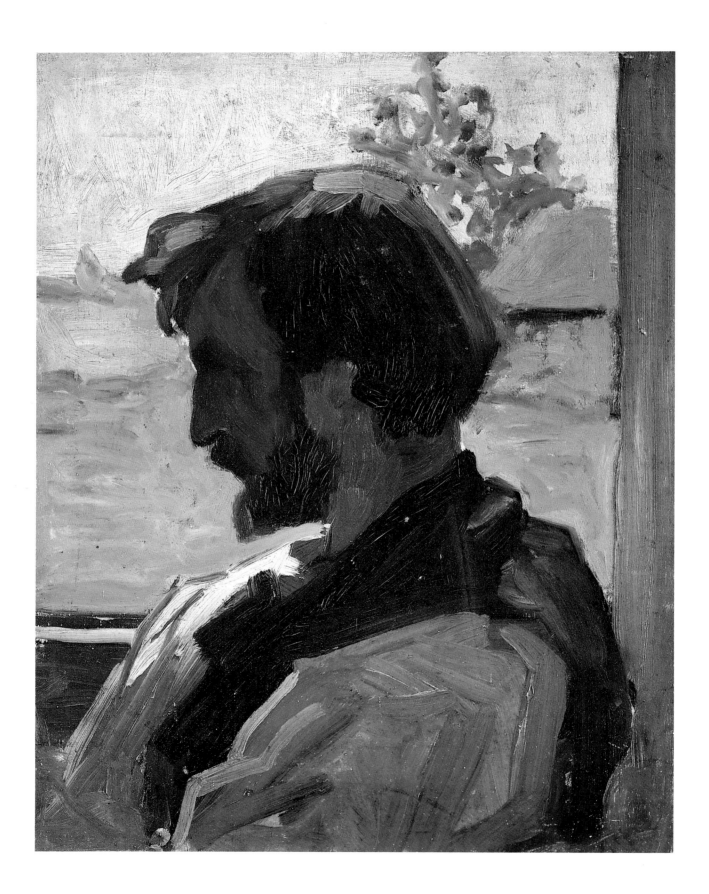

Preface

An exhibition devoted to Frédéric Bazille is especially appropriate at a time when complexity and contradiction are the currency of contemporary art. Bazille's place at the threshold of a radically new kind of painting, recording his observations of everyday life while still attempting to reconcile the dictates of academic practice, resonates in today's post-modern world, where pastiche and a confluence of styles and meanings pervade artistic production. The very awkwardness of some passages in Bazille's paintings, where the perspective is skewed, or physiognomy is distended, or even the facial features are awkward, adds immeasurably to the power of the image. In this way, Bazille's pictures impress themselves on the viewers' minds, as memorable as, and yet distinct from, those icons of the New Painting painted by Manet.

Partly because of the strength and individuality of Bazille's paintings, we decided, in bringing this exhibition from Montpellier to America, that we would change the nature of the show to highlight exclusively Bazille's oeuvre. His early death four years before the first Impressionist exhibtion, his limited production, and his individual style deserve a focus not distracted by the achievements of his better-known friends.

Though intending to organize a Bazille exhibition of our own several years from now, we were delighted when Aleth Jourdan, Conservateur at the Musée Fabre, invited us to collaborate with her on this exhibition. Without her enthusiasm, spirit, and dedication, it would have been impossible to mount such a significant exhibition on these shores in the space of one year. Her associate, Didier Vatuone, as well as the entire staff at the Musée Fabre, were equally helpful and solicitous of our needs. Anne de Margerie and Nathalie Brunet of the Réunion des Musées Nationaux were extremely kind and helpful regarding the production of the catalogue. Without the aid and encouragement, not to mention the generous loans of Françoise Cachin, Director of the Musée d'Orsay, this exhibition would not have been able to take place the same way.

The exhibition would not have been realized without the munificence of Mr. and Mrs. B. Gerald Cantor, who have been such longstanding supporters of this Museum. It was at Mrs. Cantor's suggestion that we approached The Dixon Gallery and Gardens, Memphis, whose association with the project secured the American tour. John E. Buchanan, Jr., Director of the Dixon, is to be thanked for all his efforts on behalf of the show.

At The Brooklyn Museum, it was the strong desire of our director, Robert T. Buck, that the Bazille exhibition inaugurate the special exhibition gallery in the newly renovated West Wing of the building. His tireless efforts on behalf of the exhibition ensured

FIG. 2

Frédéric Bazille

Self-Portrait at Saint-Sauveur

Autoportrait à Saint-Sauveur

oil on wood

h. 40; w. 31

Montpellier,

Musée Fabre

its success. The new temporary exhibition galleries, designed by Arata Isozaki and James Stewart Polshek, will display Bazille's works to their greatest advantage. We were fortunate to have John Goodman translate the catalogue. An art historian himself, he brought great sympathy to the task. Elaine Koss, Editor-in-Chief, worked with her usual grace, charm, and characteristic good humor. Vivian Gill, a graduate intern, saw to all the minutiae of the catalogue, Karen Davidson designed the English-language version, and Vajra Kilgour edited the text. Larry Clark, Curatorial Administrator, and Elizabeth Reynolds, Registrar, worked tirelessly on the National Endowment for the Arts indemnity application. Others at the Museum whose assistance was invaluable are Linda Adams, Teresa Carbone, Roy R. Eddey, Linda S. Ferber, Mira Goldfarb, Carole Gragez, Barry Harwood, Pamela Johnson, Barbara Kennedy, Charlotta Kotik, Michelle Menendez, Kenneth Moser, Brooke Kamin Rapaport, Deborah Schwartz, Cheryl Sobas, Kevin Stayton, Jeanette Stimpfel, Jeffrey Strean, Carolyn Tomkiewicz, Sally Williams, Karyn Zieve, and Rena Zurofsky. Most of all, this project benefited from the endless wisdom of Sarah Faunce, Curator of European Painting and Sculpture, who guided the project throughout.

Friends and colleagues in the field were instrumental in providing support, advice, and, at times, help with loans: Colin Bailey, Hilary Ballon, Andrea Bayer, Emily Braun, Joan Easton, Yasmine Ergas, Alain Goldrach, Leonard Groopman, Anne Coffin Hanson, Christine de Lombarès, Henri Loyrette, Jean-Patrice Marandel, Charles Moffett, Priscilla de Moustier, Peter Nisbet, Anna Persson, Michael Rips, Anne Roquebert, Anne Schirrmeister, George Shackelford, Margaret Smith, Judy Sund, Marvin and Lee Traub, Alan Wintermute, and especially James and Alexander Traub.

Regarding loans and other collegial efforts, thanks are due the following individuals: Malika Bouabdellah, Musée des Beaux-Arts, Algiers; Guy Barral; Gladys Bouchard; Patricia Buvat-Carrette; Sarah Campbell; Catherine Camboulives; James Wood and Douglas Druick, The Art Institute of Chicago; Denis Coutagne; Richard Brettell and Susan Barnes, The Dallas Museum of Art; François Daulte; Samuel Sachs and Jean-Patrice Marandel, The Detroit Institute of Arts; Karin Blanc, Getty Foundation; Jacques de Grasset; James Cuno, Harvard University Art Museums, Cambridge; Ned Rifkin and Rhonda Baer, The High Museum of Art, Atlanta; Peter Marzio and George Shackelford, The Museum of Fine Arts, Houston; Christian Landes; Serge Lemoine; Emmanuel Le Roy-Ladurie; Régis Michel and Françoise Viatte, Musée du Louvre, Département des Arts Graphiques; Arnaud d'Hauterives, Musée Marmottan; Philippe de Montebello, Gary Tinterow, and Pat Coman, The Metropolitan Museum of Art, New

York; Evan Maurer and Lynne Ambrosini, The Minneapolis Institute of Arts; Akira Ozasa, Mitsubishi Bank and Trust Co.; J. Carter Brown, Earl A. Powell III, and Charles Moffett, National Gallery of Art, Washington, D.C.; Françoise Cachin and Caroline Mathieu, Musée d'Orsay, Paris; Robert Clementz, Rau Foundation for the Third World; Béatrice de Parseval; Marie-Domitille Porcheron; Brigitte Portal; Manuel Schmit, Robert Schmit; Christiane Sinnig-Haas; Frédéric-Jacques Temple; Roland Vaschalde; Jean-Louis Vaysettes; Verena Villeger; David Curry and Katherine Lee, Virginia Museum of Art; Joseph Baillio and Ay-Wang Hsia, Wildenstein & Co.

Elizabeth W. Easton
Associate Curator
European Painting and Sculpture
The Brooklyn Museum

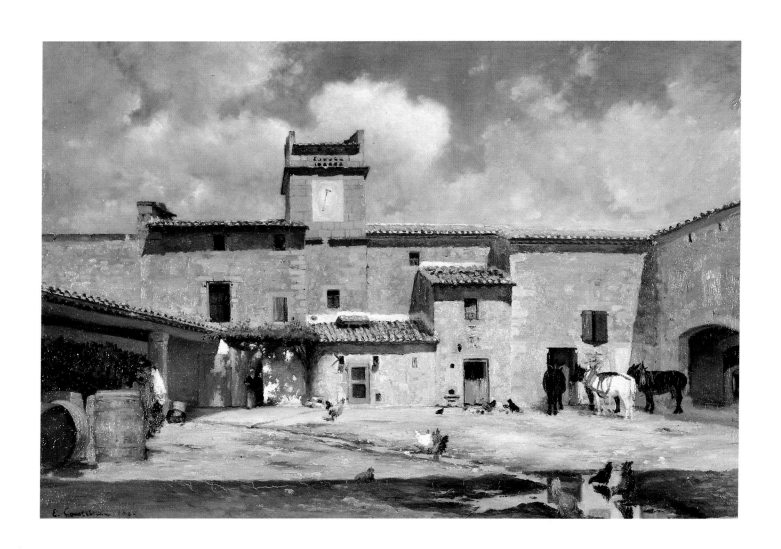

Our Young Fellow Citizen, Son of the Honorable President of the Society of Agriculture...

Frédéric Bazille in Montpellier: a mere youth. His career, his life, and his painting would never attain maturity. Having died young in Impressionism's early years, he never made or attempted to make a masterpiece, a manifesto which, like a rite of passage, would have signaled his attainment of adulthood.

Did he manage to liberate himself in Paris? When he wrote to his parents he signed his letters not "Frédéric" but "F. Bazille," thus asserting his sense of the preeminence of his family name. Marc, his brother, seems to have been a bit more mature: he had a greater sense of individual identity, though he didn't exploit it. Till the end Frédéric remained well reined in. It would take the war, for which he volunteered — and which killed him — to liberate him.

The city of Montpellier was itself undergoing rejuvenation at this time. Towards 1860, after a century of sleep, it seemed to reawaken to new life. Urban growth, with the initiation of grand projects (Haussmann on a small scale); the university, with its rediscovered pride; and the hopeful state of local agriculture emerged as the reference points for a possible rosy future. The father, Gaston Bazille, took a firm stand at the intersection of these three forces (fig. 3). As city councillor, he promoted the rue Impériale, which opened a vital artery to the city's heart.[1] As President of the Society of Agriculture, he traversed the French countryside with his livestock, winning ever more medals.[2] An apostle of progress, he was a co-discoverer, with Professor Planchon, of phylloxera — the bacteria that all but wiped out the French wine industry in the nineteenth century — and the means for its eradication. Gaston Bazille died in April of 1894, and so could not attend the dedication the following December of the monument honoring the wine industry erected opposite the Protestant church: beneath a bust of Planchon, it features an eternally youthful Frédéric, as depicted by Auguste Baussan, his first teacher, holding out a bunch of grapes (fig. 4).

The city also believed in the arts: it showed respect for artistic institutions and encouraged its citizens to practice the arts in their spare time. What was this milieu in which the break wasn't between artists and non-artists, but rather between rich and poor? Alexandre Cabanel was born into poverty. Art made him a gentleman, opening all doors to him. Édouard Marsal, an exemplary scholarship student mentioned in Gaston's correspondence,[3] would achieve parity with the elite. The banker Alfred Bruyas received Courbet (fig. 5), and was more shocked by his truculence than by finding himself, in the face of genius, reduced to mere Fortune. Louis Bazille, the cousin who collected Delacroix, wanted to die listening to a Mozart quartet.[4] Louis Tissié, the charming friend

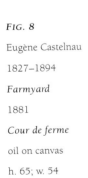

FIG. 8

Eugène Castelnau

1827–1894

Farmyard

1881

Cour de ferme

oil on canvas

h. 65; w. 54

Private collection

of Bruyas and father-in-law of Marc Bazille, was a banker, but that didn't prevent him from painting at Courbet's side at Palavas on his time off. Fajon, an examiner at the Banque de France, exhibited paintings at all the Montpellier Salons.

And there were many exhibitions. No sooner were canvases dry than a small notice appeared in *Le Messager du Midi* announcing they would be displayed on Sunday in the hall of the museum. Nothing was planned, not even an agricultural competition, without an art exhibition. A rather irritated Gaston Bazille saw his son refrain from sending any paintings to the 1868 competition, of which he himself was the undisputed king.[5] Hearty visual appetites were the norm.

This did not last, of course; Bruyas forgot Courbet, and was frightened by Monet when Bazille, father and son, introduced him ten years after *The Meeting*: he closed up like an oyster, and the city along with him. But the meeting commemorated by that canvas indeed took place, and during Bazille's youth, in Montpellier.

In this cultural context, the Bazille family adopted a rather high profile. One that lacked brilliance, certainly, before Frédéric; but the family's interest in artistic matters was genuine and never flagged. Cousin Louis wanted a collection: accordingly, he solicited the aid of Frédéric, as the Parisian correspondent best equipped to assist him. Earlier, in 1798, when the grandfather Marc-Antoine Bazille set out to create a museum in Montpellier, he wrote to Paris asking that "some paintings by our good masters"[7] be sent down on loan. The importance of art was taken more or less for granted: for good or ill, Frédéric would not have to put up much of a fight in defense of his chosen vocation.

The Bazille family belonged to the old Montpellier bourgeoisie:[8] Protestants and metalworkers, they were committed advocates of progress. After the revolution, they turned to trade, banking, and agriculture: Marc-Antoine purchased the property of Saint-Sauveur in Lattes, sold off by the nation. Gaston was to turn it into the marvel he would make renowned throughout agricultural France.[9] Méric, on the Lez, which Frédéric's mother, Camille Vialars, brought with her as a wedding gift (co-owned with her sister Adrienne des Hours-Farel),[10] would be Frédéric's second share of nature. Louis XIII had bombarded the Protestants out of it; two centuries later, the Bazille family spent its summers and falls there. These sojourns in the "country," actually within view of the city center, were the obligatory alternatives to the house in town, to which they retired once more after the harvest, at the start of the opera season.

All eminent citizens then reestablished contact with one another at the Circle of the Grand Loge, a club to which only those with sponsors could belong.[11] On June 3, 1870, when Frédéric finally became a member, he was presented by the marquis Élie de Roquefeuil, Albert de Fesquet, and his father, Gaston. This was a necessary ritual, though one that Frédéric satisfied rather belatedly — three years after Marc, his younger brother. Gaston, who never ceased "breaking lances"[12] with those he referred to as "les beaux de la Loge," was nonetheless an assiduous member. It was there that the countless duck-hunting parties which Frédéric loved from his early youth[13] were planned. They

24

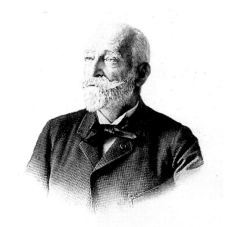

GASTON BAZILLE
1819 ~ 1894
ANCIEN SÉNATEUR DE L'HÉRAULT
VICE-PRÉSIDENT ET PRÉSIDENT DE 1864 À 1886
DE LA SOCIÉTÉ CENTRALE D'AGRICULTURE DE L'HÉRAULT
OFFICIER DE LA LÉGION D'HONNEUR

FIG. 3

Gaston Bazille
portrait of the
senator from the
Hérault (1879)
from the *Bulletin de la
Société d'agriculture de
l'Hérault* (1894)

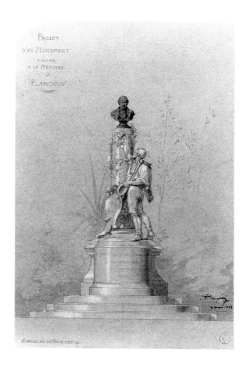

FIG. 4

Auguste Baussan

1829–1907

Project for the

Monument to Planchon

black lead and wash

h. 35; w. 22

Montpellier, Musée Fabre

provided two of the prominent themes of his work: the natural landscape through which he'd traveled so frequently, and the birds themselves, in which he was passionately interested. In his room at 11 de la Grand'Rue he kept a collection of stuffed birds, which he abandoned to the vermin and his mother's anger when he left.[14] And so much the worse for the pigs! When Gaston wanted a portrait of one of them for his study, he was obliged to turn to the Swiss painter Lugardon.[15]

Summers at Méric were family reunions, a theme very dear to Frédéric, in which his cousins the des Hours-Farel, Camille, Thérèse (*The Pink Dress*, cat. 7), and Pauline often figured; cousins always figure in one's youth.

Aside from hunting expeditions and sojourns at Méric and Saint-Sauveur, it seems Frédéric spent little time away from his family. When Courbet passed through Montpellier for the second time, in June 1857, during a conference on botany and entymology, Frédéric was sixteen. He was no longer the child he'd been at the time of the master's first visit in 1854, but he didn't join the hordes of students who cultivated Cévennes at the seaside or the "joyous scientists come to study the vine in its local products."[16] On May 23, he wrote to his father, who was in Paris: "There's nothing new here. Mama… took us to Méric on Thursday to make us happy…. I've seen a few sphinxes… but I was unable to catch any. You told me you've seen some beautiful insects, it would give me great pleasure if you could bring me a few." Courbet was not to be his teacher.

Curiously, the man who did become Bazille's teacher would be a native of Montpellier and a sculptor: Auguste Baussan, who was officially appointed professor of drawing at the École des Beaux-Arts de Montpellier only on February 12, 1869[17] — and not Charles Matet — who taught life drawing at the same institution. One senses here the influence of Gaston, who perhaps saw the difficulties Frédéric was having, and thought that a solid drawing was three-quarters of a finished painting.

It has been said that Frédéric, who was sent to Paris to study medicine, really went there to pursue a budding vocation. Perhaps; but his father had also pursued his law studies in Paris. And his brother, to whom no aspiration of any kind has ever been attributed, received his education in Germany and England: Marc left home with a heavy heart, but he left. Like all Montpellier citizens from good families, he was sent to live elsewhere before marrying. In Paris, Bazille found himself once more surrounded by his friends, his cousins, and his fellow students. If he'd remained he would have broken with custom. By leaving Montpellier, he may have been gratifying a desire to pursue painting, but above all he was satisfying a social obligation: one requiring the initiation of the provincial elite into the realities of Parisian life.

The problem of his vocation was not resolved by his departure for Paris, but his sentimental and familial ties were not severed. Letters were exchanged. Gaston, usually clearheaded and reasonable, was crazy about his son, calling him "cher ami," or "dear friend" (Edmond Maître did likewise, often merging the phrase into the single word "cherami"), and wanting him to be an alter ego;[18] the figure sketched in by his mother, whose letters have been widely dispersed, is far more reserved.

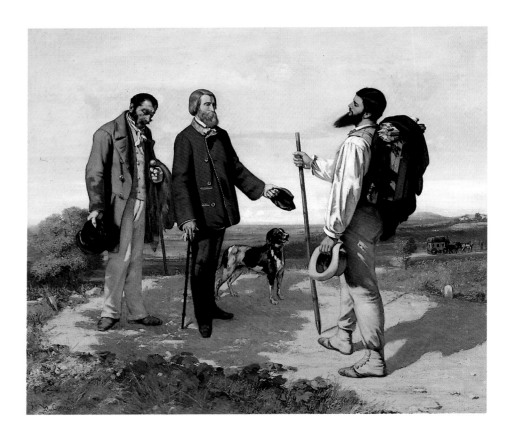

FIG. 5

Gustave Courbet

1819–1877

The Meeting

1854

La Rencontre

oil on canvas

h. 129; w. 149

Montpellier,

Musée Fabre

Respective roles were quickly established. Frédéric sent his provincial correspondents news of Parisian social life. The latter made timid attempts at returning the favor, but they were more forthcoming about the family and about Gaston's activites as an elected official and an agronomist. Their commentaries were endless when it was necessary to send provisions, clothing, or, above all, money.

Despite his financial needs, Frédéric's life in Paris did not cause his parents any anxiety: there are no indications of those traps in which sons of good families sometimes become entangled. This was the result of a solid upbringing, and doubtless of self-discipline. Frédéric never forgot himself. But he was also accompanied by an impressive squadron of cousins, some of whom possessed unexpected qualities. These included the Mamignards, who were ill-tempered, but whom Manet visited regularly, and the Lejosnes, military men who sometimes invited Cézanne, Baudelaire, Nadar, Verlaine, or Gambetta to dinner. All things considered, the family provided more artistic contacts than the studio, which put Bazille into contact with Monet, Renoir, and Sisley — and it was a relative, the painter Eugène Castelnau (fig. 8), who recommended the Gleyre studio and introduced Bazille into it. The role of the family is fascinating; it was omnipresent, even in the realm of art.[19]

So nominal a distancing from his home sphere, so gentle a transition from the family into the world of artists, made adaptation easy. If homesickness surfaced on occasion,[20]

it didn't last long. Gaston's feeble threats about the consequences of abandoning medicine for art ("if you persist, you'll have to come back"[21]) received cutting responses: "I'm awfully nervous about what I'd do in Montpellier for six months.... I'd waste quite a lot of time."[22] With the passage of time Bazille's way of working changed. In the beginning, his paintings were sketched in Méric and completed in his Paris studio, and this was still the case for *The Family Gathering* (cat. 18). Increasingly, his works would be conceived in Paris, with Parisian models, and only the "mise en lumière" (lighting effects) would be added in Méric. The most typical case is that of *Summer Scene (Bathers)* (cat. 25): "I'm making drawings in advance for the figures in the painting of male nudes that I plan to make in Méric." "I'm working on my Méric painting and I hope I'll be able to continue with it on the spot."[23] Natural light was becoming a crucial pictorial element. Impressionism was coming into view.

Which is not to say that the image of Montpellier was obscured. On the contrary! In Bazille's surviving work, there are no fewer than thirty paintings (of the sixty-five catalogued by F. Daulte) connected with Montpellier, or painted at Montpellier. Of these, only eight (of twenty-two that survive) date from the years 1863–66, while twenty-two (of forty-three that survive) are dated from 1867 to 1870. Given the competitive atmosphere prevailing in Parisian studios, exacerbating or accelerating the creative process, the remarkably high proportion of canvases having to do with his native city painted over so brief a span, and in artistic isolation, indicates that Frédéric was comfortable with his Montpellier background.

Méric was an ideal spot for painting. The laurel, the Lez River — a shallow but indispensable stream — the family to serve as models, everything favored the production of paintings. But Méric was not the only place to paint. The Louvre notebooks are full of sketches of the grape harvest, which were not exhausted in the twin paintings in Montpellier (cat. 39, 40).[24]

There are two notable absences in these images of the Midi. Firstly, the sea. Courbet, for example, painted *The Sheds* at Palavas so many times that his authorship of all of them has been questioned.[25] Those who have, get. The sea was a stone's throw from Lattes; Bazille ignored it. His Mediterranean was situated at Aigues-Mortes — a beautiful landscape but a melancholy seashore, broken into pestilential pools. In 1866, the epidemics were so rampant that the trip there was postponed for a year.

The three canvases painted at Aigues-Mortes look towards the city and its ramparts, not the open sea; the only genuine seascape by Bazille represents Honfleur,[26] and it was painted in Paris after a painting by Monet. The city is also absent from Bazille's work. It makes one appearance, behind an odd young Italian girl playing the violin.[27] All sorts of things have been said about this painting: suburbs, Fellini, Utrillo. But we now know it was painted at Montpellier, in 1868,[28] and that the houses, far from being Parisian, have the overhanging stories typical of Languedoc. Paradoxically, it was during a summer sojourn in the country that Frédéric painted a bit of the city.

His own city ignored him. As far as Montpellier was concerned, Bazille didn't paint.

Despite the interest of the family, initially predisposed to show everything, have photographs—that is, postcards—made, Montpellier remained indifferent, even hostile.

The first hitch in the family's efforts to promote Bazille's work left a black mark on *The Pink Dress* (cat.7), and on the artist's relations with his city, that would never be effaced. Gaston's account: he is sending two photographs, among them one "which will surely take you a bit by surprise, that of the village of Castelnau with the portrait of a young lady named des Hours by a young painter known to you. I'd go so far as to say in this regard that that animal d'Huguet-Moline, the epithet is not too strong, put me into a towering rage: finding that there wasn't enough relief in his photograph, he took it upon himself without telling anyone to apply color to the dark parts of your figure. I was extremely irritated when I perceived these retouches, unfortunately the damage was done. The arm and cheek of Thérèse haven't exactly been improved by these changes, you'll fix this as best you can if you still have the study." [29]

At that point a curtain fell over the canvases. Mme Bazille put in a request for "the paintings I need for my living room and your father's study. But especially for the living room, I need something of Méric as soon as possible."[30] She wouldn't get something of Méric, and Gaston was to buy his paintings, like his cows, in Switzerland. Suzanne, Marc's wife, had a bit more luck. She was offered a painting of *Flowers* that was both tasteful and harmless. Bazille's uncle Pomier-Layrargues commissioned two overdoors: he got them, but Frédéric's interest in the project derived from his desire to learn how to suppress "a mass of details, which make a very bad impression from the great distance from which they'll be viewed."[31] Soon even the uncles were deprived of viewing rights. The rare canvases that were surrendered came with the express condition that they be relegated to the intimacy of "the small bedroom." But one can easily imagine his female cousins furtively slipping into this room: they were allowed every indulgence!

If, in returning to Paris, Frédéric, having too much baggage, left a few works behind, finished or not, he wasted no time before complaining of the delay—or the reluctance—to send them on. When Gaston went up to Paris, he managed to come away with a painting: here again, the result was grumbling and grousing, and almost cries of theft.[32]

Even to speak of exhibiting in Montpellier! Initially Frédéric hedged, but when Gaston became more pressing he exploded: "Whatever you may say, I haven't the slightest desire to exhibit in Montpellier."[33] His reasons are elusive. The twice-repeated "it would serve no purpose"[34] explains nothing. Why was it that Montpellier and Bazille stayed on opposite sides of the street to avoid an encounter? There are two possible explanations: defiance or contempt of the one for the other, or defiance or contempt for oneself. The first ingredient was certainly present in Frédéric. Was the second a factor as well? Frédéric may have been less than fully convinced that his painting was good: the laughter of his fellow citizens would have found him infinitely more vulnerable than Manet or Courbet, or even Monet. Bazille was unsure of his destiny.

The silent, painful uncertainty about his calling could be appeased by only one person. In the absence of a solid amorous attachment (he himself wrote: "I feel a violent love for no one"[35]), it was his father who would reassure Frédéric about his vocation.

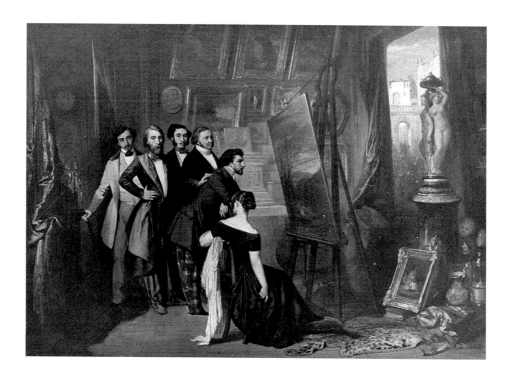

And Gaston Bazille was not a blind soul. He was a judicious man who even seems a bit harsh when he writes to his son, "Unfortunately I don't see enough of the sacred fire in you, and you retreat from difficulties instead of knowing how to overcome them through patience and energy."[36] But some such sacred fire must have burned inside Frédéric, perhaps intensifying a desire for fire that would find satisfaction in the war.

It is necessary to correct the legend disseminated by incorrigible romantics: The story of a son of genius, a bourgeois family, and a sponging Monet who hated that family is false. Gaston sensed the force of Monet. All things considered, he preferred a genius he didn't like to an amiable mediocrity: "I'm sorry about your separation from Monet. It seems he was a real worker who must have made you blush at your own laziness quite often."[37] Two years later, Camille wrote, on the occasion of Frédéric's departure from the studio he shared with Monet: "I'm very irritated about your leaving the rue Visconti."[38] Frédéric himself would write: "I'm not sorry to live a bit on my own."[39] But when he distanced himself from Monet, the family was not pleased.

Still, it didn't love him any the less, and with a love that was constant, regardless of what he did. There was something profoundly Calvinist in the soul of the Bazille family. Whatever Frédéric's actions or requests, they would be carefully considered — undoubtedly discussed, but always supported or granted. The family's support was solid, whatever one did, even if one became a painter.

The city was less indulgent. In the *Journal de Montpellier*, one J. Ixe, doubtless a former citizen of Montpellier living in Paris, ferocious but well informed, published critical notices about the Montpellier artists in the Salon.[40] About *Still Life of Fish*, exhibited in 1866 (cat. 12), he wrote: "The quality of the drawing and modeling in this still life

["nature morte"] that's too still ["morte"] falls short of what's required for a genre that derives its essential vivacity from forceful color and effect and spirited handling." In 1866, Bazille came across as a banal, mediocre painter. By 1868, things had changed. Ixe then assessed him in the context of his Parisian milieu, condemning him for his affiliation with the new school: "Bazille (Jean-Frédéric) follows in Manet's footsteps, emulating the handling and, unfortunately, the methods and ignorance of that master.... In the brackish light of the frigid, coal-black atmosphere of a prison courtyard, he painted this *Study of Flowers*[41] with a morbid brush, one lacking both grace and pity.... In *Family Portraits*,[42]... I once again emphasize the picturesque quality of certain poses and note the expressiveness of the physiognomies, probably very good likenesses, the freshness of certain passages, apparently executed from nature; but the ground is more perpendicular than horizontal.... As for the landscape background, it's as though it had been seen and executed separately." In 1869, concerning *View of the Village* (cat. 20): "Unquestionably it is original, new, very new... unless one goes back to the old style of primitive painting from the Middle Ages." And in conclusion, after taking a few potshots at the model's hands, the cavalier approach to perspective, and the greens "that would make Corot faint": "If, to these instinctive qualities, M. Bazille manages to append an entirely personal mode of conduct, independent of the governance of... Manet, you'll soon see him turn it to excellent account."

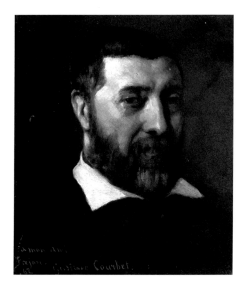

The preeminent Parisian figure of Manet was a constant reference point. Bazille was a painter in Paris, and this Parisian image was the one communicated to the residents of Montpellier by the (eminently respectable) literary communiqués of J. Ixe.

After 1869, we find Frédéric Bazille mentioned in the local press only in his death notices. They make heartbreaking reading: their denial of the life, and of the vocation, is radical. Not once, in all these lengthy notices, is painting ever mentioned.

The *Messager du Midi*[43] lamented "our young fellow citizen, M. Frédéric Bazille, son of the honorable President of the Society of Agriculture.... It would be impossible to encounter a nature that blends as much grace and distinction with such simplicity! It would be impossible not to be won over by this heart of gold!... His future was full of promise. Montpellier will be faithful to the memory of one of its worthiest sons." Was the art of painting considered so unworthy that it was not to be spoken of?

And in *La Liberté*:[44] "We learn of the death of M. Frédéric Bazille, son of the President of the Society of Agriculture of Hérault.... This loss has deeply touched all who knew him, and, political differences aside, we join our expressions of regret to the expressions of sympathy addressed from all sides to the family of this young citizen who died on the field of honor." For Montpellier, Bazille's destiny was, and would long remain, solely to have perished in the war.

Pay a visit to the monument erected by his father, the most sumptuous of all those in the city's Protestant cemetery. You'll find everything there, love and emotion, grandeur and grace — but no mention of his having been a painter.

Of the three statues in Montpellier representing Bazille, the one on his tomb depicts

30

NOTES

1. Three reports by Gaston Bazille were read before the city council: one on the Catholic churches of Saint Anne, Saint Roch, and Saint Denis, the Protestant church, and the rue Impériale (delivered on July 8, 1862); and two others on the rue Impériale (delivered on February 23, 1863, and August 19, 1869). All three reports were printed on the council's orders.
2. Letter from Gaston to Camille dated May 9 (1866): "It's been confirmed.... I won 10 prizes and not nine. Seven first prizes and not six" (at the Avignon regional competition). In 1868, at the Montpellier regional competition, Gaston Bazille took eight prizes amounting to 7,000 francs, a sum equal to a year of Frédéric's expenses in Paris.
3. Letter from Gaston Bazille to Frédéric, July 4, 1864.
4. Correspondence of Joseph Bonaventure Laurens. In *Laurens, Jean-Joseph Bonaventure: sa vie et ses oeuvres*, Carpentras, 1899, p. 311 (Anon.).
5. Letter from Gaston to Frédéric, April 30, 1868. Gaston Bazille organized, as adjunct, this competition and the accompanying festivities. As an agronomist he would prove to be its triumphant victor.
6. Correspondence from Louis Bazille to Frédéric: 1869–70.
7. Letter of 22 Nivôse, Year VI, to the Minister of the Interior. Paris, Archives de la direction des Beaux-Arts. Published in *Inventaire des richesses d'art de la France: province, monuments civils*, vol. I, p. 141, and in Joubin 1926, p. XIV.
8. Romane-Musculus, 1987.
9. Letter from Gaston to his wife on December 24 (1868): "M. Bazille of Hérault, for that's what they call me, is no longer an unknown to a crowd of farmers."
10. On the Méric property, see Albert Leenhardt, 1931.
11. The record books of this organization are in the archives départementales de l'Hérault, classed under

him as a hero; another portrays him as a viticulturist;[45] and the third (and he a Protestant!) transforms him into Saint Roch.[46] He is model, friend, but never painter — just as in Monet's *Déjeuner sur l'herbe*.

His native city would discover Bazille only by way of Paris: first at the Universal Exposition of 1900, then at the restrospective exhibition during the Salon d'Automne of 1910. It was only in 1927 that Montpellier finally organized its first exhibition — fifty-seven years after Bazille's death, and four years after the death of his brother.

Works by him first entered the collection of the Musée Fabre in 1898: *Still Life with Heron* and *View of the Village*. Twenty years later five more canvases arrived, donated by Marc and by Alphonse Tissié. As for the first purchase, that took place only in 1956.

Since then, Montpellier has made up for lost time. The 1985 purchase of *The Studio on the rue de Furstenberg*, followed by the purchase of Méric (which would be consecrated to the painter's memory) and the organization of the "Bazille Year" on the occasion of the 150th anniversary of his birth, would all seem to offer some compensation for the delay.

Guy Barral

FIG. 7

Gustave Courbet

1819–1877

Auguste Fajon

1860

oil on canvas

h. 45; w. 37

Montpellier, Musée Fabre

the numbers j14 to j16.
12. Letter from Gaston to Frédéric, February 25,1863.
13. Even in Paris he kept his Montpellier hunting permit.
14. Letter from Gaston to Frédéric, June 8, 1963.
15. Letter from Gaston to Frédéric, March 24, 1868. Jean-Leonard Lugardon, born in Geneva in 1801, was a student of Ingres. He, too, painted a *Ruth and Boaz*.
16. *Le Messager du Midi*, June 15, 1857.
17. Address by M. Léopold Carlier at Baussan's funeral, in *La Vie montpelliéraine et régionale*, March 3, 1907.
18. Letter from Gaston to Frédéric, April 30, 1868: "I would like to have in you an alter ego in whom I can take pride."
19. When Bazille died, Gide was born. They had Montpellier and Protestantism in common, but they were separated by a generation — and, of course, their family origins.
20. Note that it was Poulain, himself a native of Montpellier, who asserted this, and that in the process he confused two letters, of February and November 1863 (Poulain 1932, p. 28).
21. "Your medical studies are the reason for your sojourn in Paris, don't neglect them if you still want to remain far from us." (Letter of May 15, 1864.)
22. Letter from Frédéric to Gaston (April 1868), Musée Fabre.
23. The work in question is *Summer Scene*, The Fogg Art Museum, Harvard University (cat. 25). Letters from Frédéric to Gaston [April 9 and May 2, 1869].
24. *Studies for a Grape Harvest*, Montpellier, Musée Fabre (cat. 39, 40). Tradition fixes the site at Bionne, on the property of Louis Tissié. The landscape could also, perhaps, be that of Saint-Sauveur.
25. See Philippe Bordes, "Montpellier, Bruyas et

Courbet" in *Courbet à Montpellier*, exhibition catalogue, Montpellier, 1985, p. 31.
26. *The Beach at Sainte-Adresse*, The High Museum of Art, Atlanta (cat. 9).
27. *Italian Girl Playing the Violin*, private collection, Nîmes (Daulte 1922, no. 47).
28. In February 1869, Frédéric wrote to his mother: "The painting of the little Italian girl, which you seemed to think was so bad, is having an enormous success.... I'd very much like... one or two young girls like the little Italian to model for me at the end of May." This "bad" painting so familiar to the parents was painted in front of their eyes. In the Salon open in Montpellier from the 1st to the 31st of May, 1868, on the occasion of the agricultural competition, a *Young Girl Playing the Violin* by Bouchet-Doumenq of Arles was exhibited (it won the silver medal). Frédéric, in Montpellier during the exhibition, painted his own *Italian Girl Playing the Violin* in the course of the summer.
29. Letter from Gaston to Frédéric, December 16 (1864).
30. Letter from Gaston and Camille to Frédéric, November 28, 1867.
31. Letter from Frédéric to Camille, August 18, 1865. Marandel, p. 201, no. 45 (1865).
32. "Papa wanted to force a still life out of me, which I found most disagreeable. I very much hope you won't hang it in a place where strangers could see it, you'd do me a big favor by placing it in the small bedroom with the *Female Nude* and *Thérèse from the Back*." Letter from Frédéric to Camille, January 1, 1869. Marandel, p. 206, no. 72, January 1, 1869.
33. Letter from Frédéric to Gaston, late February, 1870. Marandel, p. 209, no. 82 (1870).
34. In two letters from Frédéric, late February and

early March, 1870. Idem and p. 209, no. 83 (1870).
35. This was his response to justify his lack of interest in a possible marriage that would net him 100,000 écus. Letter to Camille, January 1868. Marandel, p. 204, no. 60.
36. Letter from Gaston to Frédéric, May 31, 1868.
37. Letter from Gaston to Frédéric, December 28, 1865.
38. Postscript from Camille to Frédéric, at the end of a letter from Gaston to Frédéric, November 28, 1867.
39. Cited by Poulain 1932, p. 62. And to Marc: "I am happy to distance myself from my many acquaintances to work more tranquilly," December 1865.
40. *Journal de Montpellier*: June 2, 1866; May 23, 1868; June 12, 1869. All were signed J. Ixe. These three notices were published in their entirety in the catalogue *Bazille. Traces et Lieux de la création*, Montpellier, 1992.
41. *Flower Pots*. This is the painting now in New York, in the collection of Mrs. John Hay Whitney (Daulte 1992, no. 20), painted in 1866, and not, as has long been believed, the painting in Grenoble (cat. 22), which was painted in 1868 at Méric. The description of the painting and its having passed through the Lejosne collection are precise on this point:("I sent another one [to the Salon] as a favor to Lejosne, to whom I'd given it. This was *Flowers*": letter of [April 1868]).
42. *The Family Gathering*, Paris, Musée d'Orsay (cat. 18).
43. *Messager du Midi*, Monday, December 5, 1870.
44. *La Liberté: journal démocratique quotidien de l'Hérault et du Gard*, Thursday, December 8, 1870.
45. The monument to Planchon.
46. Colossal statue 3 meters high for the church of Saint Roch. All three of these statues are by Baussan.

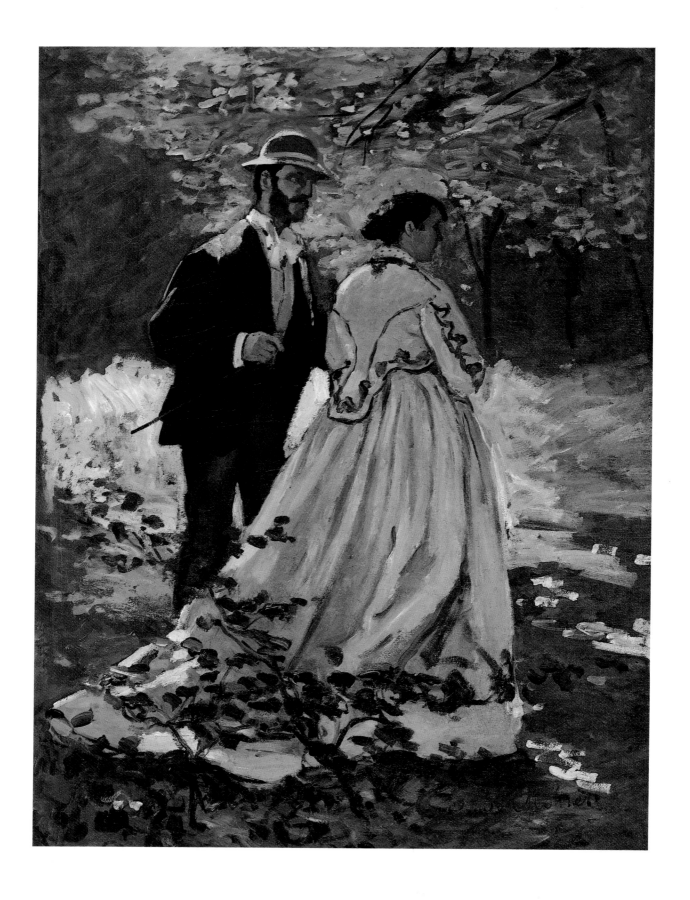

Bazille and Friendship, or the Interrupted Lexicon

APPEAL

To his mother: "I'd like it very much if you could write me a bit more often. You have no idea how interested I am in everything that happens in Montpellier since I left it." Intense loneliness of Frédéric Bazille, who had arrived in Paris a few weeks earlier, in November 1862. Authorized, not without second thoughts, by a father convinced that the medical school in Montpellier was among the very best, to pursue his studies of medicine in Paris, he introduced himself to Charles Gleyre in view of entering his studio. "He scrutinized me from head to toe, but said not a word; it seems he's like that with everyone, out of timidity. I've begun to draw, and the day after tomorrow I make my solemn entry into the studio" (fig. 9).

ANATOMY

Frédéric Bazille was not preoccupied by any kind of medical study for very long. At the end of 1862 he wrote to his parents: "I've recently made the acquaintance of monsieur le vicomte Lepic, son of the Emperor's aide-de-camp. He's a painter, and while already pretty good, he entered our studio to improve himself. He took me to his rooms, in the Louvre itself, where his father has set up a splendid studio for him. This young man, and another from Le Havre named Monet, who knows M. Wanner, are my closest friends among the art students. A few days ago I made my first daub, it's a copy of a painting by Rubens in the Louvre. It's atrocious but I am not discouraged. There are other copyists just as bad as I am." He used whatever arguments were at hand to reassure M. Bazille, his father. "Perhaps you'll find it hard to believe me, but I assure you I'm applying myself to drawing with a vengeance. I go to the studio at 8 o'clock every morning, and I don't leave before 3 in the afternoon. The remaining time is enough for me to take two courses at the medical school, one in anatomy, the other in surgery.... M. Gleyre (in the studio he's known as 'the boss') comes twice a week and passes by every student, correcting his drawing or painting, then from time to time he assigns a little compositional subject that everyone executes as best he can "(fig. 10). Can a phrase such as this — written in February 1863 — have been very reassuring to M. Bazille? The "best" for compositional subjects, "the remaining daytime hours" for medical school.

"AVERTISSEMENT" (WARNING)

There soon began, of and for painting, the period of complicity, and all that this entailed in the way of ardor and advice, of quarrels, mutual aid, jealousy, and misunderstandings. On December 8, 1863, Bazille wrote to his parents: "Villa and Monet are the only students in my studio whom I see regularly, they're very fond of me and it's reciprocal, for

FIG. 13

Claude Monet

1840–1926

The Strollers (Bazille and Camille)

1865

Les Promeneurs

oil on canvas

h. 93.5; w. 69.5

Washington, National Gallery of Art

they're charming boys." Monet, a few months later, on July 15, 1864, wrote to Bazille: "It's not with chaps like your Villa [fig. 11] and others that you can get work done." Like that of vicomte Lepic, Villa's name was never again mentioned in the letters Bazille sent to Montpellier, but another name soon appeared: that of Renoir.

Apprenticeship

Within a few months Bazille had come to understand the longing he carried within himself — his need to paint — just as he'd recognized at whose side and in reference to whose work he should pursue painting. In the spring of 1863, he visited the Manet exhibition, in the company of Monet. "You can't imagine how much I learn from looking at these paintings! One of these sessions is worth a month's work."

A few weeks later, in April, he was once more at Monet's side: "As I've already told you, I spent eight days in the little town of Chailly near the Fontainebleau Forest. I was with my friend Monet, from Le Havre, who is rather good at landscape, he gave me some advice that helped me a lot." When Bazille didn't join Monet in the forest of Fontainebleau or at the mouth of the Seine, he received letters of reproach from him that helped in another way: "I ask myself what you could be doing in Paris with such fine weather. Here, my dear, it's delightful, and every day I discover things that are more beautiful still; it's enough to drive one crazy: my head is bursting! Certainly it's ferociously difficult to make something that's complete in every respect; I think most people make do with approximations. Well then, my dear, I mean to fight, scrape, start over, because one can do what one wants and what one understands, because it seems to me, when I see nature, that I see it all done, all written; and then, when one's actually at work, it says go ——— yourself! Which proves that one must be singleminded, thinking about nothing else; it's by force of observation and reflection that one captures it. So let's sweat and sweat without interruption. Are you making progress? Yes, I'm sure you are! But I'm sure of one thing, that you don't work enough, and not as you ought" (fig.12).

34

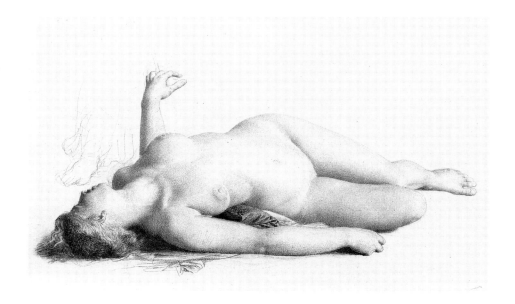

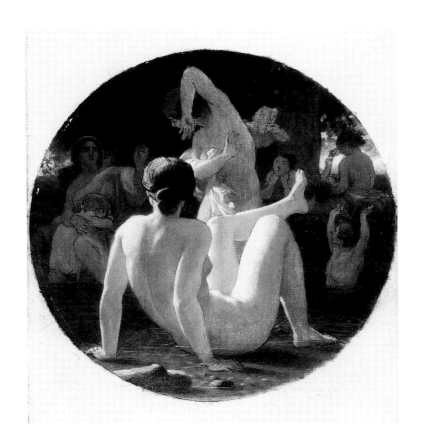

ASSISTANCE

"Renoir asks me to find out if there isn't someone of our acquaintance who has 200 to 250 liters of table wine to sell to his father." Relations between Bazille and Renoir were of a different sort: Monet and Bazille addressed each other with the formal "*vous*," while Bazille and Renoir used the familiar "*tu*."

If Bazille could paint without selling his canvases, because funds arrived regularly from Montpellier, Monet, by contrast, was always in need of money, not only because he received little from his family but because he couldn't help but spend what he had. Monet sent three canvases to Bazille, hoping they might be purchased by Alfred Bruyas, a banker and friend of Gaston Bazille's who had received Courbet in Montpellier and bought several of his paintings — a vain hope, as it turned out.

ABANDON

"I fear, my dear father, that you might be displeased at seeing me give myself over completely to painting, I'd very much like you to give me your real view on the subject.... I'm not unaware that you had me learn music only for my own pleasure. As for painting, that's something else again, I intend to apply myself to it as seriously as possible, and become more attached to it each day." As he became attached to Monet — and Monet didn't stop lecturing Bazille. From Honfleur, he wrote: "I hope you're working very hard. You have to apply yourself seriously because your family has given up on your medical

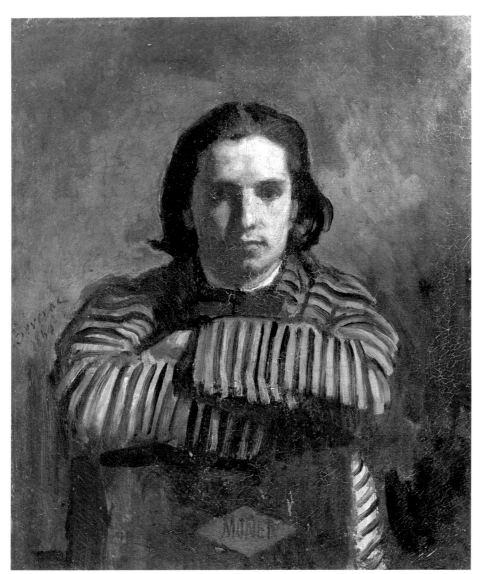

FIG. 12

Gilbert de Séverac

1834–1897

Portrait of Monet

1865

oil on canvas

h. 40; w. 32

Paris, Musée Marmottan

career…. There are a great many of us in Honfleur now…. Jongkind and Boudin are here; we get along marvelously and never leave one another. I'm very sorry you're not here, for in such company one can learn a great deal, and nature is beginning to become beautiful, it's ripening, it's becoming more various, in short it's wonderful." Which Bazille soon verified for himself; on June 1, 1864, he wrote, "It was towards the middle of last week that I left Paris with my friend Monet…. The moment we arrived in Honfleur we began to look for landscape motifs. They were easy to find, for this area is paradise." In this particular paradise, Bazille's working rhythms were intense, doubtless because Monet was urging him on. Specifics provided that same June 1, 1864: "I get up every morning at five o'clock and I paint all day until 8 o'clock in the evening. But you mustn't expect

me to bring back good landscapes, I'm making progress and that's the sum of it. It's all I ask for, I hope to be satisfied with myself after three or four more years of painting." It was in terms of rigor and objectivity that these young painters, supportive of one another, working side by side, held themselves accountable.

AUGUST 1865

Monet was in Chailly. To Bazille: "You promised to help me out with my painting, you should come and pose several figures for me, otherwise I won't have my painting.... I beg you, my dear friend, don't leave me in the lurch.... I no longer think of anything but my painting, and if I don't manage to bring it off I think I'll go crazy." Monet was beginning a *Déjeuner sur l'herbe* which, without a nude, was to build upon the one by Manet that had provoked a scandal at the Salon des refusés of 1863. Bazille to his father: "I have to go to Chailly for five or six days to help out Monet, he's making a large painting in which I'll appear, and he needs this much time to paint me." The days passed. Monet, on August 16: "If you don't answer by return mail, I'll think you've refused to write me and help me out. I'm in despair; I'm afraid you might keep me from finishing my painting, and this would be very wrong of you after having promised to come and pose for me" (fig. 13).

"AMBULANCE IMPROVISÉE" (FIELD HOSPITAL)

Bazille to his parents, August 18, 1865: "I'm leaving for Chailly where Monet awaits me as if I were the Messiah, I think he'll only need me about four or five days."

A few days later, August 24, 1865: "I've been in Chailly since last Saturday, and solely to do Monet a favor, otherwise I'd have left for Montpellier long ago and with great joy. Unfortunately, since I've been here the weather has been atrocious. I've only been able to pose for him twice, including today. Now the weather is quite beautiful and will certainly hold. Monet, working as quickly as possible, will need me for three or four more days." The demands of painting took precedence over everything else. When the weather permitted open-air sessions to begin once more, Monet was injured in the leg by a metal discus. He was furious. To help him admit he ought to keep still, Bazille, who had modeled for two figures in Monet's painting, made the reclining Monet his own model. In a room in the inn called the Lion d'or, he painted *The Improvised Field Hospital*.

ATELIERS (RUE FURSTENBERG, RUE GODOT DE MAUROY)

Over the following months the close relationship between Bazille and Monet continued. In late 1864 or early 1865 Bazille informed his father that Monet "takes the trouble" to come wake him up every morning and that he spent his days in his studio "painting from the live model." And Monet moved in with Bazille, who'd lived in the rue Furstenberg since January 15, 1865; the 150 francs that Monet's father, passing through Paris, had given his son, added to money that Bazille had received from Montpellier, allowed them to set themselves up in a shared studio. In December 1865, Bazille wrote to his brother, Marc: "But I have some interesting things to tell you. First of all, I'm working very hard on my painting for the Salon, it won the compliments of

master Courbet, who came to visit us to see Monet's painting, which enchanted him. More than twenty other painters have come to see it as well, and all admire it very much, though it's far from finished (you understand that I'm not speaking of my own work). This painting will create a huge stir at the exhibition." The work Bazille wasn't speaking about was a painting 2 by 1½ meters. "Unable to undertake a large composition, I sought to paint as best I could a subject that's as simple as possible. Besides, in my view the subject matters little so long as what I've done is interesting as painting. I chose the modern period, because it's the one I understand best, and which I find the most vital for living beings, and that's exactly what will get me refused. If I'd painted Greeks or Romans I'd have nothing to worry about; for that's still the way things are; whatever qualities my painting may have would certainly be appreciated in a peplum or a trepidarium, but I'm very much afraid that my satin dress in a living room will be refused." In the studio at 22 rue Godot de Mauroy, in which Bazille set up shop on February 4, 1866, he painted a young man lying on a sofa listening to a woman playing the piano. "What's terribly difficult is the woman, there's a green satin dress, which I rented, and a blond head that I'm very much afraid isn't all it should be, though Courbet complimented me on it when I'd begun it. But I think I've already told you that I've reworked everything since then." The same green dress was borrowed by Monet for his portrait of *Camille*. This portrait was accepted for the Salon of 1866. In *L'Événement illustré* Zola wrote: "Look at the dress. It is supple and solid. It drags gently, it lives, it clearly states what this woman is about." And a certain M. de Sarlat, in his review of the same Salon, wrote of Bazille's only accepted work, a still life: "It is solidly painted…. I urge M. Bazile [sic] to avoid dark tones…. The carp is very real: one wants to serve oneself, it is so appetizing."

ATELIER (RUE VISCONTI)

A few months later, on July 1, 1866, Bazille moved to the rue Visconti. "I don't think I've told you that I'm extending my hospitality to one of my friends, a former student of Gleyre's, who lacks a studio at the moment. Renoir, that's his name, is a real worker, he takes advantage of my models and helps me pay for them. It's very pleasant for me not to spend my days completely alone."

Bazille painted a portrait of Renoir (cat. 44). And, in late 1867, Renoir painted one of Bazille, depicting him at work on *Still Life with Heron* (fig. 14); behind Bazille, who is sitting in a chair, and above several canvases seen from the back, Renoir painted a canvas by Monet that was hanging on the studio wall, *Road near Honfleur in the Snow* — a "collective" portrait. (Some years later, Renoir recalled a comment made by Manet, "who was far from admiring what I did; but all the same, in front of each one of my canvases he repeated, 'No, this is no longer the portrait of Bazille,' which let me suppose that, at least once, I'd painted something that wasn't too bad.")

Just as Bazille had painted his studio on the rue Furstenberg — incorporating a stove, perhaps in homage to the one Delacroix had included in his canvas of his neighboring studio, where he died in 1863 (fig. 16) — he painted the one on the rue Visconti.

FIG. 14

Auguste Renoir

1841–1919

Bazille at His Easel

1867

Bazille peignant à son chevalet

oil on canvas

h. 105; w. 73

Paris, Musée d'Orsay

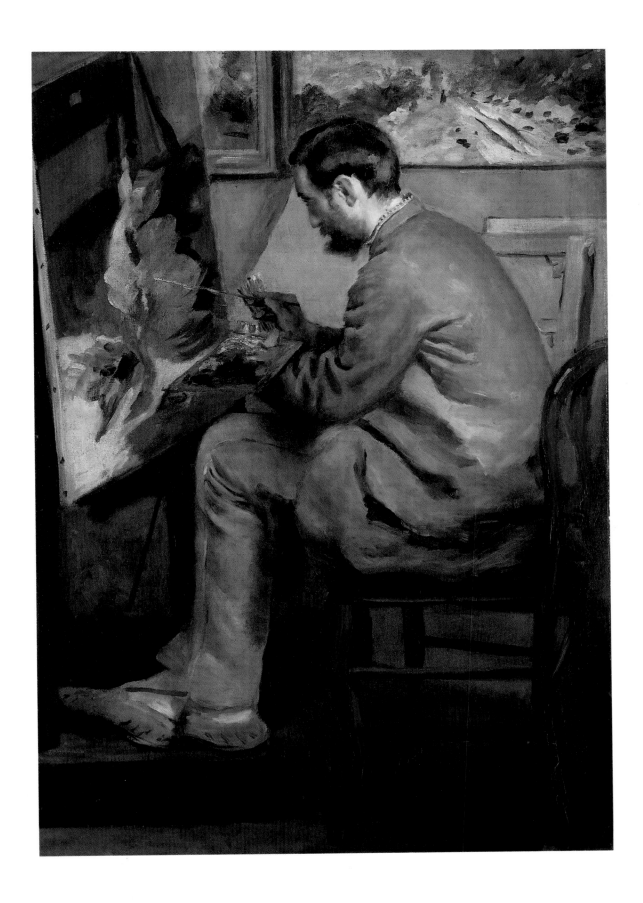

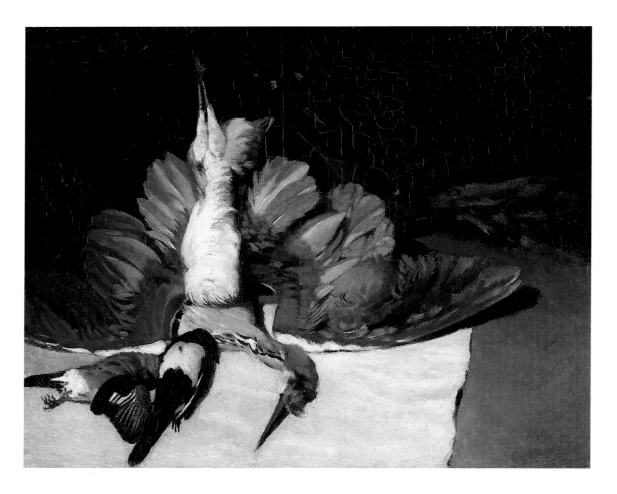

FIG. 15

Alfred Sisley

1839–1899

Still Life with Heron

1867

Le Héron aux ailes déployées

oil on canvas

h. 81; w. 100

Montpellier, Musée Fabre

The room is empty. On either side of the chimney in the corner, there are canvases on the walls: The feet and dress at the upper right are perhaps those of the *Little Italian Girl, Street Singer*, and on the other wall, there are *Boats at Honfleur*, and cliffs, also at Honfleur. What is the large framed canvas on the easel at left, turned just out of view? What work by Monet, or perhaps Bazille, is hidden by its frame?

ATELIER (RUE VISCONTI)

Late February 1867. Bazille to his parents: "Since my last letter there's news…. Monet has appeared from out of the blue with a collection of magnificent canvases…. He'll stay with me until the end of the month. With Renoir, that makes two needy painters I'm lodging. It's a veritable infirmary, which I find enchanting. I have enough room, and they're both very cheerful." But it wasn't just a question of cheer. It was always a question of painting. Bazille wrote: "Renoir has made an excellent painting that has astonished everyone."

ADMIRATION

From Montpellier, some weeks later, Bazille wrote to Monet to tell him what he thought of *Women in the Garden*, the canvas completed in Honfleur (fig. 17). Monet's response: "I received your letter, which gave me the greatest pleasure: I am very grateful for the com-

FIG. 16

Eugène Delacroix

1798–1863

Studio Corner with Stove

Coin d'atelier. Le Poêle

oil on canvas, h. 51; w. 44

Paris, Musée du Louvre

pliments you've given me, and all the happier as I rather dreaded the contrary, and it's a painful thing to be the only one who's satisfied with what one's done.... So let's stay the course, and let's arrive with things that are unimpeachable. There's nothing more at the moment. Renoir and I are still working on our views of Paris."

"ARGENT" (MONEY)

Bazille bought *Women in the Garden* for 2,500 francs. Lacking resources other than the money sent to him by his father, he undertook to make payments of fifty francs a month to Monet, who was more in need of money than ever. He was now receiving almost nothing from his family, and Camille Doncieux, his companion, was pregnant. Bazille: "At the moment Monet is staying with me, and he's more wretched than ever. His family is shamefully stingy with him, he's probably going to marry his mistress. Does this woman have parents sufficiently accommodating to see her again and assist her if she marries? Not exactly cheerful, but their child will have to eat."

After Monet left Paris, he didn't stop importuning Bazille. There were pressing letters before as well as after the birth of Jean Monet.

June 25: "But I have a favor to ask of you. On July 25 Camille is due; I'm coming to Paris, I'll remain there ten or fifteen days, I need money for lots of things; try to send me a bit more, even if it's only 100 or 150 francs. Give it some thought, because without it I'll be in a very awkward position.... So write to me, tell me a bit about what you're doing.... Are things going as well as you'd like? It's difficult, isn't it? In any case, sweat it out and be hard on yourself, because in Paris they give one credit for more talent than one has. They make do with the slightest hints."

July 3: "So forgive, my old friend, for starting in again, but this poor woman is in need; send me what you can immediately, I'm very sorry."

July 9: "I beg you, my dear friend, help me out, for my anxiety is apparent at home.... If you haven't any funds at the moment, send me even a small sum, so that at least I can summon up some good spirits."

July 16: "I received your last letter. I no longer knew what to make of your silence.... The 50 francs won't go far, and I have nothing for my departure.... I'm happy to know you're working, but it seems to me your large painting isn't coming along very fast. Take special care over the proportions and the arrangement."

August 12: "You've been very stubborn about not answering me. I sent you letter after letter, rapid post, nothing got a rise out of you; yet you know me better than anyone, and my circumstances as well. I've had to ask strangers for loans and subject myself to insults. Oh! I'm very angry with you, I didn't think you'd abandon me like this; it's very wrong."

August 20: "Naturally, I no longer attribute your silence to an oversight. I know how negligent you can be, it's true; but given the requests, the entreaties I've sent you one after the other by every available means, I thought you'd have hastened to write to me; one gives some consideration to one's friend's difficulties, usually. So I no longer dare believe in your friendship. I'm in greater need than ever, you know why, I'm sick over it.

FIG. 17

Claude Monet

1840–1926

Women in the Garden

1867

Femmes au jardin

oil on canvas

h. 255; w. 205

Paris, Musée d'Orsay

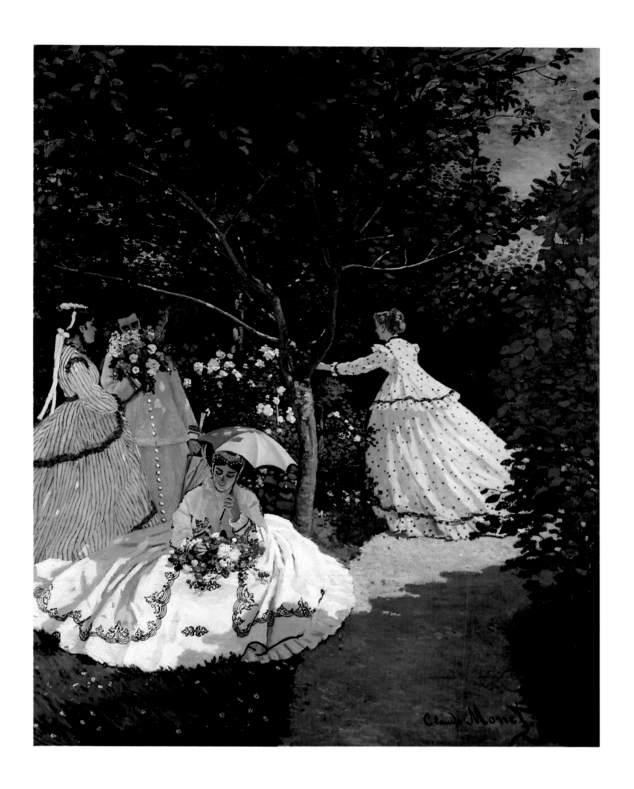

If you don't answer me, everything will be finished between us. One last time, I tell you I'm in desperate straits."

ACCUSATION

Monet's financial difficulties continued. On January 1, 1868, Monet wrote to Bazille: "My circumstances are very difficult; I have many obligations to settle tomorrow and after. I never harass you, knowing very well that you don't always have a lot of money, but in the end you'll agree that if you pay twenty or ten sous at a time we won't be done with it till the end of the world. But when you bought my painting you agreed to give me 100 francs each month…. I never dare say anything because you seem to think you bought the painting from me out of charity, and when you give me money you have the air of lending it to me." Bazille's wounded response: "I have never, so far as I know, had the air of giving you charity. On the other hand, I know better than anyone the value of the painting I've bought, and I very much regret not being rich enough to offer you better terms. I'm the only one, at least, however inadequate that may be, to have proposed any to you, and I beg you to take that into account. You say we won't be done with it till the end of the world if I make payments of twenty francs. It's very un-becoming for you to hold that against me. When I gave you twenty sous it was because I only had forty, and I paid you all I could that month…. Now, you have received from me, since I've known you, the sum of 980 francs, to which must be added the price of frames and 54 francs for this month of January '68. I haven't failed once to give you the 50 francs. Add this up, and you'll know when the world will come to an end. I'm not angry with you for your harsh letter. I'm very unhappy to know you're in such difficult circumstances; and I don't want to suffer your accusing me of indifference or ill will, when I help you out as much as I can." Did this letter ever reach Monet? Did Monet ever have any doubt that Bazille would continue to support him?

ARDOR

At the end of 1868, thanks to a collector in Le Havre, Monet's circumstances improved somewhat. From Fécamp, he wrote to Bazille: "If you see your godson" — the future Madame Camille Pissarro was the baby's godmother — "how gentle he is these days…. My desire would be to remain like this always, in a serene corner of nature like this. So I don't envy your being in Paris. Don't you think one does better work in nature itself? One is too preoccupied by what one sees and hears in Paris, whatever one's strength, and what I produce here will at least have the advantage of resembling no one else, be-cause it will simply be an impression of what I've experienced, I alone. The further I go, the more I regret how little I know, that's what annoys me the most. I hope you're full of ardor and are working very hard. Being in such handsome circumstances, you should produce marvels."

AMBITION

Monet's ambition — "to resemble no one else" — was no different from Bazille's: "I very much hope, if I ever do anything worthwhile, that it will be to my credit that I've copied no one."

On the occasion of the Salon of 1868, a single article by Zola appearing in *L'Événement illustré* on May 24 praised three painters, Monet — "He'll master the crowd whenever he chooses"; Bazille — "One sees that the painter loves his own time, like Claude Monet, and that he thinks one can be an artist even if one paints frock-coats"; and Renoir, whose Lise "seems to be the sister of Claude Monet's Camille."

ATELIER

Another studio. In January 1868, Bazille left the rue Visconti for the Batignolles quarter. "It costs two hundred francs more, but my experience last month indicates I'll be able to absorb the increased expenses.... The Batignolles quarter is calm, living expenses there are lower than in the center of Paris."

ASSISTANCE

During the summer, Bazille asked Renoir to finish setting up the new studio. From Voisins-Louveciennes, Renoir responded: "If you want me to do as you ask and if you have money, you would do well to send me some quickly, if only so you don't spend it all. You can count on me, seeing as I have neither wife nor child, and as I'm not about to have either the one or the other. Send me a note, so I'll know if I need to begin work on the renovations immediately, which would annoy me greatly, first of all because I'm working, then because I don't have resources to keep myself fed in Paris, while here I manage quite well. I'll write to you at greater length another time, for I'm hungry, and brill in white sauce is sitting in front of me. I'm not paying the postage, I only have twelve sous in my pocket, and that's to pay my way to Paris when I need to go." In the summer of 1869, Renoir wasn't the only one who didn't pay postage, leaving that to Bazille. August 9, Monet to Bazille: "Dear friend, would you like to know what my circumstances have been and how I've been living during the eight days I've been waiting for your letter? Then ask Renoir, who brings us bread from his house so we won't starve." August 17: "I have to think that what I tell you about my circumstances scarcely concerns you, because I tell you we're starving." August 25: "If I don't get some help, we'll die of hunger. I can't paint, as I hardly have any paints left; otherwise I'd be working. Just see what I must be suffering and try to help me out!" September 25: "I sold a still life and I've been able to work a bit. But as always happens, I've had to stop for lack of paints.... That makes me furious with everyone, I'm jealous, vicious, I'm fuming; if only I could work everything would be all right.... I have a dream, a painting, the baths at la Grenouillière, for which I've made a few poor sketches, but it's a dream. Renoir, who's come to spend two months here, also wants to make this painting." The Grenouillière paintings were made. And at the same time, Renoir wrote to Bazille: "I'm waiting for your masterpieces. I expect to savage them unmercifully when they arrive. I've seen no one. I'm at my parents' and almost always at Monet's, where, between parenthesis, they can't hold out much longer. We don't eat every day. Still, I'm pretty content, because for painting Monet is good company. I'm not doing very much because I don't have a lot of paints."

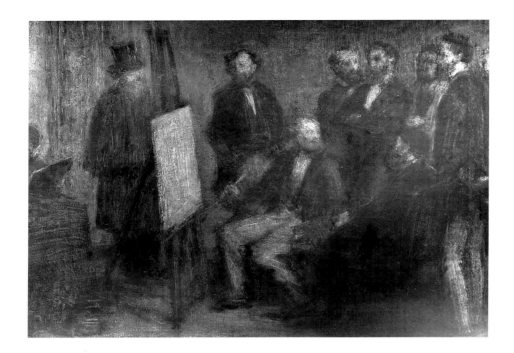

FIG. 18
Henri Fantin-Latour
1836–1904
A Studio in the
Batignolles Quarter
study, 1869
Un atelier aux Batignolles
oil on canvas
h. 29; w. 39
Paris, Musée d'Orsay

"ATELIER AUX BATIGNOLLES" (STUDIO IN THE BATIGNOLLES QUARTER)

In January 1868, Bazille moved into the Batignolles quarter: "I'm very happy with these lodgings, and I hope never to move again, unless something of great import happens." This studio was close to the Café Guerbois, where a circle gathered around Manet, near the latter's own studio on the rue Guyot, behind the Parc Monceau, which bore no resemblance whatever to the one in Fantin's *A Studio in the Batignolles Quarter*, for which Bazille posed (fig. 18). In this painting, Bazille stands behind the chair in which Astruc is seated, posing for Manet. They are surrounded by Émile Zola, Monet, Renoir, Maître, and Scholderer. Recollections of Théodore Duret: "As Fantin's painting represented Manet and his group in a studio in the Batignolles quarter, it offered the public and the journalists the qualifying tag they'd been waiting for, one that was perfectly consistent with their ideas. Thus did Manet and his friends come to be generally designated, in this moment and several years after, as the Batignolles school. There never was any Batignolles School."

ATELIER (RUE DE LA CONDAMINE)

Bazille made a painting of his own studio (fig. 19). January 1, 1870: "I've been amusing myself painting the interior of my studio with my friends. Manet is doing my own figure." Edmond Maître is playing the piano; on the other side of the studio, leaning over the stair railing, Zola speaks with Renoir, who is sitting on a table. Another conversation is under way in front of a canvas that Bazille is showing to Manet and Monet, one step behind him. Some paintings hang on the walls, others are stacked against one another. Behind Zola, there is a painting Bazille made in July 1868, *Fisherman with a Net*, which

the jury refused to accept for the 1869 Salon. Near the window, there is a painting by Renoir that was refused for the 1866 Salon (doubtless the jury felt it to be as indecent as the *Bathers* Courbet exhibited at the 1853 Salon). To paint a refused Renoir, as well as one of his own canvases that had been refused, was to turn up one's nose at the jury, to defy it. "What gives me pleasure is that there's real animosity towards us. It was M. [Jean-Léon] Gérôme who did us in, he described us as a band of madmen, and declared he felt it was his duty to do everything he could to prevent our paintings from appearing."

ADMIRATION

Letter from Berthe Morisot to her sister Edma, May 1, 1869: "The tall fellow Bazille has done something I find quite good: it's a young girl in a very light dress, in the shade of a tree beyond which one sees a village. There's a lot of light, sunlight. He's trying to do what we have so often attempted, to place a figure in the open air: this time it seems to me he's succeeded." She was speaking of *View of the Village,* which was exhibited at the Salon of 1869.

ATELIER (RUE DES BEAUX-ARTS)

Yet again, Bazille left his studio and moved onto the rue des Beaux-Arts, to the seventh floor of the building in which Fantin lived (fig. 20). "I found a studio that was very dirty, but it has everything. Now everything's cleaned up. I bought a large chest of drawers for 75 francs. I had my bedroom done in a cheap little wallpaper, Renoir and I painted the doors ourselves, now I'm quite settled in."

FIG. 20

Henri Fantin-Latour

1836–1904

Vase of Flowers

1873

oil on canvas, h. 32; w. 27.8

Paris, Musée d'Orsay

1870. Only one of the two paintings submitted to the Salon jury was accepted: the *Summer Scene (Bathers)*. *La Toilette* was refused.

"Assurance" (Engagement)

To his mother, April 1867: "So we have resolved to rent a large studio each year where we will exhibit as many of our works as we please. We'll invite the painters we like to send their paintings. Courbet, Corot, Diaz, Daubigny, and many others perhaps unknown to you have promised to send paintings and approve of our idea. With these people and Monet, who is stronger than all of them put together, we're sure to succeed. You'll see that people will talk about us."

Absence

The promised exhibition took place only after the passage of several years, from April 15 to May 15, 1874, in rooms on the Boulevard des Capucines lent by Nadar. Not a single work by Bazille was included in the exhibition, which was organized by the "Société anonyme cooperative des artistes, peintres, sculpteurs, et graveurs," whose charter had been published in the *Chronique des arts et de la curiosité* on January 17, 1874. A certain Louis Leroy, in *Le Charivari* on April 25, 1874, reported his exchange with a certain "M. Joseph Vincent, landscapist, student of Bertin, the recipient of medals and honors conferred by several governments," in front of a painting by Monet: *Impression, sunrise.*

"Impression, I was sure of it. I said to myself that since I'm impressed, there must be an impression in it." And in his derision and anger he risked a neologism: "Adopting the Impressionists' point of view, he became a strong supporter.... And to give his aesthetic the requisite seriousness, father Vincent proceeded to dance the scalp dance in front of the bewildered guard, crying out in a strangulated voice: 'Ugh!... I am a walking impression.'"

"'Archi brute!'" ("The wretch!")

On August 30, 1870, in Algeria, Bazille was wearing the uniform of a Zouave. He had enrolled on the 16th, despite the fact that some years earlier his father had purchased a replacement for him so he could avoid military service.

"Shit, the wretch!" swore Renoir, in the postscript of a letter to Edmond Maître.

Frédéric Bazille, Zouave, born December 6, 1841, was killed on November 28, 1870, during the battle of Beaune-la-Rolande.

Pascal Bonafoux

LA SOUBRETTE DE CHAPLIN.

— Mademoiselle, soyez donc assez aimable pour
nous passer un petit verre, ça nous donnera du ton.
Nous en avons bien besoin !...

Bazille and the Art Criticism of His Time

"I am enchanted with my exhibition," Bazille wrote to his brother in May 1870. "My painting is very well placed, everyone sees it and talks about it; many say more bad than good, but finally I am launched, and everything I exhibit from now on will be looked at. I have heard some harsh judgments, and there are some people who laugh, but I have also received some hyperbolic praise, which modesty prevents me from setting down in writing."[1] If acceptance at the annual salon was a crucial step for an ambitious young painter in Second Empire France, it was the response of the critics, favorable or not, that would make an artist's reputation. The vision of subsequent generations has oversimplified Bazille's position vis-à-vis the painters of his time, as well as his own aspirations, by treating him as merely a "pre-Impressionist." The criticism of his period allows us to look at his paintings with new eyes, offering a sampling of the discourse about painting that Bazille heard and to which he responded; words and pictures thus illuminate one another.[2]

New styles often evoke hostility, and indeed two contemporary caricatures seem to judge harshly the paintings that Bazille exhibited at the Salons of 1869 and 1870. In June 1869, André Gill published in his new journal *La Parodie* a caricature of Bazille's *View of the Village* (partly obscured by the image of a bronze bust that also appeared at the Salon: fig. 21, compare cat. 20). The girl under the tree in Bazille's painting has been transformed into a doll holding a parasol. A caption designates both girl and village as toys: "*View of the Village* by Bazile [*sic*]. The artist, a clever little devil, has chosen the moment when the village costs twenty-nine cents a box."[3] The following year, Bertall published in the *Journal Amusant* a caricature of Bazille's *Summer Scene* (fig. 22; compare cat. 25). One of the young bathers in that picture leans out of the frame and addresses the pretty servant in the painting hanging below, Charles Chaplin's *Young Woman Carrying a Tray*. The bather's words appear in the caption: "Mademoiselle, be kind enough to pass us a glass, it will give us some tone. We certainly need it!"[4]

The two caricatures are incisive and, to a certain degree, accurate. In the first, Gill parodies the stiffness of the figure and the synthetic perspective of the *View of the Village*; in the second, by drawing attention to the lack of "tone," Bertall underlines the inelegant subject matter of the *Summer Scene*, its oddly dissipated mood, and the harsh lighting of its background, which shuns the careful shading of traditional technique.

Bazille must have been delighted. Having one's painting featured in a caricature was neither a dishonor nor a sign of public rejection; on the contrary, it was a mark of attention, a price every successful painter had to pay. The journals of the time frequently published caricatures of Salon paintings, which constituted a veritable discourse with its

FIG. 22

Bertall

1820–1882

Caricature of

Summer Scene

published in

Le Journal amusant,

May 1870

51

own fixed codes and conventions. Without knowing the usages of the time, we might be entertained by the caricatures, but we would not recognize some of their more subtle implications. For example, the cliché about dolls and toys had been applied frequently to works by Courbet, Manet, and Monet in preceding years. In fact, Gill seems to have borrowed the idea for his caption from Bertall, who had presented Manet's *Balcony* as a "twenty-five-cent shop" in an article published two weeks earlier.[5] Moreover, Gill's parasol, which supplements Bazille's pine tree, seems to refer to Renoir's *Lise with a Parasol* (Essen, Folkwang Museum). Renoir's painting, a popular target for caricatures the previous year, does in fact share with Bazille's a fascination with strong contrasts of light and shadow. Likewise, the opposition to Charles Chaplin that Bertall advances puts Bazille in good company. Chaplin, a former student of the École des Beaux-Arts, was well known for his genre scenes and portraits of fashionable women rendered in delicate tones of rose and pistachio. Bertall had previously contrasted Chaplin's works to what he characterized as the crude, vigorous, and masculine painting of Courbet, Manet, and Monet. Indeed, he devoted the first page of the issue containing the caricature of *Summer Scene* to a symbolic confrontation between Courbet and Chaplin before an audience of women who favor the latter.[6] Preoccupied by the clumsiness of Bazille's art, the opinion of the time, as Gill's and Bertall's drawings indicate, associated him with those of his contemporaries who are most famous today, those who rejected most emphatically the mannered poses, calculated perspectives, and meticulously worked surfaces of official and academic painting.

The caricatures are, of course, the work of journalists more concerned to create clichés than to evaluate those nuances of style and artistic intention that contemporaries so often find difficult to appreciate. Happily for Bazille, three critics favorable to the new painting and knowledgeable about artistic problems reviewed the paintings that he exhibited at the Salons of 1868 and 1870: Émile Zola, Edmond Duranty, and Zacharie Astruc.[7] All three of them, along with Bazille, belonged to the Batignolles group that gathered around Manet in the later 1860s and that Henri Fantin-Latour memorialized in his *Studio in the Batignolles Quarter* (fig. 23). All three appreciated Bazille's devotion to nature, but each responded to different aspects of his style.

Although badly placed, Bazille's entry of 1868, the canvas that has come to be known as *The Family Gathering* (cat. 18), was singled out by Émile Zola, who had achieved notoriety for the spirited defense of Manet he published in 1866. We cannot be sure that Zola had made Bazille's acquaintance in 1868, but he certainly had done so a year later, when he moved into a small house with a garden at No. 14, rue La Condamine, a few steps from Bazille's studio, and when Fantin began to paint them standing close together in his large canvas.[8]

In an article published in *l'Événement illustré* on May 24, 1868, Zola comments at length on Monet's paintings of that year and briefly on Bazille's and Renoir's. His commentary on *The Family Gathering* is brief but positive in tone, perhaps as interesting for what it does not say as for what it does.

FIG. 21
André Gill
1840–1885
Caricature of
View of the Village
published in *La Parodie*,
June 1869

52

*In the same room . . . is a painting by Frédéric Bazille, Portrait of the ****
Family, which bears witness to a strong love of truth. The figures are grouped
on a terrace, in the soft shade of a tree. Each face has been studied with
great care, each figure has the appropriate attitude. One sees that the painter
loves his own time, like Claude Monet, and that he thinks one can be an
artist even if one paints frock-coats. There is one charming group in the pic-
ture, the group formed by the two young ladies seated at the edge of the
terrace.[9]

For Zola, the choice of contemporary subject matter — the first point he makes about
The Family Gathering — did not in itself constitute a proof of talent. He opened the same
article (entitled "the Actualists") by observing that the battle for modern subject matter
had been won long ago, and adding, "I shall not say that without modern subjects there
is no salvation." Nonetheless, he clearly admires what he perceives as Bazille's passion
for the world around him.

Significantly, in discussing Bazille's painting, Zola does not mention the issue of métier
or craft, which fascinates him in the works of Manet and Monet, whose vigorous brush-
work he finds clumsy and disturbing. Yet he gives no sign of admiring Bazille's more
restrained handling. One senses that he misses the excitement caused by what he con-
sidered Manet's and Monet's deficiency. "Our artists' fingers are too clever," he states,
criticizing the standard laborious technique of the majority. "If I was a great defender
of justice, I would cut off their wrists, I would use pincers to open their minds and
their eyes."[10]

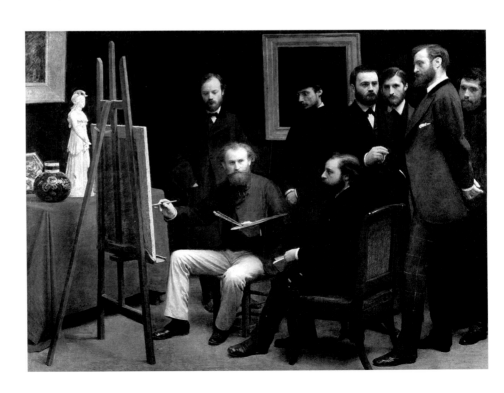

FIG. 23

Henri Fantin-Latour

1836–1904

A Studio in the

Batignolles Quarter

1870

Un atelier aux Batignolles

oil on canvas

h. 204; w. 273.5

Paris, Musée d'Orsay

53

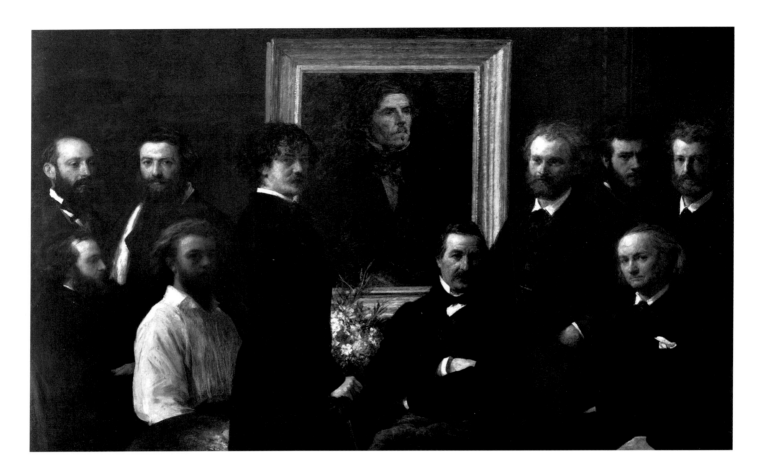

In what, then, for Zola, does the virtue of *The Family Gathering* lie? Certainly not simply in the accurate reproduction of nature, which he scorned: "the word 'realist' means nothing to me, who claims to subordinate reality to temperament."[11] Neither the sumptuous light nor the freshness of the shade in *The Family Gathering* seems to have attracted him; in effect, he alludes to Bazille's particular talent only implicitly, when he notes that "each figure has the appropriate attitude." He says no more, but one senses the impact of the unconventional poses, the suppression of narrative anecdote in *The Family Gathering*, and the models' apparent awareness of being observed. These qualities had been inspired in part by the *Déjeuner sur l'herbe* (fig. 27) and the *Olympia*, of course, but Zola, caught up in the drama of touch and color, never seemed to discern them in Manet's works.[12]

Summer Scene (cat. 25), which Bazille presented at the Salon of 1870, differs in significant respect from *The Family Gathering* and constitutes an important step in the artist's career. Appropriately, neither Edmond Duranty nor Zacharie Astruc, in their commentaries on Bazille's new painting, offers an equivalent for Zola's appreciation of the subjects from modern life.

A novelist and former director of the journal *Le Réalisme*, Duranty had championed

FIG. 24

Henri Fantin-Latour

1836–1904

Hommage à Delacroix

1864

oil on canvas

h. 160; w. 250

Paris, Musée d'Orsay

54

Courbet since the 1850s, and in 1864 Fantin had painted him in his *Homage to Delacroix* (fig. 24), seated at left, in the company of Manet, Baudelaire, and other admirers of Delacroix and defenders of new trends in painting. On May 19, 1870, Duranty's observations on Bazille — as well as Pissarro, Sisley, Renoir, and several others, Monet having been refused that year — appeared in his column in *Paris-Journal* under the rather provocative title "The Irregulars and the Naïves, or the Clan of Horrors."

> *From the lands of the south, each spring, M. Bazille returns with his summer*
> *paintings, which some, fairly or unfairly, treat as wallpaper, but which are full of*
> *greenery, sunlight, and frank handling. He does not draw like the students of*
> *Léon Cogniet, and leaves do not seem at all black to him, nor the earth*
> *Capuchin-colored, the poor thing! And this is counted against him by those who*
> *are not at all pleased to be disrupted in their habits. I for one find that people*
> *like him are wrong not to master more rigorously their craft, but I am grateful*
> *that they try to deliver us from the eternal sauces of the studios.*[13]

Duranty's reaction is generally favorable: against the stale conventions of the academic school represented by Cogniet, Bazille offers freshness and simplicity. Nonetheless, these qualities, although praiseworthy, cannot excuse faulty technique. Duranty's remarks clearly place Bazille among the group of painters whose style he had characterized two weeks earlier: "A somewhat awkward simplicity, very well-intentioned, but deficient in research and effort, of which Manet provides the strongest example."[14] In effect, Duranty could not approve without reservation the efforts of his friends of the Batignolles school. Early in 1870, his frank criticism had offended Manet, with whom he fought a duel, and Fantin, who decided to exclude the critic from his manifesto-painting, although he had included his figure in the preliminary sketches.[15] Yet in his Salon of 1870, Duranty treats Bazille and his friends fairly, if not at great length.

One new and unexpected note sounds in Duranty's commentary: the analogy between Bazille's paintings and wallpaper. Although it does not figure among the clichés generally applied to Manet or his followers in the 1860s, wallpaper does evoke the issue of decoration, which would arise in discussions of Impressionist painting after 1874 with reference to non-narrative subjects, simplified, even symmetrical compositions, and pictorial structures based on bright colors of more or less uniform high tonality. Was Bazille, in the *Summer Scene*, groping towards such a solution? We note that Duranty, the convinced realist, neither embraces nor rejects this prophetic analogy, as if uncertain of its significance and wary of his own intuition.

The most extensive and enthusiastic commentary on Bazille was written by Zacharie Astruc, who also appears in Fantin's *Studio in the Batignolles* (fig. 23), sitting for his portrait by Manet.[16] Astruc, too, had long been a supporter of Courbet, and he had been associated with Fantin and Manet from the late 1850s before playing an important role in the formation of the Batignolles group. Bazille had met him before the end of 1866.[17] A detail testifies to the closeness of their ties in 1870: Astruc refers to the *Summer Scene*

as the "bathers" ("*les baigneurs*"), as Bazille had often done in his personal correspondence, rather than using its official title.

In his Salon of 1870, published in his own journal *L'Echo des beaux-arts*, Astruc begins his lengthy commentary on Bazille by contrasting *Summer Scene* with Jules Lefebvre's allegorical *Truth* (fig. 25).

> *Here is a man who passionately seeks truth. Not at all like Lefebvre, upon*
> *my word, oh! Not at all. How could we compare them? — the one alive,*
> *searching light with a great painterly instinct, the other absorbed by*
> *sculptural studies, little or not at all attracted by history, poetry, the natural*
> *beauties of the fields, the horizons, the waters, the forests, the multiple*
> *effects of light. One is a man of the studio: his eye works, but his imagination*
> *sleeps. Bazille sets up his easel in the open sunlight to practice painting the*
> *magic effects of daylight.*[18]

A good example of the popular artists of the time whom history has forgotten, Lefebvre was one of the students of Léon Cogniet, previously alluded to by Duranty. Astruc found Lefebvre's allegorical nude with a mirror cold, correctly drawn, and monotonous; in 1870 many critics agreed, but this did not prevent the painting from receiving a medal at the Salon.[19]

Despite his admiration for his "great painterly instinct," Astruc believes that Bazille can improve his technique. But unlike Duranty, Astruc distinguishes between the artist's weaknesses and his strengths.

> *If he would apply himself to form and to finding it in its purity, if he attends*
> *to his still somewhat hard manner and grants to nature the suppleness that*
> *she always has, he will create some remarkable pages. Bazille is already the*
> *master of one element that he has conquered: the astonishing fullness of*
> *light, the power of daylight. Sunlight floods his paintings. In the* Bathers, *the*
> *meadow seems to burn with it.*

Astruc's commentary is remarkable not only for its enthusiasm but also for its response to yet another aspect of Bazille's work, one that no other critic seems to have noticed: his interest in paintings of the old masters. After the comparison with Lefebvre, who represents academic practice, Astruc discovers in Bazille's picture a different and more authentic tradition.

> *The true spirit of the past returns. Does not Corot work in the great tradition*
> *when he paints his Toilette? He and Giorgione (think of the* Concert) *can*
> *shake hands....Thus we rediscover the ancient feeling that captivates us in*
> *the work of the masters — because for them, the dream is tied to nature,*
> *beauty to truth — because their figures live in breathable air — because the*
> *artist is struck by everything in the exterior world that is charming,*
> *enjoyable, or terrible, unexpected.*

FIG. 25

Jules-Joseph Lefebvre

1834–1912

Truth

1870

La Vérité

oil on canvas

h. 265; w. 112

Paris, Musée d'Orsay

56

In referring to the *Concert champêtre* (fig. 26) — at that time attributed to Giorgione — Astruc opens up a new world of associations. Recovery of the grandeur of the past had been a constant preoccupation in his criticism of the previous ten years. And it was Astruc who, alone among the critics of 1863, commented that Manet's *Déjeuner sur l'herbe* (fig. 27) was inspired by Giorgione.[20] Manet's compulsion to recover and transform the art of the past certainly informed Bazille's project, and both artists incorporated into their paintings figures from the old masters, although neither Astruc nor any other critic of the period commented on Bazille's borrowings (see the entry on the *Summer Scene* in this catalogue).[21] But if the alert self-consciousness of the human figures in *The Family Gathering* owes even more to Manet's art, in *Summer Scene* Bazille seems to revert to something of the peculiar dreamlike, absorbed mood of Giorgione's scene. The reference to Corot, whom both Astruc and Bazille greatly admired, and who excelled at scenes of unselfconscious relaxation and reverie, strengthens this impression. Alone among the critics of his time — in contrast to Duranty, for example, who lumped together all of Bazille's "summer paintings" — Astruc seems to have noticed the evolution

FIG. 26

Titian

1485–1576

Le Concert champêtre

1511

oil on canvas

h. 110; w. 138

Paris, Musée du Louvre

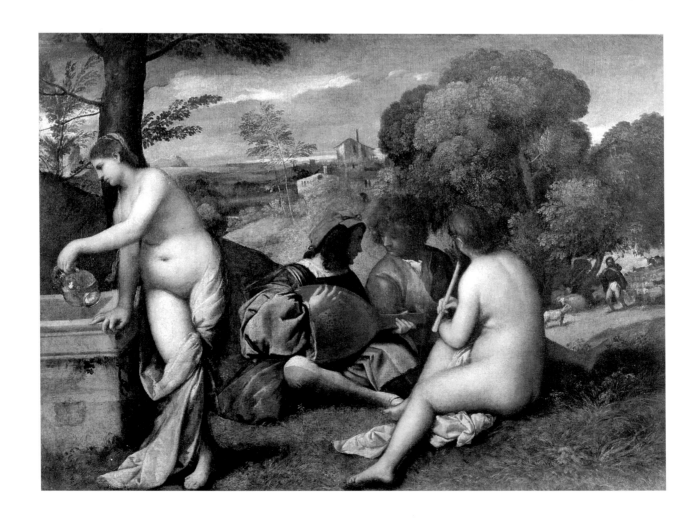

57

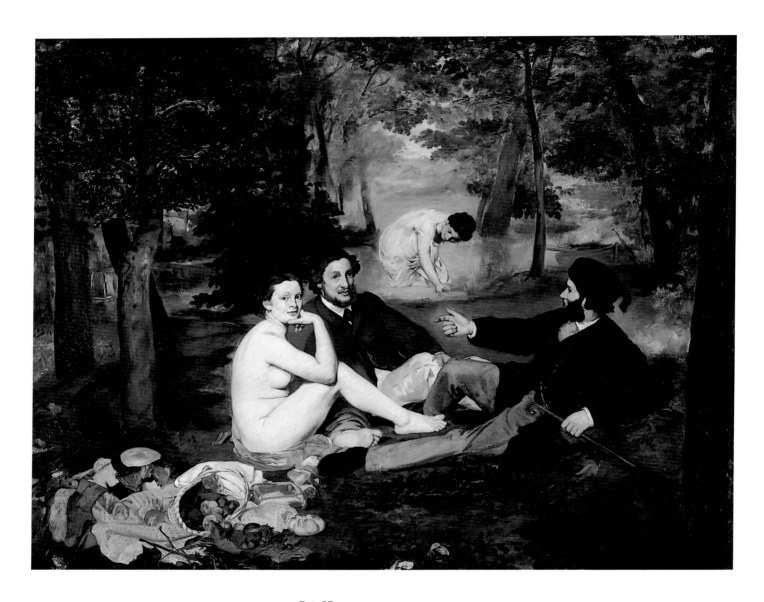

FIG. 27

Édouard Manet

1832–1883

Le Déjeuner sur l'herbe

1863

oil on canvas

h. 208; w. 264.5

Paris, Musée d'Orsay

of Bazille's style from a predilection for modern subject matter to a less anecdotal and more formal meditation that still has nothing to do with the academic art of the period.

The art critics of his time also offer us hints of Bazille's goals and aspirations. All of them, including the caricaturists Gill and Bertall, underline the influence of Manet and Courbet and remind us not to stigmatize Bazille for not being Monet, or for not yet being an Impressionist. How did they judge the potential of the painter struck down at the battle of Beaune-la-Rolande? Although Astruc largely ceased to write art criticism after 1871, he had already recognized in Bazille qualities that promised "one of the most unusual painters of the time." Duranty was to memorialize the artist from Montpellier in his story about Louis Martin, a sincere and talented young painter who dies in the war of 1870 and whose pictures resemble those of Bazille.[22] As for Zola, another great defender of Impressionism, he became more and more dissatisfied with the casual and fragmentary nature of that style, wishing to see its spontaneity and vividness incorporated into a grand and monumental art. Perhaps he, too, remembered Bazille's attempts, crude still in their execution but ambitious and full of promise. As it was, one had to wait for the 1880s, for Seurat and the Post-Impressionists, to see the realization of such a grand ambition.

Dianne W. Pitman

NOTES

This essay and the catalogue entries by Dianne Pitman are published in their original English.

1. Marandel 1978, letter no. 84, p. 209. All translations in this essay are my own.
2. Some of the material for this essay appears in my doctoral dissertation, Pitman 1989, and will be treated more extensively in my forthcoming book on Bazille.
3. Gill 1869, p. 8. Gill's caricature was published in Marandel 1978, p. 75, where its provenance was misidentified as *Le Journal amusant*.
4. Bertall 1870, 28 May, p. 2. I identified and discussed this caricature in Pitman 1989, pp. 98–101.
5. Bertall 1869, 22 May, p. 7.
6. Bertall 1870, 28 May, p. 1.
7. For biographical and bibliographic information about the critics discussed here, and samples of their writing, see Riout 1989 and Bouillon 1990. Commentaries on Bazille before 1868 are rare; see the entry in this catalogue for the *Still Life of Fish* of 1866 (cat. 12).
8. Zola *Correspondance*, vol. 1, pp. 217–18. The improbable date of 1863 has been proposed for the first meeting of Bazille and Zola, based on a note (undated) from the latter found among the papers of the former and the often inaccurate memories of the aged Renoir. See Poulain 1932, p. 166 n. 2; Vollard 1920, p. 32.
9. Zola 1868, 24 May, pp. 2–3. Compare also the brief reference to *The Family Gathering* in Castagnary 1892, vol. 1, p. 313.
10. Zola 1868, 10 May, p. 3.
11. Zola 1866, 4 May: "Le Moment artistique."
12. On the following day (May 25, 1868), J. Ixe praised the attitudes of the human figures in *The Family Gathering* in similar terms, although he objected to the synthetic and fragmentary effect of the whole. See Barral 1992, p. 17.
13. Duranty 1870, 19 May, p. 2
14. Duranty 1870, 4 May, p. 1
15. Druick and Hoog 1982, pp. 203, 206; Crouzet 1964, pp. 291–92.
16. An unfinished and undated painting by Bazille known as *Man with a Cigar* (private collection) has been seen by some scholars as a portrait of Astruc, although others doubt that identification. See Marandel 1978, p. 103; Dejean 1984, verso. I suspect that Astruc appears in Bazille's *Studio on the rue La Condamine*: see Pitman 1989, pp. 144–45.
17. See Astruc's letter to Bazille of 22 December 1866, cited in Poulain 1932, p. 71.
18. Astruc 1870, 12 June, pp. 2–3.
19. Astruc 1870, 19 June, p. 2.
20. Astruc 1863, 20 May, p. 5. On Astruc and the old masters generally, see Flescher 1980, pp. 291–304.
21. On Manet, see especially Fried 1984.
22. Duranty 1872.

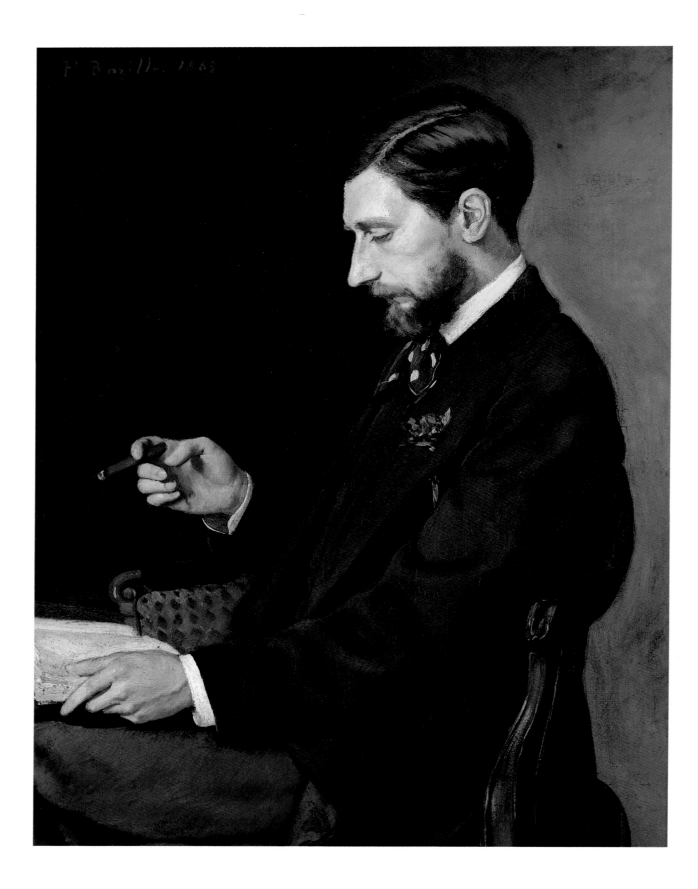

Frédéric Bazille and Love of the Fine Arts

Frédéric Bazille was not only a painter smitten with his craft, he was also an eclectic spirit open to impressions of all kinds and a passionate lover of the fine arts, if this phrase is understood to include not only the plastic arts but also music, dance, opera, theater, poetry, and the novel. His cultural proclivites were very different from those of several of his colleagues from the Gleyre studio, such as Renoir, Monet, and Pissarro, who were of working-class origins and were much more independent in their attitudes towards all traditions. Bazille was closer to Manet and Degas, to Cézanne and above all Edmond Maître (fig. 28), the dilettante from Bordeaux who, like him, came from a wealthy family and an established middle-class milieu, and offered the same highly unusual mixture of "*grande culture*" and a singular vigor of expression.

Early on, from the age of fourteen or fifteen, Bazille developed a taste for and interest in all forms of art. The family house was directly in front of the Bruyas residence. This patron of the arts, then in ill health, lived a secluded life in his dark rooms filled with canvases by the masters, but the Bazille family maintained cordial relations with its rich neighbor. And Frédéric was rapidly admitted to the circle that had formed around the residents of Montpellier who collected art at the time. These included his cousin Louis Bazille, just beginning to collect; the banker Louis Tissié, future father-in-law of his brother, Marc; and the grandson of the partner of Bruyas's grandfather, the original M. Alfred Chaber, who sought out canvases of the Spanish school. It was in this company that he met, among others, Pierre-Auguste Fajon, Sunday painter, model, and friend of Gustave Courbet, whom he would later introduce to Courbet the author of *The Family Gathering*.

The connoisseur

Exposure to the masterpieces in the Bruyas collection not only encouraged Bazille to become a painter, it also shaped the young man's critical faculties by according him access, if not to the reigning masters themselves — Delacroix, Ingres, Corot, and Courbet — then at least to some of their most important canvases.

From his arrival in Paris, in November 1862, Bazille took a passionate interest in a wide range of schools and artists. Entrusted with following the picture sales and buying what seemed interesting for the collection of his cousin Louis Bazille, he quickly became an experienced connoisseur. His correspondence with his relative not only provides us with precious information concerning the prices for works of art between 1863 and 1870, it also reveals to us his tastes, his preferences, and his opinions about his contemporaries.

FIG. 28

Frédéric Bazille

Portrait of Edmond Maître

1869

oil on canvas

h. 84; w. 65

Washington,

National Gallery of Art

Collection of

Mr. and Mrs. Paul Mellon

Like Cézanne, Bazille admired Eugène Delacroix above and beyond everyone else. He considered him to be a kind of spiritual guide. From early on, he'd been able to contemplate the *Women of Algiers* in Bruyas's collection, in Montpellier; later, he visited the Morny gallery and sought out canvases by the author of the *Massacres at Chios* in the Louvre as well as in Lyon, Rouen, and Bordeaux. In 1869, he tried to persuade his cousin to buy an *Entombment* from the collection of Count Geloes, which he considered to be "one of the most beautiful works in all of French painting," "a pure masterpiece."[1] Bazille continually declared his admiration for the great Romantic master. After having viewed the posthumous exhibition of works by Delacroix, he wrote his parents on February 15, 1864: "You can't imagine how much I learn from looking at these paintings! One of these sessions is worth a month's work." And some years later, he stated to his cousin Louis Bazille: "I admire Delacroix above all others."

But however strong an influence Delacroix was on Bazille, the latter never sought to find a rule or a repeatable technical approach through imitation of the master. It was by means of his own investigations that Bazille attempted to express his personality. He always feared subjecting himself to an influence that might restrict his freedom. "I very much hope, if I ever do anything worthwhile, that it will be to my credit that I've copied no one,"[2] the young artist wrote his father. Bazille knew it served no purpose to imitate the masters' working methods and techniques. It was the virtues underlying their mastery, making it possible, that should tempt one and provide food for thought.

Aside from Delacroix, Bazille had great admiration for Corot, from whom he commissioned a landscape for his cousin. He justified this purchase in the following terms: "For me, Corot is the finest of landscapists, present or past, and one of the finest of French painters. Furthermore, he is alive and produces a great deal, which means his paintings are not too expensive, though their price increases considerably with each passing day. So I think that at present Corot is a good buy."[3] Bazille's letters also bear witness to his love for Ingres, Rousseau, Millet, and, above all, Gustave Courbet.

If Bazille was able to discern the real painters among his contemporaries, he was also able to recognize undeserved fame. He was suspicious of Troyon. "This painter," he wrote, "made some very pretty things at the beginning, but success spoiled him, one senses too much facility looking at his canvases, not the love he invested in making them." But it was above all for his compatriot Cabanel that Bazille professed a veritable horror. He found absolutely nothing to admire in the academic painter's work. "This man," he wrote, "is not a born painter. He can't convey anything, he doesn't even have the strength to express the banality of his intentions. He is full of good intentions, it is said, but the road to hell is paved with them."[4]

Shrewdly, Bazille realized from observation of those around him that "there are very few painters who are truly in love with their art. Most of them are only out to make money by flattering the taste of the public, which is usually false."[5]

The music-lover

Frédéric Bazille was also a passionate lover of music, which was for him the "sacred plea-

sure." Each week he attended concerts at the Conservatoire, where he knew several musicians. "The most admirable thing about this orchestra," noted his friend Edmond Maître, "is precisely that it doesn't command admiration; one doesn't think about praising it, one just follows the composer's thought, which it gives us in all its pith, freshness, and poetry."[6]

The great concerts were important events in the life of Bazille. He appreciated the operas of Mozart and Cimarosa, which he applauded at the *Théâtre des Italiens*, but he also loved Schubert, Beethoven, and Brahms. He worshiped at the altars of Berlioz and, above all, Wagner. But his admiration did not prevent him from formulating criticism. "I am an admirer of Berlioz's *Troyens*, which I've heard twice and I hope to see again. Everyone attacks this score, which is found to be boring, or at least difficult to understand. I admit however that the last act is much inferior to the others."[7] Some weeks earlier, after attending the premiere of Wagner's *Rienzi*, Bazille wrote to his father: "You will have learned about the details of the evening in the press. The hall was splendid, and the piece full of great beauties, with rather a lot of banality and too much noise. In sum, it's a youthful work by a man of genius."[8]

When he wasn't at one of the Concerts Pasdeloup or at the Conservatoire, Bazille spent his evenings with his friend Edmond Maître playing four-handed piano compositions, often continuing late into the night. There was always an opera by Wagner, an oratorio by Schumann, or some new work by Rossini to get through. Bazille even took lessons in harmony from a cousin who was a composer, because, he said, "to really enjoy any of the arts one must practice it oneself.... Pears taste much better when one knows where they come from, without that one has only the banal pleasure of a glutton."[9]

The friend of poets

A voracious reader, Bazille devoured new novels by Victor Hugo (*Les Travailleurs de la mer*), Flaubert, Zola, and Alphonse Daudet, as well as volumes of poetry by François Coppée, Paul Verlaine, and Stéphane Mallarmé.

With his intimates, Bazille took pleasure in writing charades and occasional verse. Though he was often lazy about writing to his parents and his family in Montpellier, he and his friend Édouard Blau (fig. 29) wrote a play in the Romantic tradition, *The Son of Don César*. Unfortunately, despite the authors' efforts, the play was never produced.

In his free time, Bazille also enjoyed playacting in a broad comic style and with a rather breathy delivery, which predisposed him to take the roles of ridiculous, grandiloquent old men. It was doubtless from his mother's cousins the Commandant and Mme Lejosne that Bazille got his taste for the theater; from his arrival in Paris in 1863, they invited the young Frédéric to share their loge. Thus he was able to attend the opening night of Sardou's *Ganaches*, and to see the final successes of Émile Augier and Alexandre Dumas *fils*.

General Magnan's aide-de-camp, Commandant Lejosne was a military man who loved the arts. He was delighted to receive painters and men of letters in his apartment in the rue Trudaine and he organized theatrical evenings that were very popular. In the fall of

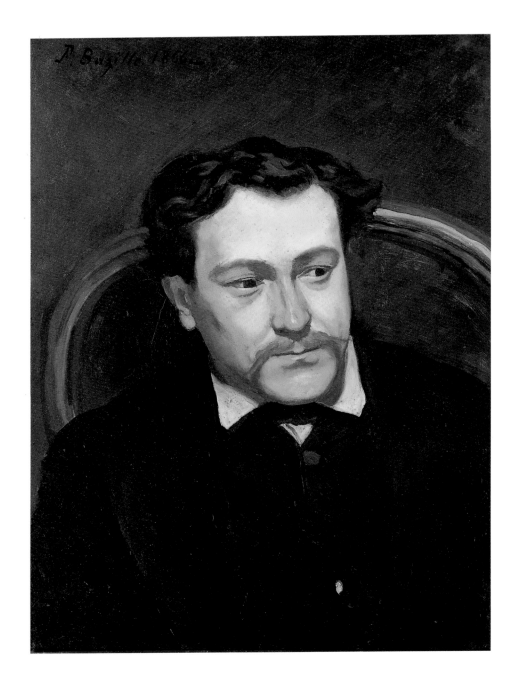

FIG. 29

Frédéric Bazille

Portrait of Édouard Blau

1866

oil on canvas, h. 60; w. 44

Washington, National Gallery

of Art, Chester Dale Collection

1868, Mme Lejosne fixed upon *Ruy Blas* by Victor Hugo. In casting it, she turned to Frédéric and several of his friends. After many vicissitudes, the performance took place on Monday, March 8, 1869, and she had a great success.

During the rehearsals for *Ruy Blas*, Bazille got to know the young François Coppée, and the latter introduced him to his friend Paul Verlaine, whose collection *Poèmes saturniens* had suddenly made him famous. Captivated by Verlaine's changeable, expressive face, Bazille proposed to paint the poet's portrait, and invited him to come pose in his studio (cat. 58). While the fallen Verlaine, with his bushy eyebrows, faunlike mouth, and bald forehead, is well known, there are very few images of the poet at the beginning of his literary life: thus the importance of Bazille's portrait. In it we see Verlaine at age twenty-four, an elegant, nervous young man with a thin mustache and a Newgate fringe just coming in, wearing a black jacket and a loose cravat. This is the Verlaine of his carefree, bohemian period, a minstrel's red bonnet on his head, a mandolin slung across his back,

> *Chantant sur le mode mineur*
>
> *L'amour vainqueur et la vie opportune.*
>
> (Singing in a minor mode
>
> Of victorious love and expedient life.)

Never, however, did music, opera, poetry, or the theater monopolize Bazille. "These hors-d'oeuvres," he wrote to his father, "don't make me forget that painting is my only main dish, and I give myself over to it more ardently each day, telling myself that it's permissible for a specialist in roasting to try his hand at an omelette from time to time."[10]

François Daulte

NOTES

1. Letter from Bazille to his cousin Louis Bazille, Monday, December 20, 1869.
2. Letter from Bazille to his father, Wednesday, January 27, 1864.
3. Letter from Bazille to his cousin Louis Bazille, Tuesday, April 27, 1869.
4. *Idem.*
5. Letter from Bazille to his father, Wednesday, June 3, 1863.
6. Letter from from Edmond Maître to his father, June 17, 1865.
7. Unpublished letter from Bazille to his mother, November 20, 1863.
8. Letter from Bazille to his father, April 9, 1869.
9. Letter from Bazille to his father, March 23, 1869.
10. Letter from Bazille to his father, July 17, 1865.

Frédéric Bazille:
The Lure of Exoticism

FIG. 30

Frédéric Bazille

Mauresque

1869

oil on canvas

h. 97; w. 58

Pasadena, Norton

Simon Foundation

The work of Jean-Frédéric Bazille poses numerous questions. The brevity of the period in which it was produced and the variety of its genres and styles have often encouraged commentators to ask themselves how he might have developed as an artist if he had not met with a tragic end in the war of 1870. The question is as legitimate as it is futile, for all responses to it must be conjectural, and cannot but be influenced by the enthusiasm of those who have studied this painter's moving and complex body of work. Bazille can be classified as an Impressionist only with the wisdom accorded by hindsight, because of his association with those painters, particularly Monet and Renoir, who were his youthful companions, and who sometimes painted the same subjects as he. At the time of Bazille's death, these artists, steeped in the example of Courbet, would have been perfectly willing to classify themselves as Realists.

And a Realist is what Bazille was, if we are to judge from the subjects he frequently chose to depict: his own family, familiar views of the countryside around Montpellier, arid still lifes, or austere studio interiors proclaiming their author's love for his art. This was limited repertory, deploying its modernity within the most established pictorial tradition and, in its banality, defiantly rejecting the anecdotal painting so beloved of the Salon jury. But there was another Bazille who, paradoxically, would seem to negate the first one.

How are we to understand, for example, the painter of the *Mauresque*, 1869[1] (fig. 30), *La Toilette*, 1870 (cat. 26), and the two versions of *African Woman with Peonies*, 1870[2] (cat. 27 and fig. 69)? Certainly these paintings can be defined in terms of a jerry-built exoticism, of a simple pretext "to exhibit Indian women,"[3] in François Daulte's phrase, but it is also tempting to view them as initial efforts in a new endeavor Bazille was beginning to undertake around the time he left for the front. While any attempt to break down Bazille's career into distinct periods will prove vain, it seems clear that his art of hesitation and experiment took a new turn in the last two years of his life, one that set him apart from the Impressionist group rather than bringing him closer to it. Several reasons for this can be cited. His friendly, almost fraternal relations with Monet soured considerably when the payments Bazille owed Monet for *Women in the Garden* became irregular. "You tell me in all seriousness, because you think it, that in my place you would chop wood. Only someone in your circumstances could think such a thing, and if you were in mine you would perhaps be even more put out than I am. It's much harder than you think, and I wager you wouldn't get much wood chopped," Monet wrote to Bazille on September 25, 1869.[4] With the friendship between the two painters fading, Monet's influence on Bazille also began to wane. During the last

two years of his life, Bazille produced only one landscape, *The Banks of the Lez;*[5] its almost Neoclassical clarity and legibility set it very much apart from Monet's work of like date. The *Nude Young Man Lying on the Grass*, usually dated 1869,[6] is painted in a style close to that of Puvis de Chavannes and quite distinct from that of Monet's sketchy approximations. Would it be going too far to suggest that this canvas is the metaphorical affirmation of a new style, a perhaps unconscious expression of Bazille's liberation from the ascendency Monet had previously exercised over him?

Other artistic friendships were taking shape on Bazille's social horizon, most notably with Renoir, a friend since his early days in Paris, who benevolently tried to smooth over the difficulties that had arisen between Monet and Bazille. It was with Renoir that Bazille shared a studio at this time. More surprising, perhaps, are the ties that then developed between Bazille and more solidly established painters. Alfred Stevens, relishing his role as mediator between the academic painters and the young Impressionists whose company he enjoyed, visited Bazille's studio at the beginning of 1869 and was especially complimentary of his *Fisherman with a Net* (cat. 19). Stevens was a member of the Salon jury, and his support must have been a decisive factor in the acceptance of *View of the Village* (cat. 20) for the Salon of 1869. Puvis de Chavannes noticed the painting in the exhibition and congratulated its author. And Cabanel himself voted in favor of Bazille, perhaps out of loyalty to a fellow native of Montpellier.

The Salon, feared and desired, represented for every self-respecting painter the measure of success. For the young Impressionists, differing to a certain extent in this from Manet and Courbet, the trajectory of rebellion passed through the doors of the Salon.

Frédéric's letters to his family clearly indicate his intention to obtain official success, to somehow defeat the academic painters on their own ground. Stylistic compromise being excluded, it was apparently through the choice of subject that certain painters, Renoir and Bazille in particular, not only tried to win admission to the Salon, but managed to formulate their own version of "*la grande peinture.*"

Of all the genres current in the nineteenth century, exoticism is the least realistic. By definition, it is nothing but a pretext for depiction of the extraordinary, the strange, the unaccustomed. Only the most naive observer would take Gérôme's creations to be precise or even approximate representations of the East. These chilly images are but mental reconstructions of the Orient as fetishized in literature. While it is appropriate to speak here of Bazille's orientalism, or of his attraction to it in his last years, it must be specified immediately that what is in question is another exoticism, not the literary one but rather one whose sources are to be found in the French visual tradition. This pictorial exoticism, in contrast to anecdotal orientalism, received its letters of nobility in the nineteenth century, along with Delacroix, Chasseriau, and Ingres, whose *Turkish Bath* (1863) preceded Bazille's exploratory efforts in this domain by only a few years. It is interesting to consider *Summer Scene* (cat. 25) — one of Bazille's most fascinating but disconcerting paintings — in this connection. With good reason, it has often been compared with Cézanne's *Bathers*, which it prefigures in its subject and atmosphere. But this composition is above all revelatory of the young painter's desire to inscribe his

FIG. 33

Auguste Renoir

1841–1919

Odalisque or

Algerian Woman

1870

oil on canvas, h. 130; w. 157

Washington, D.C.,

National Gallery of Art

Chester Dale Collection

FIG. 34

Auguste Renoir

1841–1919

Parisian Women

Dressed as Algerians

1872

Parisiennes habillées en Algériennes

oil on canvas, h. 157; w. 130

Tokyo, National

Museum of Western Art

work within the tradition of great painting. Like Renoir and even Monet, Bazille never confused academicism, which he abhorred, with classicism, an inexhaustible source of examples. Thus the pose of the young man leaning against a tree at the left has the suppleness of a Renaissance Saint Sebastian,[7] and must have been suggested to Bazille by a figure he saw or copied in the Louvre. In addition, the crisply drawn figures and even the compositional syntax of this work would be all but inexplicable without the example of Ingres. Could one go further and suggest — without positively affirming it — that the languor of this *Summer Scene*; the odalisque-like pose of the reclining young man (most evident in the preparatory drawing in the Louvre, and more attenuated in the final composition); and the intimacy of the gesture with which one bather helps another emerge from the water all tend to create an atmosphere close to that of Ingres's *Turkish*

Bath, which Bazille could easily have seen in 1868 in Paris, on the occasion of the Khalil Bey sale in which it figured?[8]

But the cold, senile eroticism of Ingres's painting was hardly consistent with Bazille's pictorial ambitions. And, of course, it was to Delacroix that Bazille turned for inspiration. Even in the background of *Summer Scene*, the group of two young wrestlers — rather than evoking the smooth musculature of Gérôme's gladiators — recall the energy with which Delacroix was able to infuse the protagonists in his fresco of *Jacob Wrestling with the Angel* in the church of Saint-Sulpice (1857–61). And even before his arrival in Paris, Bazille had been able to admire one of the orientalist masterpieces of Delacroix, the *Women of Algiers* (1847; fig. 31), which Bruyas had purchased for his gallery in Montpellier in 1852, and which he lent to the Montpellier Salon in 1860. Even

more than Courbet, Delacroix was taken as an absolute model by many painters. The brief friendship between Cézanne and Bazille was largely rooted in their common love for this master's work. The anecdote, later recounted by Monet, of him and Bazille, young art students in 1862, peering through the windows of a studio on the Place de Furstenberg to observe Delacroix at work, presents a moving image of the younger generation's veneration. Bazille never forgot Delacroix, nor, perhaps, the lesson — stunning for a young painter — obtained through observation of the master: namely that "the model moved ceaselessly and did not pose in the customary way," and that Delacroix "only drew her in movement."[9]

Renoir's admiration for the great Romantic painter was similar. As John Rewald has noted, in the group that frequented the Café Guerbois around 1869–71, Renoir differed from Degas, Pissarro, and Monet in his lack of interest in Japanese prints, preferring the vivid colors of Delacroix's orientalist works to the prints' "meticulous harmonies."[10] Renoir transmuted his preoccupation with Delacroix's work into two masterpieces, the *Portrait of Madame Stora*[11] (fig. 32) and the *Odalisque* or *Algerian Woman*[12] (fig. 33), both dated 1870, as well as the astonishing but problematic *Parisian Women Dressed as Algerians*[13] (fig. 34) of 1872. For Renoir, as for Bazille, Delacroix's exoticism not only embodied painterly virtuosity, it could also serve as a kind of token for obtaining admission to the Salon. It is well known how crucial a goal such admission had become for young painters around 1870. Accepted and refused simultaneously, they kept jostling against this bloc whose monolithic identity was beginning to crack. Through the subterfuge of subject painting, much preferred by most members of the jury, they minimized the risk of exclusion and the almost systematic opposition that mobilized against them when they submitted more extreme examples of their work, especially landscapes.

Anecdotal orientalist painting flourished at the Salon, its jury being presided over by, among others, Gérôme. His status as unchallenged master of the genre was largely the result of his ability to dazzle through depiction of the minute details of objects — carpets, Turkish slippers, camel saddles — accumulated in the depths of his dark studio in the Batignolles quarter. Gérôme had vehemently refused to accept *Fisherman with a Net* for the 1869 Salon, and only admitted *View of the Village* reluctantly, characterizing the young painters, in Bazille's words, as a "band of madmen." He was no more charitably disposed the following year: Bazille's *La Toilette* was refused. Renoir's *Odalisque*, on the other hand, was accepted, as was Bazille's *Summer Scene*. Bazille felt this to be the result of a misunderstanding: "My other painting [*La Toilette*] was refused by mistake,"[14] he wrote his parents. Bazille must have been all the more wounded by this setback given that the chief attraction in that year's Salon was the *Salomé* (fig. 35) — a work squarely within the academic orientalist tradition — by Henri Regnault, a young painter destined to die at the front like Bazille. The strategy, perhaps unconscious on Bazille's part, of using the genre most popular with the public to obtain his own ends, and so defeat it on its own territory, had failed. *La Toilette* had cost Bazille considerable effort, and in his

view, it was successful to a degree he had rarely achieved. If the central figure's lack of internal structure can still surprise, this is largely compensated for by the opulence of the composition, with its rich textural contrasts and subtle links between the figures. Would Bazille have seduced the jury if he'd submitted his *Mauresque*, a single figure for which Lise — the model in Renoir's *Odalisque* — had also posed? The austerity of this figure, its gray-blue harmonies contrasting with the pink of the dress, is more reminiscent of Liotard (fig. 36) than Delacroix, and suggests a more classical vision of the Orient. And there is no explanation — if not the artist's sincerity and his adamant refusal to compromise — for his not having submitted the first version of his *African Woman with Peonies*, probably already finished. The facile exoticism of this painted homage to Manet might easily have managed to convince the members of the jury.

It is, of course, impossible for us to know whether Bazille would have continued to mine this "oriental" vein, or if, disappointed by his defeats at the Salon, he might have taken his art in other directions. As a raw recruit in Algeria, he wrote: "I wouldn't be at all disappointed at seeing a real Arab village…. I haven't seen a single palm tree, I've seen two or three chaemerops and a very few orange trees. The Arabs are all poor and filthy; however, there's plenty here that would make for really lovely paintings!" It is perhaps fortunate that Bazille didn't execute these "lovely paintings," for his brief orientalist phase transcends the lovable and anecdotal, constituting an underappreciated benchmark of pictorial exoticism linking Delacroix and Matisse.

Jean-Patrice Marandel

NOTES

1. Oil on canvas, 97 x 58 cm. Pasadena, Norton Simon Museum. The absence of this major canvas from the present exhibition is much to be regretted.
2. Second version (1870), oil on canvas, 60 x 74 cm. Washington, D.C., National Gallery of Art, Collection of Mr. and Mrs. Paul Mellon.
3. François Daulte, *Frédéric Bazille*, Paris, 1991, p. 125.
4. Gaston Poulain, *Bazille et ses amis*, Paris, 1932, p. 160; Wildenstein 1974, no. 53.
5. Oil on canvas, 138 x 202 cm. The Minneapolis Institute of Arts.
6. Oil on canvas, 148 x 139 cm. Private collection.
7. There is a drawing by Bazille representing *Saint Sebastian* in the sketchbook in the Cabinet des dessins of the Louvre, ref. 5259 fol. 62 verso.
8. It is worth noting that Bazille submitted this painting for the Salon of 1870 along with *La Toilette*, the most orientalist of all his works.
9. Poulain, *op. cit.*, pp. 47–48.
10. John Rewald, *The History of Impressionism*, 4th ed., New York, 1973, pp. 208–9.
11. Oil on canvas, 84 x 58 cm. San Francisco, Fine Arts Museums.
12. Oil on canvas, 69 x 123 cm. Washington, D.C., The National Gallery of Art, Chester Dale Collection.
13. Oil on canvas, 157 x 130 cm. Tokyo, National Museum of Western Art.
14. Poulain, *op. cit.*, p. 178; correspondence 1992, no. 138.

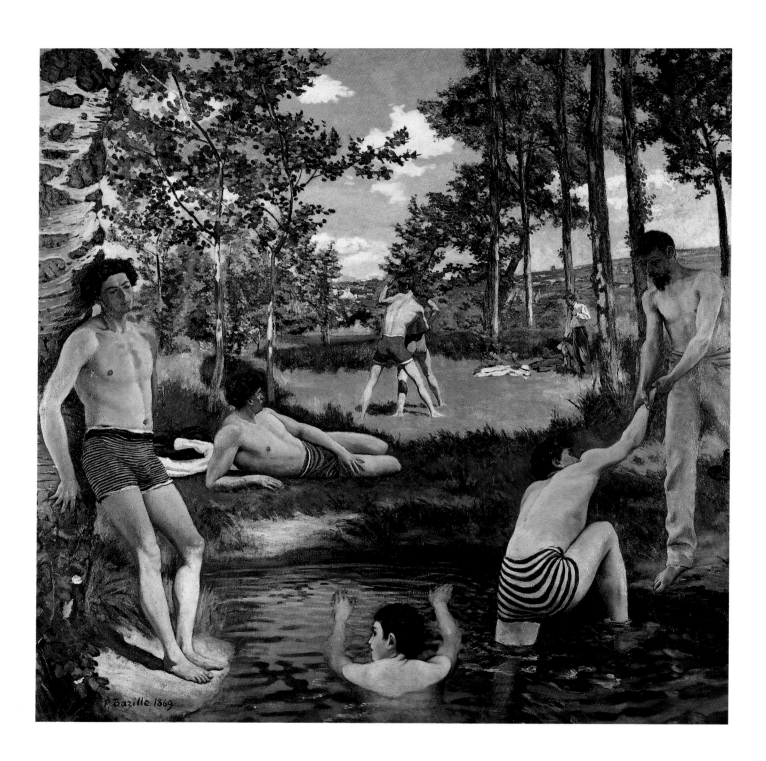

Catalogue

Since the renewal of interest in Frédéric Bazille at the beginning of this century, several publications have been devoted to him. The earliest was that of Gaston Poulain in 1932: *Bazille et ses amis*. It was succeeded in 1948 by a thesis at the École du Louvre by Gabriel Sarraute. This unpublished thesis served as the foundation for the third catalogue devoted to Bazille, that of an exhibition held at the Wildenstein Gallery in Paris in 1950. Two preceding catalogues were for exhibitions in 1935 (Paris) and 1941 (Montpellier), the first organized by the Association of Protestant Students and the second by Gaston Poulain at the Musée Fabre. In 1952, the art historian François Daulte published *Frédéric Bazille et son temps*. The catalogue of the exhibition *Bazille and Early Impressionism* at The Art Institute of Chicago in 1978, written by Jean-Patrice Marandel, was largely dependent on that volume, which has recently been republished. The texts of the present catalogue build upon all these publications, which have served us as guides in our own systematic verification of the sources. The ordering and dating of the artist's correspondence by Didier Vatuone and Guy Barral (of the Municipal Library in Montpellier) has facilitated the establishment of a precise chronology of the artist's life, illustrated with many documents, some of which are included in the exhibition, and of a new classification of the works in the catalogue. This essential work has been carried out in close collaboration with Dianne Pitman, Ph. D., whose dissertation was on the artist ("The Art of Frédéric Bazille," 1989).

The complete correspondence is being published in a separate volume. Many documents will be included there thanks to lenders who have preferred to remain anonymous; we would like to express our warm appreciation to them for their generous cooperation. When a letter is used in a catalogue entry, its previous published appearances are referenced and the new dating from the forthcoming edition is given.

The catalogue is divided into two sections. The first consists of works that are securely dated, either because a date appears on the work itself or because one can be determined by relevant information in the artist's correspondence. The second section is devoted to works whose dating is problematic. In this section, the paintings and drawings have been organized thematically and are broken down into five parts: studies and drawings, landscapes, self-portraits, portraits, various subjects. After these, we have included the artist's only known copy, and additional paintings of questionable attribution. The numbering in the catalogue is continuous.

The catalogue entries have been prepared by Aleth Jourdan (A.J.), Dianne Pitman (D.P.), and Didier Vatuone (D.V.). Each entry includes a history of the work with a full provenance (to the extent possible), its exhibition history, and a bibliography. These citations are given in abbreviated form, referring the reader to the back of the catalogue. For exhibitions: date, city or country for traveling exhibitions, catalogue number. For bibliographic references: author's name, date, and page number. Dimensions are given in centimeters: height, then width.

1 MALE NUDE

1863

Académie d'homme

Study after the model

Conté crayon and charcoal on paper

h. 62; w. 47. d.t.l.: 7 mars 63

Montpellier, Musée Fabre, inv. 49.5.2

PROVENANCE:

Family of the artist. Gift of Frédéric Bazille, the artist's nephew, to the Musée Fabre in 1949.

EXHIBITIONS:

1950, Paris, Wildenstein Gallery, no. 2; 1959, Montpellier, Musée Fabre;

1978, Chicago, The Art Institute, no. 2

BIBLIOGRAPHY:

Sarraute 1947, p. 6, no. 6; Sarraute 1950, no. 2; Daulte 1952, p. 193, no. 6; Exhibition cat., 1959, p. 23, no. 41; Claparède 1962, no. 14; Marandel 1978, no. 2; Daulte 1991, p. 153, no. 1; Jourdan 1991, pp. 16–21, fig. 20.

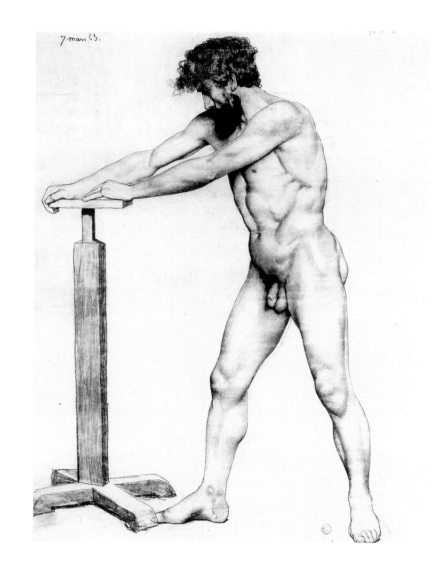

"I will shortly send you an *académie* made in the studio," Bazille wrote to his mother on January 6, 1863.[1] The studio in question was that of Charles Gleyre, where the young man registered upon his arrival in Paris in November 1862, on the advice of Henri Bouchet-Doumenq, a friend of his cousin the painter Eugène Castelnau (1827–1894). This *académie* comes from a portfolio of drawings rediscovered at Méric in December 1947. This drawing, with clear, precise contours, executed in Conté crayon and charcoal, represents a man with thick black hair, bearded, his torso in three-quarter view, his head in profile, leaning on a sculptor's work stand. With a *Female Académie*, dated February 18, 1863 (private collection), it is an interesting example of the artist's earliest studio work, to which he alludes frequently in his correspondence in the winter of 1863. "I take greater and greater pleasure in my studio work which will be, if not the honor, then the happiness of my life. But the more I advance, the more difficulties I encounter, and every day I feel the need to work. You will perhaps find it difficult to believe me, but I assure you that I apply myself to drawing with a will. I go to the studio every morning at 8 o'clock, and I don't leave before 3 in the afternoon. You ask me for study drawings, and I understand very well that you want to judge for yourself what I'm capable of doing; but aside from its being difficult to send rolled paper, my studies are usually not very presentable by the end of the week, so filthy are they, and covered with caricatures made by my neighbors" (letter from Bazille to his father[2]). In studying drawing so assiduously, he was following the advice of his earliest teachers, the Montpellier sculptor Auguste Baussan (1829–1907; "Draw, draw a great deal, it will doubtless be of use to you, but also study medicine. I know what I'm telling you to do is difficult, but believe me, make your father happy, don't make a mess of your examinations.... My father is very touched by the warm memories you retain of him, both he and I will be very pleased to see the *académies* you promise him."[3]) and Charles Gleyre, who in his teaching stressed drawing as the basis of all art. A.J.

NOTES

1. Marandel 1978, no. 58; correspondence 1992, no. 12 [Thursday, January 6, 1863].

2. Marandel 1978, no. 4, p. 191; corresponndence, 1992, no. 16 [before February 20, 1863].

3. Letter of March 17, 1863, cited by Sarraute 1949, p. 6.

2 Study for RECLINING NUDE

1864

Étude pour *le Nu couché*

charcoal on paper

h. 42; w. 57

Montpellier, Musée Fabre

inv. 49.5.1

PROVENANCE:

Family of the artist. Gift of Frédéric Bazille, the artist's nephew, to the Musée Fabre in 1949.

EXHIBITIONS:

1950, Paris, Wildenstein Gallery, no. 9; 1959, Montpellier, Musée Fabre, no. 42; 1978, Chicago, The Art Institute, no. 9

BIBLIOGRAPHY:

Sarraute 1947, p. 16, no. 7; Sarraute 1950, no. 9; Daulte 1952, p. 194, no. 10; Exhibition cat., 1959, p. 23, no. 42; Claparède 1962, no. 15; Marandel 1978, no. 9; Daulte 1991, p. 17; Jourdan 1991, pp. 16–21, fig. 21.

Study of the catalogue of Bazille's drawings, as successively established by Sarraute and Daulte, informs us that Bazille made at least four preparatory studies for the first important painting he executed in Paris during 1864. Aside from this study from the Musée Fabre, given by the artist's nephew in 1949, Sarraute catalogues another drawing very close to this one, and on the same sheet, of the same model but viewed from the vantage point of the feet, in foreshortening (Sarraute, "Appendice à ma thèse: dessins de F. Bazille et de ses camarades retrouvés á Méric en décembre 1947," no. 15). Another study is mentioned by Daulte as belonging to the collection of André Bazille in 1952 (Daulte 1952, no. 8). In all the studies for the *Reclining Nude*, the model is posed exactly as in the painting, and the figure is unclothed. In the Musée Fabre drawing the left arm does not appear, nor do the accessories, the cushion, the draperies, or the slippers. A.J.

3 PORTRAIT OF A MAN

1864

Portrait d'homme

charcoal on white paper

h. 57; w. 42

Montpellier, Musée Fabre, inv. 49.5.1

BIBLIOGRAPHY:

Daulte 1952, no. 3; Daulte 1991, p. 19; Jourdan 1991, pp. 16–21, fig. 21 *bis*; Pitman 1989, pp. 72–73.

On the verso of the preceding drawing. The model has not been identified: an annotation in pencil, perhaps not in the artist's hand, gives the name Villa, that of the artist with whom Bazille shared his first studio in Paris, on the rue de Vaugirard, from January 1864. Five years older than Bazille, Louis-Émile Villa (1836–1915) first studied with Charles Matet in Montpellier, then briefly in Courbet's studio on the rue Notre-Dame-des-Champs before entering the Gleyre studio, where he met Bazille. Exhibiting at the Salon beginning in 1859, Villa essentially specialized in animal painting. The two artists shared a studio for several months, and then Villa seems to have disappeared from Bazille's circle. A.J.

4 RECLINING NUDE

1864

Nu couché

oil on canvas, h. 70; w. 180

s.b.r.: F.B. 64

Montpellier, Musée Fabre, inv. 18.1.1

PROVENANCE:

Collection of Marc Bazille, the painter's brother. Given by Marc Bazille to the Musée Fabre in 1918.

EXHIBITIONS:

1910, Paris, Salon d'Automne, no. 17; 1927, Montpellier, Exposition internationale, no. 2; 1939, Paris, Musée de l'Orangerie, no. 2; 1939, Berne, Kunsthalle, no. 2; 1941, Montpellier, Musée Fabre, no. 9; 1950, Paris, Wildenstein Gallery, no. 8; 1959, Montpellier, Musée Fabre, no. 3; 1971, Montpellier, Musée Fabre; 1978, Montpellier, Musée Fabre, no. 35; 1978, Chicago, The Art Institute, no. 8; 1985, Montpellier, Musée Fabre, no. 36; 1991, Montpellier, Musée Fabre.

BIBLIOGRAPHY:

Joubin 1926, no. 359; Poulain in *La Renaissance*, April 1927, p. 166; Poulain 1932, no. 2; Gillet

1935, p. 242; Baderou, Faré 1937, p. 7; Bazin 1947, p. 63; Sarraute 1947, p. 16; Sarraute 1950, no. 8; Daulte 1952, p. 168; Exhibition cat., 1959, p. 13, no. 3; Champa 1973, p. 82, fig. 113; Boime 1974–75, p. 120, fig. 102; cat. *Le Nu*, 1978, no. 35; Marandel 1978, p. 42, no. 8; Bordes, Jourdan 1985, no. 36; Le Pichon 1986, p. 156; Pitman 1989, pp. 72–73; Daulte 1991, p. 154, no. 3; Jourdan 1991, pp. 16–21, fig. 13.

At the end of June 1864, Bazille was working "very hard on a life-size study of a woman which I'd like to bring to you if it doesn't turn out too badly" (letter to his mother[1]). He was probably referring to the *Reclining Nude* now in the Musée Fabre. According to Marandel, the fact that the preparatory drawing shows the figure within a frame suggests that the initial inspiration for this composition was a painting by Guido Cagnacci, the *Young Female Martyr* in the Musée Fabre (fig. 37), which Bazille could have seen there. This idea, first put forward by Sarraute, is certainly worth considering, but it seems clear that Bazille was inspired by academic models directly before his eyes. The pose of the figure is reminiscent of those used by Gleyre in his *Dance of the Bacchantes* (Lausanne, Musée Cantonal), and one can't help but be struck by the similarity of the pose in the *Reclining Nude* to the one in Cabanel's *Birth of Venus* (Paris, Musée d'Orsay), exhibited at the Salon of 1863. But the sensuality and grace of the female body so dear to academic painters did not interest Bazille. His female nudes are always characterized by a reserve that is difficult to distinguish from clumsiness and awkwardness in the rendering of anatomy: the left arm brought up under the head, obviously the result of reworking, and the ugliness of the bosom, less notable in the preparatory drawing, signal the artist's difficulties in transferring his composition to a large canvas. A.J.

NOTE

1. Marandel 1978, no. 35, p. 199; correspondence, 1992, no. 53 [late June 1864].

FIG. 37

Guido Cagnacci

1601–1681

Young Female Martyr

circa 1650

Jeune martyre

oil on canvas, h. 97; w. 130

Montpellier, Musée Fabre

5 SOUP BOWL COVERS

1864

Couvercles de bouillon

oil on canvas

h. 22; w. 35

d.b.l.: juin 64

Private collection

PROVENANCE:

Collection of Jean Thuile. Private collection.

EXHIBITIONS:

1950, Paris, Wildenstein Gallery, no. 11; 1959, Montpellier, Musée Fabre, no. 3.

BIBLIOGRAPHY:

Sarraute 1950, no. 11; Daulte 1952, p. 169, no. 7; Exhibition cat., 1959, p. 13, no. 5; Daulte 1991, p. 155, no. 7.

Sarraute, like Daulte, dates this little still life with its awkward treatment to Bazille's sojourn at the Saint-Siméon farm near Honfleur, in June 1864, where he had arrived in the company of Monet in the last days of May. The artist, in a letter dated June 1 and addressed to his mother, describes the farm's amenities and alludes to the landscape motifs the two painters wasted no time in seeking out. This study, not mentioned by the artist, is his only known work from this period. During their stay, Bazille painted a series of landscapes that were damaged during the trip back to Paris: a box of pastels overturned in the case containing these works, and its powdery contents dusted the paintings, which were not yet dry.[1] A.J.

NOTE

1. Marandel 1978, no. 35, p. 199; correspondence, 1992, no. 53 [late June 1864].

6 Study for THE PINK DRESS

1864

Étude pour *La Robe rose*

charcoal on paper

h. 48; w. 30

Paris, Musée du Louvre,

département des Arts graphiques,

fonds du Musée d'Orsay

inv. RF 29730

PROVENANCE:

Family of the artist. Given by Frédéric Bazille, the artist's nephew, to the Louvre in 1949.

EXHIBITIONS:

1959, Montpellier, Musée Fabre, no. 43.

BIBLIOGRAPHY:

Sarraute 1949, no. IV, *Bulletin des musées de France*, pp. 91–93; Daulte 1952, p. 195, no. 17; Pitman 1989, pp. 70–71.

This preparatory drawing for *The Pink Dress* comes from the set of drawings rediscovered at Méric in 1947, and it was published in 1949 by Gabriel Sarraute with a study for *Summer Scene*: "M. Frédéric Bazille, nephew of the painter of *The Family Gathering*, has just made a gift to the Louvre Museum of two drawings by his uncle, rediscovered at the end of 1947 on the family property at Méric, near the gates of Montpellier. These two documents are of considerable importance in the history of Impressionism." The only known study for the painting executed over the summer of 1864 at Méric, it is squared for transfer. It was drawn in charcoal on the back of a sheet of paper on which Bazille had represented a plaster cast of an ancient statue (a female head) placed on the arm of a chair. In contrast with the final composition, the model, Thérèse des Hours-Farel, the painter's cousin, is seen in three-quarter view, gazing into the distance, her hands resting on her apron. The young woman's dress is fuller than in the painting, and its sleeves extend to the wrists. The silhouette here, abandoned in the painting, is a near mirror image of the pose Bazille would give Thérèse des Hours-Farel in *The Family Gathering* (cat. 18); he used it again for the young woman in *View of the Village* (cat. 20).
A.J.

7 THE PINK DRESS

1864

La Robe rose

oil on canvas, h. 145; w. 110

s.b.r.: F. Bazille

Paris, Musée d'Orsay

inv. RF 2450

PROVENANCE:

Collection of Marc Bazille, the artist's brother. Gift of Marc Bazille to the Musée du Luxembourg in 1924. Entered the Musée du Louvre in 1929. Transferred to the Jeu de Paume in 1947. In the Musée d'Orsay since 1986.

EXHIBITIONS:

1910, Paris, Salon d'Automne, no. 8; 1935, Paris, Association des étudiants protestants, no. 17; 1953, Compiègne, Château de Compiègne, no. 11; 1954, London, Tate Gallery, no. 30; 1955, Marseille, Musée Cantini, no. 30; 1965, Lisbon, Gulbenkian Foundation, no. 4; 1969, Troyes, Musée des Beaux-Arts, no. 45; 1971, Madrid, Prado Museum, no. 27.

BIBLIOGRAPHY:

Masson 1927, p. 13; Poulain 1932, no. 12; Sarraute in *Bulletin des musées de France*, 1949, IV, p. 93; Daulte 1952, p. 170, no. 9; Champa 1973, pp. 75–86, fig. 118; Rewald 1973 (4th ed.), p. 222; Pitman 1989, pp. 68–71; Daulte 1991, p. 157, no. 9.

This painting was executed at Méric, the family property close to Montpellier where the Bazille and des Hours-Farel families spent their summer vacations. The property had belonged to the artist's mother's family, the Vialars, since 1741. Mme Gaston Bazille, born Camille Vialars, and her sister Adrienne, Mme Eugène des Hours-Farel, inherited it in 1859. This country house in an English park overhangs the bed of the Lez, opposite the village of Castelnau. Each summer, the two families assembled there, and Frédéric faithfully adhered to this tradition. He was joined there by his dear cousins, Pauline, Thérèse, and Camille, who were ever present in his thoughts and his letters. *The Pink Dress*, for which Thérèse, the second daughter of Mme Eugène des Hours-Farel, was the model, is the earliest example of a theme dear to Bazille and one of his first attempts to paint in the open air, "*sur le motif*," setting the human figure in a landscape. This notion seems to have preoccupied him from as early as 1863. In a letter dated December 8, 1863, Bazille mentions the project of painting figures in the sun: "We went, my friend Villa and I, to take another look at the studio into which we're supposed to move on January 15 (1864), we still like it a lot, the owner promised us to have it entirely repainted and ceded us a little patch of garden as large as the dining room at the house, containing a peach tree and some lilies, it will be pleasant for us in the summer, for painting figures in the sun."[1] In this painting, Thérèse, who would later pose in the center of *The Family Gathering*, is seated on the low wall of the road circling Méric. Turning her back to the viewer, she contemplates the village of Castelnau, whose houses are flooded by the light of the setting sun. In contrast to the preparatory drawing, the model dominates the composition, as if to indicate that the figure should predominate over depictions of nature. The somewhat muffled luminosity of the canvas intensifies the impression it creates of calm and serenity. As in the *Reclining Nude* dating from the same year, Bazille obscured the model's face, perhaps in concession to his limited mastery of the difficulties of portrait painting. The work can be precisely dated thanks to a letter from Gaston Bazille of December 16, 1864,[2] in which he tells his son about the misadventure that befell the painting when it was being photographed by the Montpellier photographer Huguet-Molines, who had seen fit to retouch the arm and head of the model, to the great dissatisfaction of the artist. A.J.

NOTES

1. Marandel 1978, no. 10, p. 193; correspondence, 1992, no. 34 [December 8, 1863].
2. Cited by Sarraute 1949, p. 93; correspondence, 1992, no. 60.

8 STUDIO ON THE RUE DE FURSTENBERG

1865

*Atelier de la rue
de Furstenberg*

oil on canvas, h. 80; w. 65

Montpellier, Musée Fabre

inv. 85.5.3

PROVENANCE:

Collection of Eugène Leenhardt. Collection of Georges Marchand. Acquired by the Musée Fabre in 1985 with the assistance of FRAM.

EXHIBITIONS:

1927, Montpellier, Exposition internationale, no. 3; 1935, Paris, Association des étudiants protestants, no. 15; 1941, Montpellier, Musée Fabre, no. 13; 1950, Wildenstein Gallery, no. 14; 1959, Montpellier, Musée Fabre, no. 8; 1978, Chicago, The Art Institute, no. 18; 1982–83, Dijon, Musée des Beaux-Arts, no. 276; 1984, Montpellier, Musée Fabre; 1985, Paris, Grand Palais, no. 135; 1986, Paris, Musée d'Orsay, no. 80; 1991, Montpellier, Musée Fabre.

BIBLIOGRAPHY:

Poulain 1932, no. 7; Sarraute 1950, no. 15; Daulte 1952, p. 172, no. 16; Exhibition cat., 1959, p. 14, no. 8; Wildenstein 1974, p. 28; Daulte in *L'Oeil*, 1978, p. 36; Georgel 1982–83, p. 150, no. 270; (anon.), 1985, no. 1, p. 63, fig. 16; cat. *Anciens et nouveaux*, 1985–86, p. 211, no. 135; cat. *Chefs-d'oeuvre de la peinture*, 1988, pp. 180–81; Daulte 1991, p. 160, no. 18; Jourdan 1991, pp. 16–21, fig. 23.

This work is the first representing one of Bazille's studios. He occupied six studios, three of which are known to us through his paintings. Bazille moved onto the rue de Furstenberg at the beginning of January 1865, but he was making plans for the impending move in the preceding month (December 22, 1864): "I bought, on the terms I've already specified for you, an iron bed with box springs and mattress, a night table, an iron lavatory, some curtains, four chairs, a table, and an armchair that is my only luxury, as I've renounced a carpet."[1] Very scanty furnishings, but the green armchair would be retained throughout his entire Parisian sojourn, figuring again in the *Studio on the rue La Condamine.*

This studio corner was painted in homage to Delacroix, who lived in the same building until his death. The stove of reddish cast iron, at the far left of the composition, is probably intended as a signal of this, as its metaphorical embodiment, and it would be similarly used again in the Musée d'Orsay painting. On the walls are some works by Monet, with whom Bazille shared this studio — *Seashore at Honfleur*[2] and *Road to the Saint-Siméon Farm*[3] — and a portrait of Monet by G. de Séverac (fig. 12), above the table on which are placed a few objects. On the floor, near the armchair, are the painter's palette, a box of paints, and the brushes he was using to paint the picture. This studio interior was familiar to the artist; while devoid of living beings, it belonged to him. Reality is very much present here, at the heart of a project leading to modernity whose future avatars Bazille would befriend, but in which chance would prevent him from participating fully. D.V.

NOTES

1. Correspondence, 1992, no. 61 [December 22, 1864].
2. Wildenstein, 1974, vol. I, no. 41.
3. *Ibid.*, no. 29

9 SEASCAPE (THE BEACH AT SAINTE-ADRESSE)

1865

Marine

oil on canvas

h. 60; w. 140

s.d.b.l.: F. Bazille 1865

Atlanta, The High Museum of Art

inv. 1980–62

PROVENANCE:

Pomier-Layrargues Collection. Brunel Collection. Pierre Fabre Collection. The High Museum of Atlanta (Gift of the Forward Arts Foundation in Honor of Frances Floyd Cocke).

EXHIBITIONS:

1950, Paris, Wildenstein Gallery, no. 15; 1978, Chicago, The Art Institute, no. 17; 1984–85, Los Angeles County Museum of Art, The Art Institute of Chicago, Paris, Grand Palais, no. 4; 1985, New York, Wildenstein Gallery; 1991, Manchester, New Hampshire, Currier Gallery of Art, no. 1.

BIBLIOGRAPHY:

Poulain 1932, no. 3; Sarraute 1950, no. 15; Daulte 1952, p. 172, fig. 15/1; Isaacson 1972, pp. 98–9, n. 13; Champa 1973, p. 85, fig. 115; Rewald 1973 (4th ed.), p. 110; GBA March 1981, no. 216; cat. *A Day in the Country*, 1984–85, p. 52, no. 4; Daulte 1991, p. 160, no. 17.

One of two pictures painted by Bazille between May and mid-August 1865 for his uncle Pomier-Layrargues, this seascape depicts the coast at Sainte-Adresse in Normandy, which Bazille had visited the year before with Monet. The companion piece portrays the farm at Saint-Sauveur near Montpellier, property of the Bazille family (fig. 38). The decorative function of the two paintings — conceived as *dessus de porte* — accounts for their unusual proportions. In a letter dated May 5, 1865, Bazille wrote to his mother, "I have begun one of my uncle's pictures; it would be finished two weeks earlier if I could leave for Fontainebleau to do the necessary studies. In any case, they won't be done until next August. I am working very carefully on them and

FIG. 38

Saint-Sauveur

oil on canvas

h. 60; w. 140

Private collection

I hope my uncle will be pleased."[1] Bazille may have needed studies for cows for the picture of Saint-Sauveur, or perhaps he planned to paint a woodland scene at the forest of Fontainebleau, where Monet was working at the time. Painting in his studio in the rue de Furstenberg in Paris, Bazille used as model Monet's *Beach at Sainte-Adresse* of the previous summer (The Minneapolis Institute of Arts), which was no doubt among the canvases he was storing for his friend. He copied most of the landscape elements, adding a tall sailboat at right to counterbalance the horizontal emphasis of his wider format. In contrast to Monet's atmospheric forms, Bazille's are more solid; for example, the shadow of the sailboat falls across the opaque waves without the least hint of transparency or reflection. One detail in particular reveals Bazille's personality as a painter: in the place of Monet's three men in a rowboat moving away and his sailboats heading offshore, Bazille shows us the same three rowers returning and several sailboats all heading landward. Moreover, he adds a fisherman in the foreground who seems to look out at us. Never comfortable with great distances and the reveries they evoke, Bazille tries to make his picture engage the viewer forcefully and directly. He worked on the two canvases for three months, struggling with the difficulties of painting from another picture as well as the demands of the intended placement. As he explained to his mother before leaving Paris to join Monet at Chailly, "At last I will have finished, tomorrow morning, the paintings for my uncle; I reworked them completely since my last letter. Previously I had done a mass of details, which, given the distance they were intended to be viewed from, had a very unpleasant effect. I have worked relentlessly for two weeks and now I am rather satisfied, at least with one of the two."[2] Although the result is far from elegant, Bazille seems to have learned some important lessons here. D.P .

NOTES

1. Marandel 1978, no. 40, p. 200, author's translation; correspondence, 1992, no. 66 [May 5, 1865].
2. Marandel, 1978, no. 45, p. 201, author's translation; correspondence, 1992, no. 70 [August 18, 1865].

89

10 THE IMPROVISED FIELD HOSPITAL

(Monet after his accident

at the Inn of Chailly)

1865

L'Ambulance improvisée

oil on canvas

h. 47; w. 62

Paris, Musée d'Orsay

inv. RF 1967–5

PROVENANCE:

Family of the artist. Collection of Mme Meynier de Salinelles, subsequently Mme Pinchinat. Acquired at a public sale, Paris, Grand Palais, June 14, 1967, for the Musée du Jeu de Paume. In the Musée d'Orsay since 1986.

EXHIBITIONS:

1910, Paris, Salon d'Automne, no. 2; 1927, Montpellier, Exposition internationale, no. 4; 1935, Paris, Association des étudiants protestants, no. 1; 1936, Grenoble, Musée des Beaux-Arts, no. 506; 1937, Paris, Galerie des Beaux-Arts, no. 54; 1941, Montpellier, Musée Fabre, no. 15; 1950, Paris, Wildenstein Gallery, no. 17; 1959, Montpellier, Musée Fabre, no. 10; 1967, Paris, Musée de l'Orangerie, no. 400; 1973, Turin, Galleria Civica d'Arte Moderna; 1978, Chicago, The Art Institute, no. 15; 1982, Tokyo, National Museum of Western Art, no. 29; 1985, Antibes-Toulouse-Lyon, no. 3.

BIBLIOGRAPHY:

Focillon 1928, p. 212; Poulain 1932, no. 11; Scheyer 1942, p. 120; Sarraute 1950, no. 17; Daulte 1952, p. 172, no. 14; de Forges 1962; GBA, February 1968, no. 1189, p. 18; Blunden 1970, p. 60; Bouret 1972, pp. 236–37; Isaacson 1972, p. 25, fig. 9; cat. of paintings in the Louvre, 1972, vol. I, p. 26; Adhémar, Dayez 1973, p. 139, pl. 8; Champa 1973, p. 6, fig. 10; R.L., 1973, no. 45, p. 298, no. 14; Rewald 1973 (4th ed.), p. 120; Wildenstein 1974, pp. 28, 30; Bellory-Rewald 1977, pp. 40, 46–47; Marandel 1978, no. 15; Isaacson 1978, pp. 49–50; Bonafoux 1986, pp. 48–49; Compin, Roquebert 1986, vol. III, p. 49; Pitman 1989, p. 57; Rosenblum 1989, p. 226; Lacambre, Roquebert 1990, vol. I, p. 46; Daulte 1991, p. 159, no. 15.

Having completed the paintings intended for his uncle Pomier-Layrargues, Bazille left Paris for Chailly, where Monet had been asking him to come since May: "I would like to have your opinion about the landscape for my figures."[1] The repeated postponement of his departure, for lack of money, as Bazille explained to his mother [May 5, 1865], infuriated Monet, who was impatiently awaiting his arrival so he could pose for some male figures in the *Déjeuner sur l'herbe*: "I no longer think of anything but my painting," Monet wrote to Bazille, "and if I don't manage to bring it off I think I'll go crazy."[2] But Bazille did not arrive in Chailly, where he joined Monet at the inn called the Lion d'Or, until August 18, 1865. This sojourn, which he hoped would be brief because he was on his way to Montpellier[3] — "I have to spend five or six more days in Chailly to help out Monet," he wrote to his father in mid-July; "he's doing a large painting in which I'm to figure, and he needs this much time to paint me. After that I'll leave for Montpellier" — was extended because of of bad weather. "I've been in Chailly since last Saturday, and solely to do Monet a favor, otherwise I'd have left for Montpellier long ago and with great joy. Unfortunately, since I've been here the weather has been atrocious. I've only been able to pose for him twice, including today. Now the weather is quite beautiful and will certainly hold. Monet, working as quickly as possible, will need me for three or four more days, so I must delay my departure a bit longer, much to my regret."[4] As a final stroke of bad luck, Monet wounded himself in the leg and it is he, bedridden, who served as Bazille's model. The young painter is depicted lying in a long canopied bed, comfortably leaning against the pillows, his injured leg slightly elevated. An ingenious device, doubtless improvised by the former medical student Bazille, assured constant refreshment of the wound with dripping water. The chromatic range of this charming little painting is intentionally reduced to a symphony of off-whites attenuated by beiges, warm browns, black, and gray-beige, muffled colors that would subsequently appear in some of the portraits Bazille painted in Paris. A diffuse golden light bathes the scene. The spontaneity and freedom with which Bazille painted this intimate subject make *The Improvised Field Hospital* one of the artist's most successful works. A.J.

NOTES

1. Letter from Monet to Bazille on May 4, 1865, cited by Wildenstein 1974, vol. I, no. 19.
2. *Ibid*, no. 20.
3. Marandel 1978, no. 43, p. 201; correspondence, 1992, no. 69 [July 17, 1864].
4. Marandel 1978, no. 46, p. 201; correspondence, 1992, no. 72 [August 31, 1864].

11 LANDSCAPE AT CHAILLY

1865

Paysage à Chailly

oil on canvas, h. 82; w. 105

s.d.b.l.: F. Bazille 1865

Chicago, The Art Institute, The Charles H. and Mary F. S. Worcester Collection

inv. 1973.64

PROVENANCE:

Collection of Marc Bazille. Collection of Mme Meynier de Salinelles. Collection of Marc Meynier de Salinelles. Paris, Palais Galliéra, sale of March 17, 1971. Sam Salz, New York. The Art Institute of Chicago, The Charles H. and Mary F. S. Worcester Collection.

EXHIBITIONS:

1910, Paris, Salon d'Automne, no. 4; 1927, Montpellier, Exposition internationale, no. 5; 1937, Paris, Galerie des Beaux-Arts, no. 56; 1941, Montpellier, Musée Fabre, no. 14; 1949–50, London, Royal Academy, no. 224; 1950, Paris, Wildenstein Gallery, no. 18; 1974, Chicago, The Art Institute; 1978, Chicago, The Art Institute, no. 14; 1980, Albi, Musée Toulouse-Lautrec, no. 16; 1984–85, Los Angeles County Museum of Art, The Art Institute of Chicago, Paris, Grand Palais, no. 7; 1986, Edinburgh, National Gallery of Scotland, no. 61.

BIBLIOGRAPHY:

Poulain 1932, no. 10; Sarraute 1950, no. 18; Daulte 1952, p. 171, no. 11; Rewald 1973 (4th ed.), p. 98; cat. *A Day in the Country*, 1984–85, p. 56, no. 7; Bretell 1987, pp. 77–78, 80, 117; Daulte 1991, p. 158, no. 12.

During his stay at Chailly in August and September 1865, Bazille experimented with a broader touch and richer colors, appropriate to the boulders and the masses of foliage barely pierced by light, which recall certain landscapes by Courbet. Bazille includes neither human figures, such as those that so often lend anecdotal meaning to landscapes of the Barbizon school, nor paths to lead us into the space, as in his own *The Edge of the Fontainebleau Forest* (cat. 38), undated but probably earlier than this painting. Rather than producing an illusion of a space that we could enter into, the fuller forms push out towards us, emphasizing the substance of paint and canvas. D.P.

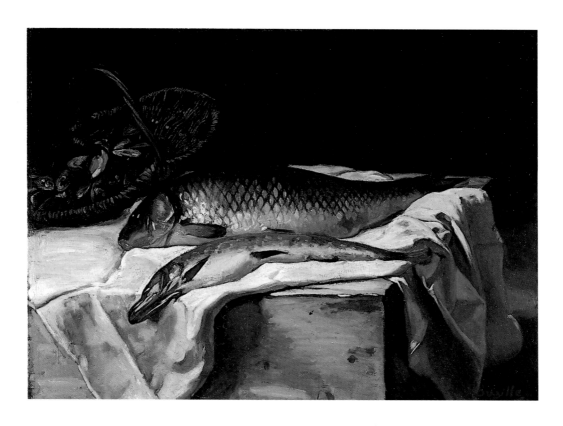

12 STILL LIFE OF FISH

1866

Poissons

oil on canvas

h. 63; w. 83

s.b.r.: F. Bazille

Detroit, The Detroit Institute
of Arts, inv. 1988.9

PROVENANCE:

Collection of André Bazille. Collection of
Mme Rachou-Bazille. Acquired by The Detroit
Institute of Arts (Founders Society Purchase,
Robert H. Tannahill Foundation Fund, 1988).

EXHIBITIONS:

1866, Paris, Salon, no. 97; 1910, Paris, Salon d'Au-
tomne, no. 6; 1927, Montpellier, Exposition
internationale, no. 6; 1941, Montpellier, Musée
Fabre, no. 16; 1950, Paris, Wildenstein Gallery, no.
23; 1959, Montpellier, Musée Fabre, no. 13.

BIBLIOGRAPHY:

Poulain 1932, no. 14; Sarraute 1950, no. 23;
Daulte 1952, p. 173, no. 17; exhibition cat., 1959,
p. 15, no. 13; Rewald 1973 (4th ed.), p. 139;
Marandel 1978, p. 132; Marandel in *Bulletin of The
Detroit Institute of Arts*, 1990, vol. 65, pp. 4–11, no.
4; Daulte 1991, p. 160, no. 19.

To the Salon of 1866, Bazille submitted a large
painting of a girl at a piano, on which all his
hopes were fastened, along with this small still
life with fish, a modest afterthought. "I am ter-
ribly afraid of being rejected," he wrote in
April 1866, "so I will send a still life of fish at
the same time which will probably be ac-
cepted."[1] Whereas the first painting was
refused (and has been lost), the second, pre-
sented here, became Bazille's first painting to
be exhibited to the public. The artist seems to
have borrowed both subject and composition
from Manet's *Still Life with Fish* of 1864 (The
Art Institute of Chicago), which had been
shown in the spring of 1865 at the Parisian
gallery of Louis Martinet. Among the thou-
sands of paintings shown at the Salon that
year, the *Still Life with Fish* caused no sensa-
tion, but at least two critics devoted some lines
to it. In the *Journal de Montpellier* of June 9,
1866, J. Ixe found Bazille too timid: "The qual-
ities of drawing and modeling in this still life
do not meet the demands of the genre, which
fundamentally depends on the force of the
color and the spirit of the touch."[2] In Paris,
writing for *L'Avant-Scène*, Charles de Sarlat of-
fered similar advice, albeit a bit more
encouraging: "It is solidly painted, but the air
does not circulate enough.... I urge M. Bazile
[*sic*] to avoid dark tones.... The carp is very
real: one wants to serve oneself, it is so appe-
tizing.!"[3] D.P.

NOTES
1. Poulain 1932, pp. 62–64, translated by Linda
Nochlin, *Realism and Tradition in Art 1848–1900*
(Englewood Cliffs, New Jersey: Prentice-Hall, 1966),
p. 87.
2. J. Ixe, *Journal de Montpellier*, 9 June 1866, cited in
Barral 1992, p. 16; author's translation.
3. Ch. de Sarlat, "Exposition de peinture," *L'Avant-
Scène*, 21 June 1866, n. pag.; author's translation.

13 STUDIO ON THE RUE VISCONTI

1867

Atelier de la rue Visconti

oil on canvas

h. 64; w. 49

Richmond, Virginia Museum
of Fine Arts, Collection of
Mr. and Mrs. Paul Mellon

PROVENANCE:

Family of the artist. Collection of André Bazille.
Collection of Mme Rachou-Bazille. Collection of
Mr. and Mrs. Paul Mellon.

EXHIBITIONS:

1927, Montpellier, Exposition internationale, no.
15; 1935, Paris, Association des étudiants
protestants, no. 8; 1941, Montpellier, Musée Fabre,
no. 19; 1950, Paris, Wildenstein Gallery, no. 28;
1958, Montpellier, Musée Fabre, no. 4; 1959,
Montpellier, Musée Fabre, no. 17; 1966, Washing-
ton, National Gallery of Art, no. 110; 1978,
Chicago, The Art Institute, no. 23.

BIBLIOGRAPHY:

Poulain 1932, no. 19; Sarraute 1950, no. 28;
Daulte 1952, p. 174, no. 21; cat. *Des primitifs à
Nicolas de Staël*, 1958, no. 4; exhibition cat. 1959,
p. 15, no. 17; Rewald 1973 (4th ed.), p. 184;
Marandel 1978, no. 23; Near, in *Apollo*, December
1985, no. 286; Daulte 1991, p. 162, no. 23.

"I shall leave Paris once I finish a small interior of my studio," wrote Bazille in May 1867 to his father, who was pressing him to return to Montpellier for the summer.[1] Bazille had taken possession of a studio at No. 20, rue Visconti, two blocks from the École des Beaux-Arts in Paris, in July 1866, and would keep it until December 1867. In February 1867, he had described to his mother the crowded condition of his studio: "Monet has come from out of the blue with a collection of magnificent canvases, which will be highly successful at the Exposition. With Renoir, that makes two needy painters I'm lodging,…which I find enchanting. I have plenty of room, and they're both very cheerful."[2] But when he returned to Paris the following fall, he found the studio too small: "Despite what Mama says, I am definitely going to change studios. I don't have enough room here on rue Visconti."[3]

Several of the paintings that appear in the studio have been identified: to the left of the chimney, *Scoter-Duck* of 1864, by Bazille (private collection); above, framed, Monet's *Rue de Village en Normandie* (Museum of Fine Arts, Boston). Sarraute proposes to identify two paintings at right as Bazille's *Young Italian Street Singer* (private collection) and *Young Woman with Lowered Eyes* (cat. 47), both undated.[4] At the far left, on an easel, we see the edge of a large framed painting. According to Marandel, this might be Bazille's *Terrace at Méric* (fig. 57; Geneva, Petit Palais), which had just been refused at the Salon of 1867.[5]

Apart from the documentary interest of the depicted paintings, this empty interior resonates with the presence of the artist: as Pierre Georgel so aptly describes it, it exists in the present tense, unlike most artists' depictions of empty studios, which evoke retrospective reveries. D.P.

NOTES

1. Cited by Poulain 1932, pp. 83–84; Sarraute 1948,
pp. 40, 45–46, author's translation.
2. Marandel 1978, no. 56, p. 173; correspondence,
1992, no. 88 [late February 1867].
3. Marandel 1978, no. 67, p. 177; correspondence,
1992, no. 95 [late 1867].
4. Sarraute 1950, nos. 20, 28.
5. Marandel 1978, p. 64.

14 STILL LIFE WITH HERON

1867

Le Héron

oil on canvas, h. 100; w. 79

s.d.b.l.: F. Bazille 67

Montpellier, Musée Fabre

inv. 898.5.2

PROVENANCE:

Family of the artist. Gift of Mme Gaston Bazille, the artist's mother, to the Musée Fabre, 1898.

EXHIBITIONS:

1927, Montpellier, Exposition internationale, no. 9; 1939, Paris, Musée de l'Orangerie, no. 3; 1939, Berne, Kunsthalle, no. 3; 1941, Montpellier, Musée Fabre, no. 24; 1950, Paris, Wildenstein Gallery, no. 38; 1954, Rotterdam, Museum Boymans Van Beuningen, no. 96; 1959, Montpellier, Musée Fabre, no. 25; 1974, Bordeaux, Galerie des Beaux-Arts, no. 85; 1971, Montpellier, Musée Fabre; 1978, Chicago, The Art Institute, no. 24; 1991, Bordeaux, Musée des Beaux-Arts, no. 46; 1991, Montpellier, Musée Fabre.

BIBLIOGRAPHY:

Joubin 1926, no. 360; Baderou, Faré 1939, p. 17; Poulain 1932, no. 26; Gillet 1935, no. 241; Poulain in *Itinéraires*, November 1942, p. 27; Claparède in *Languedoc méditerraneen...*, 1947, p. 237; Sarraute 1948, no. 27; Sarraute 1950, no. 38; Wildenstein in *Arts*, no. 266, June 9, 1950, p. 8; Daulte 1952, p. 179, no. 32; Daulte in *Connaissance des arts*, no. 60, February 1957, p. 48; exhibition cat., 1959, p. 17, no. 25; cat.Rotterdam, 1954, pp. 81–82; Rewald 1973 (4th ed.), p. 182; cat. 1874: *naissance de l'impressionisme*, 1974, no. 85; Daulte 1978 in *l'Oeil*, p. 43; Marandel 1978, no. 24; Lassaigne-Gache-Patin 1983, p. 158; cat. *Cent chefs-d'oeuvre*, 1988, p. 182; cat. *Trophées de chasse*, 1991, no. 46; Daulte 1991, p. 168, no. 35; Jourdan 1991, pp. 16–21, fig. 17.

The tradition of the *"trophée de chasse,"* or hunting trophy, such as the one painted by Bazille in 1867 and before him by Monet in 1862, in his *Hunting Trophy and Accessories with a Dog* (Paris, Musée d'Orsay), dates back to the sixteenth century, and since then the genre has been much favored by western painters. But as Olivier Le Bihan has noted, in the nineteenth century this theme was of only passing interest to young artists like Bazille, Sisley, and Monet.[1] Bazille painted this *Still Life with Heron* at the same time as Sisley executed his version of the same subject (fig. 15; Montpellier, Musée Fabre). The fact that Renoir, who shared the rue Visconti studio with Bazille, painted him at his easel working on this painting (fig. 14) symbolizes well the friendships established among the future Impressionists between 1865 and 1879, and their tendency to paint similar subject matter, often out of financial necessity and for lack of models, which were expensive. Bazille was already complaining about this in a letter dating from the last weeks of 1866, in which he begged his parents to allow him to hire a model so he wouldn't be condemned to paint "everlasting still lifes."[2] The heron hangs by one of its feet from a table visible at the back, against which a rifle is leaning. In contrast with Monet, who brought together, on a marble entablature, a pheasant, some woodcocks, baby woodcocks, and various accessories of the hunt, Bazille concentrates his composition on the bird — the pale gray heron, almost in the center of his canvas, its wings spread wide over a brilliant white cloth on which have been placed some jays and a magpie. The painting is executed in a cameo palette of browns, beiges, whites, and grayish blues. Only the more intense blue passages in the jay's wings introduce a livelier note into this still life, which is characterized by a marked simplicity of means and great subtlety of touch. Gaston Bazille, who was a great lover of duck hunting (the artist executed a small painting for him on this theme [*The Scoter-Duck*, private collection]), placed this work in his study: "It's some birds, a heron hanging from a nail and some jays on the top of a buffet. The canvas is a bit higher than it is wide and could go between the two windows of my study if there's enough light there," Gaston Bazille wrote to his wife on December 23, 1868.[3] He took the painting against the artist's own wishes. Bazille subsequently wrote to his mother: "Papa wanted to force a still life out of me, which I found most disagreeable. I very much hope you won't hang it in a place where strangers could see it."[4] A.J.

NOTES

1. Cat. *Trophées de Chasse*, 1991, p. 56.
2. Marandel 1978, no. 55, p. 203; correspondence, 1992, no. 86 [between November 21 and December 15, 1864].
3. Cited By Sarraute 1950, no. 38.
4. Marandel 1978, no. 72, p. 207; correspondence, 1992, no. 113 [late December, 1864].

15 Porte de la Reine at Aigues-Mortes

1867

oil on canvas

h. 80.6; w. 99.7

s.d.b.r.: F. Bazille 1867

New York, The Metropolitan
Museum of Art

PROVENANCE:

Collection of Mme Brunel. Mme Jules Castelnau.
Collection of Henri Cazalis. Wildenstein Gallery,
New York; Alan Clore, Paris. Sale at Christie's,
London, June 27, 1988, to The Metropolitan
Museum of Art, New York.

EXHIBITIONS:

1927, Montpellier, Exposition internationale, no.
13; 1941, Montpellier, Musée Fabre, no. 20; 1950,
Paris, Wildenstein Gallery, no. 31; 1959, Montpel-
lier, Musée Fabre, no. 20; 1978, Chicago, The Art
Institute, no. 21; 1984, Lausanne, Fondation de
l'Hermitage, no. 24; 1986, Edinburgh, National
Gallery of Scotland, no. 75.

BIBLIOGRAPHY:

Poulain 1932, no. 20; Sarraute 1950, no. 31;
Daulte 1952, p. 175, no. 23; Daulte 1970, in
Connaissance des Arts, p. 87; Daulte 1971, in *Réal-
ités*, p. 32, no. 279; Champa 1973, p. 86, fig. 121;
Marandel 1978, p. 62, no. 21; Jourdan 1985, p.
67; Howarth 1986, pp. 518 ff., fig. 1; Tinterow
1989, p. 34; Pitman 1989, pp. 83–84; Daulte
1991, p. 164, no. 26.

The medieval walled city of Aigues-Mortes
near Montpellier would have attracted Bazille
for several reasons. As a landmark of local and
Protestant history, it drew the attention of
those around him: for example, Jules Pagézy,
mayor of Montpellier (under whom the artist's
father served as assistant), and, later, senator,
whom Bazille visited in Paris. By the 1850s,
Pagézy had assembled for publication a num-
ber of documents concerning Aigues-Mortes.[1]
The city also offered an ideal motif for a
painter in love with sunlight but unwilling to
relinquish solid form: pale stone walls in
Mediterranean sun. Bazille had already had
the idea of painting at Aigues-Mortes a year
earlier, in 1866, but he let his parents per-
suade him to put it off because of the
unhealthiness of the marshes during an out-
break of cholera.[2] In June 1867, he finally
arrived at Aigues-Mortes. "I have begun three
or four landscapes of the area around Aigues-
Mortes," he wrote to his mother. "In my large
canvas, I am going to do the walls of the city
reflected in a pond at sunset. This will be a
very simple painting, which should not take
long to do. Nevertheless I would need at least
eight beautiful days."[3]

None of the three paintings of Aigues-
Mortes that survive includes a sunset; in each
we find an open, spacious composition and
an even, light tonality. Here Bazille shows the
east wall of the city in the afternoon shadows,
which form a broad, cool, luminous zone in
which a few humans and animals appear. A
flow of sunlight erupts suddenly within this
space, coming toward us through the open
gate of the city and given substance by the
thick, smooth paint — a fascinating first oc-
currence of the sunlit background and shaded
foreground which reappeared in almost all of
the painter's large landscapes with figures. D.P.

NOTES

1. Jules Pagézy, *Mémoires sur le port d'Aigues-Mortes*, 2
volumes (Paris: Hachette, 1879, 1866). As the preface
explains, most of the documents had been collected by
1852.
2. Correspondence cited by Poulain 1932, pp. 67–68;
Sarraute 1948, pp. 30, 49; Daulte 1952, p. 53.
3. Marandel 1978, no. 64, p. 176; correspondence,
1992, no. 94 [May 1867].

FIGS. 40, 41, 42

Studies of Horses

charcoal on paper, h. 25; w. 35

Paris, Musée du Louvre, département
des Arts graphiques, sketchbook
RF 5259, fols. 21 recto,
22 recto, 23 recto

FIG. 39

Study of a Child

charcoal on paper, h. 25; w. 35

Paris, Musée du Louvre, département
des Arts graphiques, sketchbook
RF 5259, fol. 43 recto

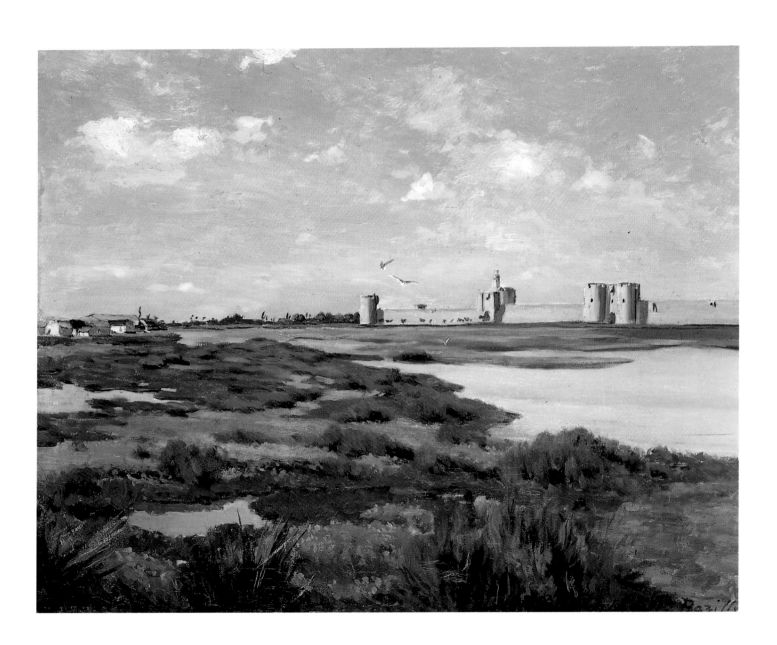

FIGS. 43, 44, 45

Studies of *Aigues-Mortes*

charcoal on paper

h. 25; w. 35

Paris, Musée du Louvre,

département des Arts

graphiques, sketchbook

RF 5259, fols. 10 recto,

11 recto, 31 recto

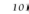

16 AIGUES-MORTES

1867

oil on canvas

h. 46; w. 55

s.b.r: à M. Fioupiou,

son ami F Bazille

Montpellier, Musée Fabre,

inv. 56.13.1

PROVENANCE:

Collection of Joseph Fioupiou. Collection of Léon
Deshons. Acquired by the Musée Fabre in 1956.

EXHIBITIONS:

1950, Paris, Wildenstein Gallery, no. 33; 1959,
Montpellier, Musée Fabre, no. 22; 1971, Montpel-
lier, Musée Fabre; 1974, Bordeaux, Galerie des
Beaux-Arts, no. 84; 1977, Montpellier, Musée
Fabre; 1978, Chicago, The Art Institute, no. 22;
1985, Montpellier, Musée Fabre, no. 37.

BIBLIOGRAPHY:

Poulain 1932, p. 221; Poulain 1947, in *Arts de
France*, pp. 122–23, nos. 17–18; Planche 1949, p.
127; Sarraute 1950, no. 33; Daulte 1952, p. 176,
no. 25; Exhibition cat., 1959, p. 16, no. 22;
Champa 1973, p. 86, fig. 122; cat. *1874: Naissance
de l'impressionisme*, 1974, pp. 122–23, no. 84;

Daulte 1978, in *l'Oeil*, p. 42; Bazin 1982, p. 20; Bordes, Jourdan 1985, no. 37; Daulte 1991, p. 165, no. 28.

The many preparatory studies for *Aigues-Mortes*, in a sketchbook preserved in the graphic arts department in the Louvre (RF 5259), provide ample documentation of Bazille's interest in this subject in June of 1867. The work in the Musée Fabre, the third of his *Aigues-Mortes* landscapes, is organized very much like that in the National Gallery of Art in Washington, *The Western Ramparts at Aigues-Mortes* (fig. 46), for which the artist made two compositional studies (fols. 10–11) and three studies of the boats moored at the right (fol. 31, fig. 49). In these two works, the ramparts of the medieval town emerge from water and marshlands between earth and sky. In the Montpellier painting, for which there are also sketches (fols. 27–29, 34; figs.

43–45), they appear on the right, viewed from the south, beyond the blue lagoon and a green expanse of clumps of rushes and reeds. Bazille accords prominence to the open space, treating the walls as distant structures. Some white, gray, and pink cabins appear slightly closer on the left, while in the distance the tops of poplars and umbrella pines on the seaward side can be made out. The painting creates an impression of controlled grandeur, of horizontal breadth and equilibrium that recalls the work of the Provençal painter Paul Guigou, whom Bazille knew from the Café Guerbois. Here, too, the Mediterranean light reinforces the compositional structure and the perspective. The work is dedicated to Joseph Fioupiou, assistant at the Finance Ministry in Paris, a bibliophile and informed collector of drawings and prints who belonged to the Parisian circle of Bazille and Maître. A.J.

FIG. 46

The Western Ramparts at Aigues-Mortes

oil on canvas

h. 62; w. 110

s.b.l.: F. Bazille

Washington, National Gallery of Art, Collection of Mr. and Mrs. Paul Mellon, inv. PM 1324

FIGS. 47, 48, 49
Studies for
Aigues-Mortes
charcoal on paper
h. 25; w. 36
Paris, Musée du Louvre,
département des Arts
graphiques, sketchbook
RF 5259

FIG. 50

Compositional study for

The Family Gathering

charcoal on paper

h. 20; w. 28

Paris, Musée du Louvre,

département des Arts

graphiques, RF 5258

17 Study for
THE FAMILY
GATHERING

1867

Étude pour la

Réunion de famille

charcoal and pencil on paper

h. 30; w. 30

Paris, Musée du Louvre,

département des Arts graphiques,

fonds du Musée d'Orsay

inv. RF 5257

PROVENANCE:

Collection of André Joubin. Given by André Joubin to the Cabinet des dessins of the Louvre in 1921.

EXHIBITIONS:

1948, Berne, Kunsthalle, no. 120; 1959, Montpellier, Musée Fabre, no. 45; 1963, Lausanne, Musée Cantonal, no. 3; Aarau, Aangauerkunsthaus, no. 98; 1978, Chicago, The Art Institute, no. 27; 1987, Paris, Musée d'Orsay, no. 5.

BIBLIOGRAPHY:

Genges 1929, fig. LXII, pl. XLXXV; Danète 1932, no. 20, pl. 196; Poulain 1932, p. 222; Daulte 1952, p. 196; Marandel 1978, no. 27; Daulte 1991, p. 130.

The graphic arts department of the Louvre preserves two preparatory studies for *The Family Gathering*, on separate sheets (RF 5257 and 5258), the more summary of which, in heavy charcoal lines, includes nine figures in a grouping quite different from the one used in the final painting (fig. 50). In one of the artist's sketchbooks, also in the Louvre (RF 5259), Marandel identified no fewer than nine studies for *The Family Gathering*, some of them for the overall composition (fols. 52 recto and 62 verso; figs. 51, 52) and others of hands (fols. 38 recto, 48 verso; figs. 53, 56) or of individual figures — Mme Bazille, Camille des Hours-Farel (fol. 36 recto; fig. 55), and Marc Bazille (fol. 32 recto; fig. 54) — this last executed at Aigues-Mortes in June, as is indicated by a note elsewhere (fols. 5 recto, 36 recto, 32 recto) — as well as a self-portrait of the artist (fol. 39 recto), and certain accessories (fol. 28). The study exhibited here shows a composition almost identical to that in the painting. The figure placement is more or less the same: the artist's parents seated in the left foreground, behind them Bazille and his uncle M. des Hours-Farel, in the center Mme des Hours-Farel seated in front of a round table, the Teulons standing behind her, Thérèse des Hours-Farel also standing (differing in this from the canvas), and Marc and Suzanne Tissié at the far right, turned towards one another. Only Camille des Hours-Farel is absent. The dog in the foreground, which added a note of intimacy, does not appear in the final version. A.J.

FIG. 55

Portrait of

Camille des Hours

(Bazille's cousin)

charcoal on paper, h. 25; w. 35

Paris, Musée du Louvre,

département des Arts

graphiques, sketchbook

RF 5259 fol. 36 recto

FIGS. 51, 52

Studies for

The Family Gathering

charcoal on paper, h. 25; w. 35

Paris, Musée du Louvre,

département des Arts

graphiques, sketchbook

RF 5259, fols. 52 recto,

62 verso

FIG. 54

Portrait of Marc Bazille

(the artist's brother)

charcoal on paper, h. 35; w. 25

Paris, Musée du Louvre,

département des Arts

graphiques, sketchbook

RF 5259 fol. 32 recto

FIG. 53

Study of crossed hands for the

figure of Thérèse des Hours in

The Family Gathering

charcoal on paper, h. 25; w. 35

Paris, Musée du Louvre,

département des Arts

graphiques, sketchbook

RF 5259 fol. 38 recto

FIG. 56

Study of the hands of

Émile Teulon for

The Family Gathering

charcoal on paper, h. 25; w. 35

Paris, Musée du Louvre,

département des Arts

graphiques, sketchbook

RF 5259 fol. 48 verso

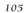

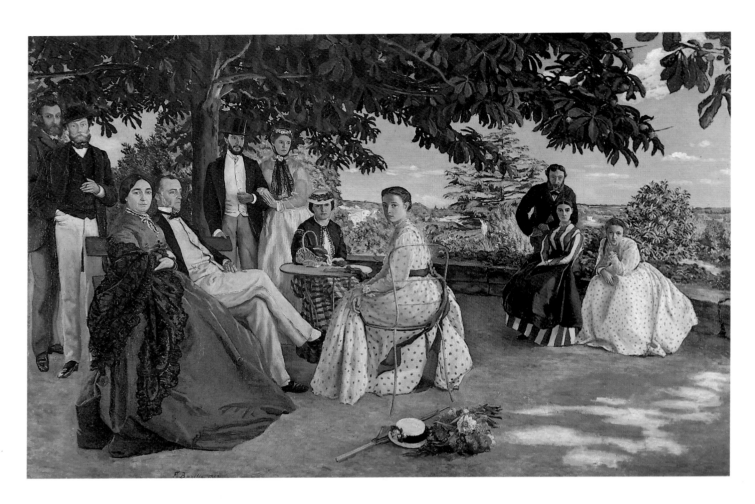

18 THE FAMILY GATHERING

1867

Réunion de famille

oil on canvas, h. 152; w. 227

s.d.b.l.: F. Bazille 1867

Paris, Musée d'Orsay, inv. RF 2749

PROVENANCE:

Collection of Marc Bazille. Acquired with the participation of Marc Bazille for the Luxembourg Museum in 1905. Entered the Musée du Louvre in 1929. Jeu de Paume in 1947. In the Musée d'Orsay since 1986.

EXHIBITIONS:

1868, Paris, Salon, no. 146; 1910, Paris, Salon d'Automne, no. 10; 1923, Paris, Salon d'Automne, no. 2348; 1927, Montpellier, Exposition internationale, no. 8; 1941, Montpellier, Musée Fabre, no. 23; 1950, Paris, Wildenstein Gallery, no. 36; 1954, London, Tate Gallery, no. 51; 1957, Paris, Musée Jacquemart-André, no. 7; 1974, Bordeaux, Galerie des Beaux-Arts, no. 83; 1978, Chicago, The Art Institute, no. 28.

BIBLIOGRAPHY:

Zola 1868, cited in *Zola*, Paris, 1974, p. 114; Bénédite 1924; Masson 1927, p. 13; Focillon 1928, p. 211; Poulain 1932, no. 23; Gillet 1935, pp. 239–41; Romane-Musculus 1938, pl. XVI; Huyghe 1950, p. 204; Sarraute 1950, no. 36; Daulte 1952, p. 178, no. 29; Sterling, Adhémar 1958, vol. I, pl. XIV; Praz 1971, pp. 134, 253, fig. 291; cat. *Peintures*, Musée du Louvre, French school vol. I, 1972, p. 26; Adhémar, Dayez 1973, p. 139; Champa 1973, p. 87, pl. 24; Rewald 1973 (4th ed.), p. 177; Alexandrian 1974, p. 12, no. 5; Huyghe 1974, p. 117, no. 102; Serullaz 1974, p. 65; cat. *Naissance de l'impressionisme*, 1974, no. 83; Marandel 1978, no. 28; Bazin 1982, p. 241; Compin, Roquebert 1986, vol. III, p. 49; Laclotte 1986, pp. 79–81; Mathieu 1986, p. 76; Pitman 1989, pp. 21–23, 53–59; Rosenblum 1989, p. 227; Lacambre, Roquebert 1990, vol. I, p. 46; Daulte 1991, p. 166, no. 32; Lacave 1991, p. 11, fig. 3.

"Before closing," Zola wrote in his review of the 1868 Salon, "I will say a few words about two canvases I deem worthy of discussion next to those of Claude Monet. In the same room, close to the latter's seascape, is a painting by Frédéric Bazille, *Portrait of the *** Family*, which bears witness to a strong love of truth. The figures are grouped on a terrace, in the soft shade of a tree. Each face has been stud-

ied with extreme care, each figure has the appropriate attitude. One sees that the painter loves his own time, like Claude Monet, and that he thinks one can be an artist even if one paints frock-coats. There is a charming group in the canvas, the group of the two young women sitting on the edge of the terrace." The painting had been begun at Méric early in the summer of 1867, with the intention of submitting it for the Salon of that year. It would require almost eight months of work. With this ambitious composition, prepared with great care, as the many preparatory studies attest, Bazille attempted a large-scale depiction of figures in the open air, as Monet had done in his *Déjeuner sur l'herbe* and *Women in the Garden* (Paris, Musée d'Orsay). These two works, and Monet's problems in conceiving and executing them, were well known to Bazille: not only had he shared his studio in the rue de Furstenberg with Monet in 1865, he had also posed for the first painting, and owned the second. Kermit Champa has emphasized in this connection that Bazille was the first of his generation to try to combine group portraiture with plein air figure painting.[1] Regarded as the painter's major work, even his masterpiece,[2] the scene brings together the Bazille and des Hours-Farel families on the terrace at Méric, in the shade of a chestnut tree that no longer exists. From left to right: the artist, standing beside his uncle Eugène des Hours-Farel; his parents, Camille and Gaston Bazille; in the center, Mme des Hours-Farel and her daughter Thérèse (the model for *The Pink Dress* of 1864); behind Mme des Hours-Farel, Émile Teulon and his wife Pauline, née des Hours-Farel; and to the right, seated on the low wall of the terrace, with Marc Bazille standing beside them, Suzanne, Marc's young wife, and Camille des Hours-Farel, who had not been included in the preparatory studies. The participants in this scene (none of whom would be the subject of individual portraits by Bazille, in contrast with his Parisian friends) look toward the viewer, with the exception of Gaston Bazille, seen in

profile, and the Teulon couple. The multiplicity of fixed stares and a certain stiffness in the poses give this family grouping an aura of imposing solemnity and formality. Bazille abandoned the spontaneity of the preparatory drawings, in which the face-to-face placement of some of the figures created a relaxed, familiar quality similar to that in *Oleanders* (Cincinnati Art Museum) and the *Terrace at Méric* (Fig. 57), painted a year earlier, in which he evoked the intimate family life of a middle-class Montpellier family. The rejection of the *Terrace at Méric* for the 1867 Salon having made him cautious, the following year Bazille decided to submit, in addition to the family portrait, a second painting belonging to Lejosne. Much to his surprise, *The Family Gathering* was accepted. "My two canvases have been accepted for the Salon. Almost all my friends were refused. Monet among others had only one of his two canvases accepted. Mine just slipped through the net, I don't

know how, probably by mistake. The X… Family will be in the exhibition, I hope it will be noticed, and received with open arms."[3] His wish was to be granted by the critic J. Ixe, a native of Montpellier, in his review of the Salon (*Journal de Montpellier*, May 23, 1868; see article by G. Barral). A.J.

NOTES

1. Champa 1973, p. 97.
2. Sarraute 1950, no. 36.
3. Marandel 1978, no. 66; correspondence, 1992, no. 105 [mid-August 1868].

FIG. 57

The Terrace at Méric

oil on canvas

h. 97; w. 128

s.d.b.r.: F Bazille 1867

Geneva, Musée du Petit-Palais

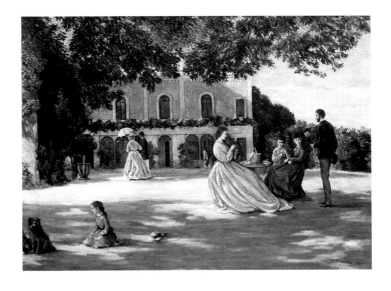

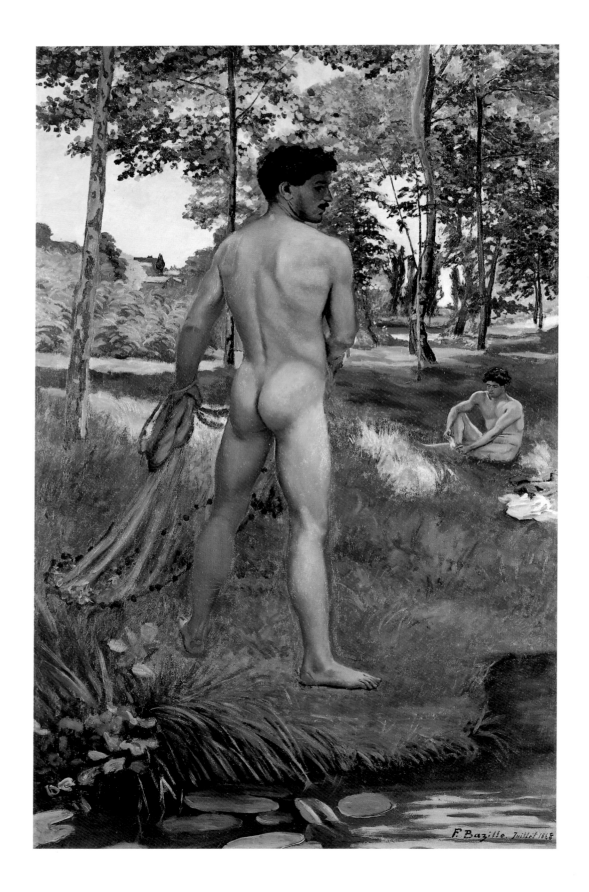

FIG. 58

Study for

Fisherman with a Net

pencil on paper

h. 35; w. 25

Paris, Musée du Louvre,

département des Arts graphiques,

sketchbook

RF 5259, fol. 64 recto

19 FISHERMAN WITH A NET

1868

Le Pêcheur à l'épervier

oil on canvas

h. 134; w. 83

s.d.b.r.: F. Bazille juillet 1868

Zurich, Rau Foundation

for the Third World

PROVENANCE:

Family of the artist. Collection of Mme Rachou-Bazille. Collection of Jean Davray. Auctioned on June 23, 1961, at the Palais Galliera in Paris. Private collection.

EXHIBITIONS:

1910, Paris, Salon d'Automne, no. 15; 1927, Mont-pellier, Exposition internationale, no. 19; 1939, Liège; 1950, Paris, Wildenstein Gallery, no. 40.

BIBLIOGRAPHY:

Poulain 1932, no. 28; Sarraute 1950, no. 40; Daulte 1952, p. 180, no. 35; Cooper 1963, p. 255; Champa 1973, p. 89, fig. 126; Marandel 1978, p. 77, no. 32 (not exhibited); Pitman 1989, pp. 86–88; Daulte 1991, p. 169, no. 38.

This canvas was painted in the summer of 1868; a study for it is included in one of the Louvre sketchbooks (fig. 58). It was submitted for the 1869 Salon with *View of the Village*, but was refused. Here is the artist on the judgment of his friends: "Some prefer the Italian girl, others the male nude."[1] And on the circumstances of its rejection: "The jury made quite a massacre of the canvases by the four or five young painters of our circle. Only one of my canvases was accepted: the woman."[2]

This canvas was painted on the banks of the Lez, a small strip of which, with water lilies, is visible in the foreground. A nude man, seen from the back, prepares to throw a net; his figure is a particularly successful study of the male anatomy. A second man, sitting on the ground a bit farther back, is almost finished undressing; this figure is less skillfully executed. The rays of the sun passing through the trees cast their irregular patterns of light over both the bodies and the grass. This painting is visible on the wall of the *Studio on the rue La Condamine*, where it is prominently hung. Marandel has suggested that this painting was of particular interest to Suzanne Valadon, who represented a similar subject in her painting *The Casting of the Net* (1914, Paris, Musée National d'Art Moderne). D.V.

NOTES

1. Marandel 1978, no. 71; correspondence 1992, no. 115 [mid-February 1869].
2. Marandel 1978, no. 74; correspondence 1992, no. 119 [April 9, 1869].

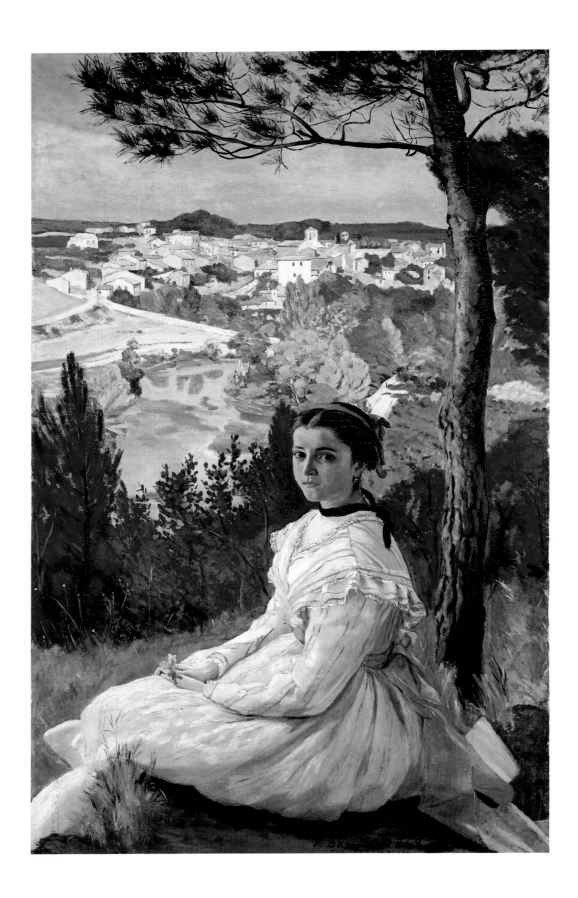

20 VIEW OF THE VILLAGE

1868

La Vue de village

oil on canvas, h. 130; w. 89

s.d.b.c.: F. Bazille 1868

Montpellier, Musée Fabre

inv. 898.5.1

PROVENANCE:

Collection of Gaston Bazille, the artist's father.
Given by Mme Gaston Bazille to the Musée Fabre
in 1898.

EXHIBITIONS:

1869, Paris, Salon, no. 149; 1900, Paris,
Exposition centennale, no. 22; 1910, Paris, Salon
d'Automne, no. 14; 1927, Montpellier, Exposition
internationale, no. 17; 1935, Paris, Association des
étudiants protestants, no. 18; 1939, Paris, Musée
de l'Orangerie, no. 4; 1939, Berne, Kunsthalle, no.
4; 1941, Montpellier, Musée Fabre, no. 25; 1948.
Brussels, Palais des Beaux-Arts, no. 104; 1950,
Paris, Wildenstein Gallery, no. 41; 1959, Montpel-
lier, Musée Fabre, no. 29; 1971, Montpellier,
Musée Fabre; 1974, Bordeaux, Galerie des Beaux-
Arts, no. 86; 1974, Paris and New York, Grand
Palais and The Metropolitan Museum of Art, no. 1;
1978, Chicago, The Art Institute, no. 30; 1985,
Montpellier, Musée Fabre, no. 38; 1991, Montpel-
lier, Musée Fabre.

BIBLIOGRAPHY:

Joubin 1926, no. 361; Gillet 1935, no. 241;
Poulain 1932, no. 29; Daulte 1952, p. 180, no. 36;
exhibition cat., 1959, p. 17, no. 29; Champa 1973,
pp. 88–89, fig. 125; Rewald 1973 (4th ed.), p.
223; cat. *Impressionism: A Centenary Exhibition*,
1974–75, no. 1, pp. 37–39; Marandel 1978, no.
30; Bordes, Jourdan 1985, no. 38; cat. *Cents Chefs-
d'oeuvre*, 1988, p. 184; Pitman 1989, pp. 66–76;
Daulte 1991, p. 170, no. 39; Jourdan, de Grasset
1991, pp. 22–31, fig. 25; Saunier n.d., p. 192.

Berthe Morisot wrote to her sister Edma Pon-
tillon, in a letter dated May 1, 1869, about
View of the Village, which she'd seen at the Sa-
lon: "The tall fellow Bazille has done
something I find quite good: it's a young girl in

a very light dress, in the shade of a tree beyond
which one sees a village. He's trying to do
what we have so often attempted, to place a
figure in the open air: this time it seems to me
he's succeeded."[1]

In *View of the Village*, Bazille took up once
more, in reverse, the original motif of the
preparatory drawing for *The Pink Dress*,

FIGS. 59, 60, 61

Studies for View of the Village

charcoal on paper

h. 35; w. 25

Paris, Musée du Louvre,

département des Arts

graphiques, sketchbook

RF 5259 fols. 52 verso,

53 verso, 54 verso

painted four years earlier, for which his cousin
Thérèse had posed. Here the model was the
daughter of an employee of the Bazille family.
The young woman, serious and a bit stiff in
her Sunday raiment, poses in a white dress
belted by a wide pink sash. She is seated at
the foot of a tree, against the light, holding
some flowers. The site is in the Bel-Air woods,
at the end of the Méric property, where a steep
incline in the terrain creates a view of the vil-
lage of Castelnau flooded with light. There are
three charcoal sketches for *View of the Village*
in one of the artist's sketchbooks preserved in
the Cabinet des dessins of the Louvre (RF
5259). They reveal the stages of the composi-
tion's evolution. The traditional procedure of

squaring for transfer facilitated their use in organizing the different levels of the landscape in the upper section, which are much as in the final painting. Each of these studies focuses on a principal component of the subject — the landscape background (fol. 52 verso; fig. 59), the young woman in the foreground (fol. 53 verso; fig. 60), and the tree (fol. 54 verso; fig. 61) — rendering it with great concision and economy. Bazille noticeably modified the pose of his model, adopting a solution which Champa has associated with a work by Monet, *The River* (Chicago, The Art Institute). The young woman's pose more closely resembles that of Thérèse des Hours in *The Family Gathering*, painted a year before on the terrace at Méric. In his comparison of Bazille's work with the one by Monet, Champa also emphasized the lack of homogeneity between the foreground figure and the landscape. This is largely the result of a faulty handling of perspective. Bazille devised a composition that is classical and logical: an effect of spatial recession is created through use of successive levels of depth and orthogonal lines. But he skewed the perspective by placing the horizon line and the bed of the Lez too high in the composition. The river should be lower, almost invisible. He made the landscape seem closer by disposing it in successive vertical bands and by refusing to employ aerial perspective. The light of Languedoc inundates the village of Castelnau, accentuating the rigor of its architecture. What sets Bazille apart from Monet is readily apparent here: an interest in line and form that remain solid, with the brilliant, ever-changing light of the Midi creating zones of light and shadow that reinforce the painting's structure and suggest space.

The painting was submitted for the Salon of 1869, along with *Fisherman with a Net*. The painter Alfred Stevens, who had admired *View of the Village* in the artist's studio, wrote to Bazille to inform him that his painting had been accepted by the jury: "My dear Bazille, your painting of the woman is accepted; I am happy to convey this good news to you. You were defended (between us) by Bonnat and… can you guess who else? By Cabanel."[2] This astonished the young painter: "The jury made quite a massacre of the canvases of the four or five young painters of our circle. Only one of my canvases was accepted: the woman. Aside from Manet, whom they no longer dare refuse, I am one of the least badly treated. Monet was completely refused. What gives me pleasure is that there's real animosity towards us. It was M. Gérôme who did us in, he described us as a band of madmen, and declared he felt it was his duty to do everything he could to prevent our paintings from appearing. All that's not so bad, when I've made a really good painting it will just have to be seen. I was defended, to my great astonishment, by Cabanel."[3] A.J.

NOTES

1. Cat. *Impressionism: A Centenary Exhibition*, 1974, p. 37.
2. Cited by Daulte 1952, p. 75.
3. Poulain 1932, p. 147; Daulte 1952, p. 75; Marandel 1978, no. 74, p. 207; correspondence, 1992, no. 119 [April 9, 1869].

21 VIEW OF THE VILLAGE

1868

La Vue de village

etching

h. 24; w. 16.2

Monogram b.c.: FB.

Montpellier,

Musée Fabre

PROVENANCE:

Given by Gabriel Sarraute to the Musée Fabre in 1987.

BIBLIOGRAPHY:

Daulte 1952, p. 181; Marandel 1978, p. 74; Bailly-Herzberg 1985, p. 22; Pitman 1989, p. 35.

This, the only known print by Frédéric Bazille, was undoubtedly executed in 1868. Marandel indicates that about fifty impressions were pulled after the artist's death. In 1951, the artist's family authorized the pulling of six more from the original copper plate, which had survived. Two of these were bestowed as gifts, one to Jean Claparède for the Musée Fabre and the other to Gabriel Sarraute, who donated his impression to the museum in 1987. A.J.

22 FLOWERS

1868

Fleurs

oil on canvas, h. 130; w. 97

s.d.b.c.: F. Bazille 1868.

Grenoble, Musée de Peinture

et de Sculpture

PROVENANCE:

Collection of M. and Mme Teulon, the artist's cousins. Given by M. Teulon to the Musée des Beaux-Arts in Grenoble in 1940.

EXHIBITIONS:

1868, Paris, Salon, no. 147; 1910, Paris, Salon d'Automne, no. 11; 1927, Montpellier, Exposition internationale, no. 14; 1935, Paris, Association des étudiants protestants, no. 16; 1950, Paris, Wildenstein Gallery, no. 37; 1959, Montpellier, Musée Fabre, no. 24; 1978, Chicago, The Art Institute, no. 33; 1979, Paris, Musée du Petit-Palais, no. 58; 1982, Saint-Tropez, Musée de l'Annonciade, no. 4.

BIBLIOGRAPHY:

Poulain 1932, no. 25; Schmidt in *Le Semeur*, June 1935; Sarraute 1950, no. 37; Daulte 1952, pp. 178–79, no. 30; exhibition cat., 1959, p. 17, no. 24; Marandel 1978, no. 33; Daulte 1991, p. 167, no. 33.

This large painting of flowers has been mistakenly assumed to be the one exhibited in the 1868 Salon along with *The Family Gathering*. In fact, the painting of flowers in that exhibition was the one Bazille painted for his Lejosne cousins in 1866, *Flower Pots* (private collection). A critical notice penned by a Montpellier native signing himself J. Ixe, published in the *Journal de Montpellier* of May 25, 1868, and recently discovered by Guy Barral, removes all doubt on this point. The Grenoble *Flowers* was also intended for relatives of Bazille, his cousins Pauline and Émile Teulon. Dianne Pitman has correctly emphasized the painter's attraction to flowers, which he depicted in pots and in vases, arranged by young women, or still in the garden, as Monet had suggested to him in August 1864;[1] Bazille also refers to them as subjects several times in his

correspondence. While in 1866 Bazille painted some pots of flowers on the floor in a corner of the greenhouse at Méric, two years later he chose to dispose them carefully in a more elegant decor; perhaps he had taken account of the remarks made by J. Ixe, who criticized the arbitrary, haphazard character of the composition of *Flower Pots* as well as its dark background and insensitive handling. The simple clay pots and wrapping paper have been replaced by a large white faience vase with a blue ornamental motif resting on a console table with a white marble top. A stool with tapestry upholstery is between the table's legs in the foreground. The later composition is more complex and majestic. As Daulte has noted, Bazille here juxtaposes, in apparent disorder, flowers arranged in the vase and others scattered over the table, some of their branches hanging over its edge at the right. He thus fills the entire space with floral luxuriance, which is skillfully played off against the pattern on the stool, executed in complementary reds and greens that repeat the basic colors of the central bouquet. A.J.

NOTE 1. Wildenstein 1974, vol. I, no. 9.

23 PORTRAIT OF EDMOND MAÎTRE

1869

oil on canvas

h. 84; w. 65

s.d.t.l.: F. Bazille 1869

Washington, National
Gallery of Art
inv. 1985.64.2

PROVENANCE:

Collection of Edmond Maître. Collection of André Bazille. Collection of Mme Rachou-Bazille. Collection of Mr. and Mrs. Paul Mellon.

EXHIBITIONS:

1927, Montpellier, Exposition internationale, no. 25; 1935, Paris, Association des étudiants protestants, no. 6; 1937, Paris, Palais de Tokyo, no. 240; 1941, Montpellier, Musée Fabre, no. 29; 1950, Paris, Wildenstein Gallery, no. 50; 1952, Paris, Galerie Charpentier, no. 1; 1959, Montpellier, Musée Fabre, no. 34; 1966, Washington, National Gallery of Art, no. 111; 1978, Chicago, The Art Institute, no. 37.

BIBLIOGRAPHY:

Blanche in *l'Art Vivant*, July 1927, p. 607, no. 61; Poulain 1932, no. 33; de Laprade in *Beaux-Arts*, March 29, 1935, p. 8; Blanche 1949, pp. 123–25; Sarraute 1950, no. 50; Daulte 1952, p. 185, no. 47; exhibition cat., 1959, p. 19, no. 34; Daulte in *Connaissance des arts*, December 1970, p. 90, no. 266; Marandel 1978, no. 37; Daulte 1991, p. 176, no. 52.

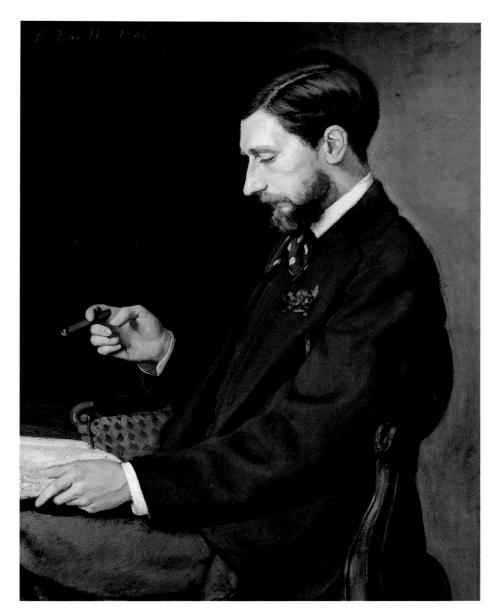

"I have started to do another portrait of Maître to replace the one I gave him two years ago, and which I find simply too bad," wrote Bazille to his mother on January 1, 1869.[1] In the earlier *Portrait of Edmond Maître*, of which only a fragment survives (private collection), Bazille's best friend stared straight outward; here, he sits tranquilly in an armchair, absorbed in a book. The austerity of the profile, the plain gray background, and the solemnity of his expression recall Holbein's portrait of Erasmus in the Louvre, cited the summer before (i.e., in

1868) by Bazille's and Maître's friend the critic Zacharie Astruc as one of three masterpieces of portraiture to be seen in Paris.[2] In Bazille's second portrait of Maître, certain casual touches suggest intimacy. Maître's hand, holding a cigar, is somewhat absentmindedly poised in midair, while a bright blue flower in his lapel adds a lively note to an otherwise subdued color scheme. D.P.

NOTES

1. Marandel 1978, no. 72, p. 179; correspondence, 1992, no 114 [January 1, 1869].
2. Zacharie Astruc, "Salon de 1868 aux Champs-Élysées," *L'Étendard,* 29 July 1868. Astruc ranks Holbein's painting with the *Mona Lisa* and David's *Madame Récamier*.

24 Study for SUMMER SCENE (BATHERS)

1869

Projet pour la *Scène d'été*

charcoal and brown ink on cream
paper, h. 30.4; w. 23.5

Paris, Musée du Louvre, département
des Arts graphiques, fonds du Musée
d'Orsay, inv. RF 29731

PROVENANCE:
Family of the artist. Given by Frédéric Bazille, the
artist's nephew, to the Musée du Louvre in 1949.

EXHIBITIONS:
1955, Paris, Cabinet des dessins du Louvre, no.
55; 1959, Montpellier, Musée Fabre, no. 47; 1962,
Mexico City, Museo de Ciencias y Arte; 1978,
Chicago, The Art Institute, no. 42.

BIBLIOGRAPHY:
Dorival in *Bulletin des musées de France*, May 1949,
no. 4, pp. 94–96. fig. 3; Sarraute in *Bulletin des
musées de France*, May 1949, pp. 92–93, no. 4, fig.
2; Daulte 1952, pp. 196–97, no. 22; Exhibition
cat, 1959, p. 24, no. 46; Marandel 1978, no. 42;
Daulte 1991, p. 148.

The second drawing given to the Louvre by
Frédéric Bazille, the artist's nephew, in 1949,
at the same time as the study for *The Pink
Dress*, is this study in charcoal and ink for
Summer Scene (*Bathers*) in the Fogg Museum at
Harvard. Thanks to the many preparatory
drawings in one of the artist's sketchbooks (RF
5259, fols. 7 recto, 25 recto, 37 recto, 39
verso, 40 recto; figs. 63–67) and this loose
sheet, the evolution of this unusual work has
now been clarified. This drawing is the only
known study of the entire composition. Its
square format is like that of the finished paint-
ing (all the other studies are horizontal), but
the composition differs from that of the can-
vas. There are seven figures instead of eight,
and only four of them — the wrestlers, the fig-
ure in the left foreground, and the young man
reclining in the grass — are placed as in the
painting. As Gabriel Sarraute has noted, the
bather seated on the bank at left, testing the
water with his foot, does not yet have the pose
of a Saint Sebastian.[1] The group at right is not
present here, and Bazille suppressed one of the
bathers to the left. He placed the man who is
undressing close to the row of poplars in the
background. Outside the bottom line indicat-
ing the frame is the annotation "1.60 m,"
which specifies the dimensions of the paint-
ing, and a study for the swimmer seen from
the back in the foreground. On the back of the
sheet there is a portrait of a bearded man,
which some critics have thought was a self-
portrait of the artist. Dorival, in his 1949
study of the drawing, emphasized the work's
influence on Cézanne, whose series of male
and female bathers it prefigures.[2] A.J.

NOTES
1. Sarraute 1949, p. 93.
2. Corival 1949, no. 4, pp. 94–96.

FIG. 63-67 (clockwise)

Studies for *Summer Scene*

(*Bathers*)

charcoal on paper

h. 25; w. 35

Paris, Musée du Louvre, département

des Arts graphiques, sketchbook

RF 5259, fols. 7 recto, 25 recto,

37 recto, 39 verso, 40 recto

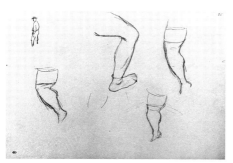

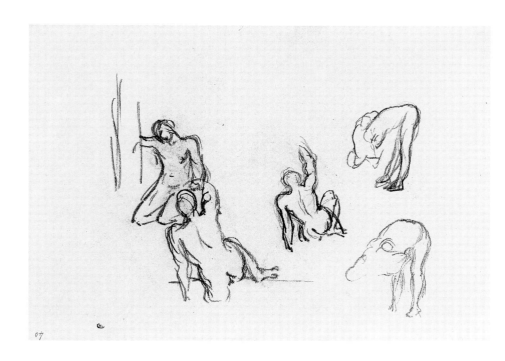

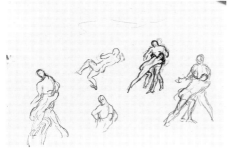

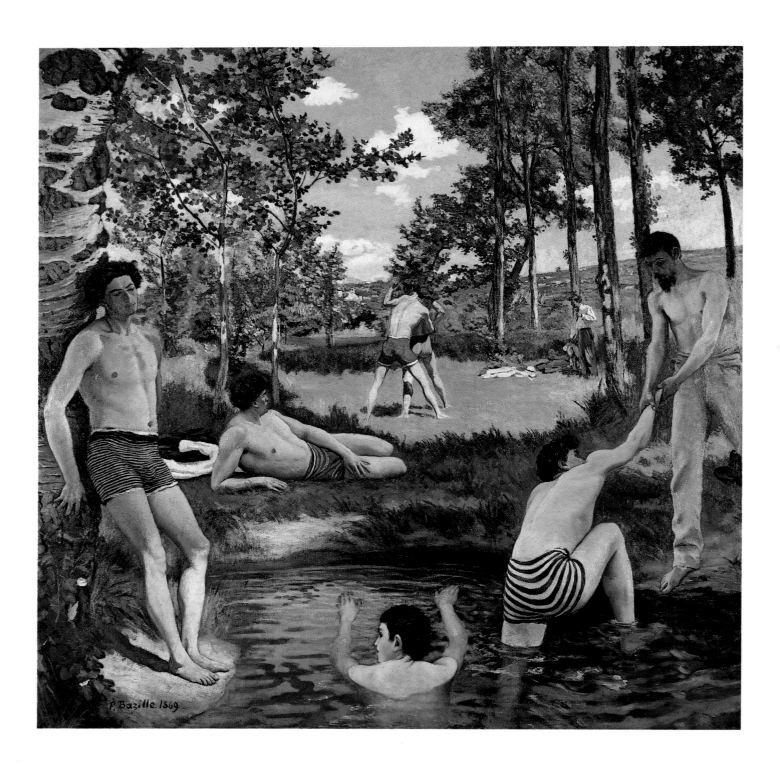

25 SUMMER SCENE (BATHERS)

1869, *Scène d'été*

oil on canvas, h. 158.2; w. 158.8

s.d.b.l.: F. Bazille 1869

Cambridge, Harvard University Art

Museums, The Fogg Art Museum

inv. 1937.78

PROVENANCE:

Family of the artist. Collection of Meynier de Salinelles. Given by M. and Mme F. Meynier de Salinelles to the Fogg Museum in 1937.

EXHIBITIONS:

1870, Paris, Salon; 1910, Paris, Salon d'Automne, no. 19; 1927, Paris, Exposition internationale, no. 23; 1937, Paris, Galerie des Beaux-Arts, no. 55; 1937, Boston, Institute of Fine Arts; 1940, New York, World's Fair, no. 32; 1950, Paris, Wildenstein Gallery, no. 46; 1978, Chicago, The Art Institute, no. 43.

BIBLIOGRAPHY:

Poulain 1932, no. 36; *Fogg Art Museum Bulletin*, vol. VII, no. 1, 1937, p. 15; (anon.), *Art News* XXXVI.9.27, November 1937, p. 19; (anon.) 1938; Scheyer in *Art Quarterly*, spring 1942, pp. 127–28; Tietze, GBA, July-December 1944, vol. XXV; Dorival in *Bulletin des musées de France*, May 1949, no. 4, pp. 94–96; Sarraute 1950, no. 46; Daulte 1952, p. 184, no. 44; Courthion 1964, no. 25; Muehsam 1970, pp. 491–92; Aldernam 1972; Courthion 1972, p. 166; Daulte, in *l'Oeil*, 1972; Champa 1973, pp. 89–90, pl. 23; Rewald 1973 (4th ed.), p. 234; cat. *Caillebotte*, 1976–77, p. 84; Marandel 1978, no. 43; Le Pichon 1983, p. 112; Jones, *Harvard University Art Museums* 1985, p. 30, fig. 15; Le Pichon 1986, p. 78; Thomas 1987, p. 118; Thomson 1988, pp. 26–27; Pitman 1989, pp. 89–90, 106–20, 149–57; Dolan in GBA, February 1990, p. 101, fig. 3; Daulte 1991, p. 175, no. 49.

Spurred no doubt by the refusal at the Salon of his *Fisherman with a Net* (cat. 19), in April 1869, Bazille began making sketches for a painting for the following year. "I shall not waste my time between now and then," he wrote to his father, to justify remaining in Paris. "I am drawing in advance the figures for the painting of nude men that I plan to do at Méric."[1] In the summer of 1869, Bazille painted most of the canvas, which apparently gave him much trouble. "If I'm obliged to stop," he complained to a friend, "I shall arrive in Paris with a single painting, which you may find atrocious; I don't know where it's going. This is my nude men."[2] Retouched and relined the following winter, the painting appeared at the Salon of 1870 under the title *Summer Scene*, while Bazille in his letters called it simply "the bathers" or "the nude men." The painting depicts a party of young men relaxing and amusing themselves on the banks of the river Lez. A range of activities from passive to almost aggressive, and a range of natural lighting effects from full sunlight to semitransparent water, fill out this complex space.

Bazille's last Salon painting, *Summer Scene* was the best received, praised by a few knowing critics as the very depiction of freshness and sincerity (see my essay in this catalogue). Modern commentators, however, have been put off by the undeniable strangeness of this painting. Instead of acknowledging the viewer with direct gazes, as do the figures in *The Family Gathering* (cat. 18) and *View of the Village* (cat. 20), here the young men stubbornly and rather awkwardly avert their gazes, refusing also any emotional communication among themselves.

According to Champa, the bathers' comportment reveals the artist's homosexual tendencies.[3] Adding to the strangeness are the quotations or reminiscences of paintings by the old masters that many observers have found in this painting: for example, the posture of the figure leaning on a tree at left seems to be borrowed from the martyr Saint Sebastian,[4] and that of the reclining figure on the river bank recalls a classical river god. We can propose two specific visual sources: the *Saint Sebastian* attributed to Jacopo Bassano in the Musée des Beaux-Arts of Dijon, which Bazille visited in the fall of 1868, and the reclining shepherd in the *Landscape with Shepherd Playing a Flute* by Laurent de La Hyre, long in the collection of the Musée Fabre.[5] The unexpected symmetry of the composition, the unusual square format, and the richness of the colors also serve as reminders of the art of the Renaissance, and seem to defy the principle of painting everyday reality that Bazille had up until then followed. It is as if Bazille were impossibly trying to discover in his own world something of the grandeur and detachment of the old masters. D.P.

NOTES

1. Marandel 1978, no. 75, p. 207; author's translation; correspondence, 1992, no. 120 [May 2, 1869].
2. Cited by Poulain 1932, pp. 151–52; Daulte 1952, pp. 76–77; author's translation.
3. Champa 1978, p. 110.
4. Another Saint Sebastian appears in a drawing by Bazille: Louvre, département des Arts graphiques, RF 5259, fol. 62 verso.
5. *Catalogue raisonné du Musée des Beaux-Arts de Dijon: Peintures Italiennes* (Dijon: Musée des Beaux-Arts, 1980), no. 13; Pierre Rosenberg et Jacques Thuillier, *Laurent de La Hyre 1606–1656, l'homme et l'oeuvre*, (Geneva: Skira, 1988), no. 239.

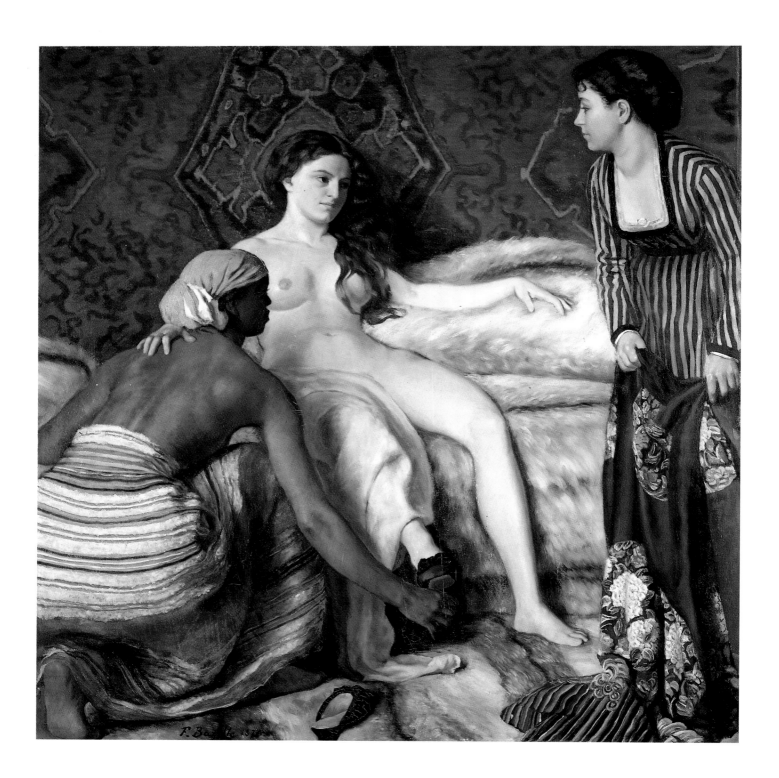

26 LA TOILETTE

1870

oil on canvas, h. 132; w. 127.

s.d.b.l.: F. Bazille 1870.

Montpellier, Musée Fabre

inv. 18.1.2

PROVENANCE:

Family of the artist. Collection of Marc Bazille, the artist's brother. Given by Marc Bazille to the Musée Fabre in 1918.

EXHIBITIONS:

1900, Paris, Exposition centennale, no. 23; 1910, Paris, Salon d'Automne, no. 20; 1927, Montpellier, Exposition internationale, no. 28; 1939, Paris, Musée de l'Orangerie, no. 7; 1939, Berne, Kunsthalle, no. 7; 1941, Montpellier, Musée Fabre, no. 36; 1950, Paris, Wildenstein Gallery, no. 53; 1959, Montpellier, Musée Fabre; 1978, Montpellier, Musée Fabre, no. 36; 1978, Chicago, The Art Institute, no. 54; 1991, Montpellier, Musée Fabre, no. 45; 1991–92, Montpellier, Musée Fabre.

BIBLIOGRAPHY:

Duret 1906, p. 11; Joubin 1926, no. 364; Poulain, in *La Renaissance de l'art français*, April 1927, p. 163; Focillon 1928, p. 212; Poulain 1932, no. 41; Gillet 1935, pp. 241–42; Bazin 1947, p. 162; Claparède in *Languedoc méditerranéen…*, 1947, p. 237; Poulain in *Itinéraire*, November 1947, p. 27; Sarraute 1950, no. 53; Daulte 1952, pp. 187–88, no. 50; Exhibition cat., 1959, p. 19, no. 35; Champa 1973, p. 90, fig. 127; Rewald 1973 (4th ed.), p. 253; Marandel 1978, no. 54; cat. le Nu, 1978, no. 36; Van Liere 1980, p. 110; Le Pichon 1986, p. 174; cat. *Cent Chefs-d'oeuvre*, 1988, p. 188; Honour 1989, p. 207; Pitman 1989, pp. 120–31; Daulte 1991, p. 178, no. 55; Jourdan 1991, no. 45; Jourdan 1991–92, pp. 16–21, fig.15.

Hanging on the wall at the back of the *Studio on the rue La Condamine* (fig. 19), at right, we see the rough sketch of a painting of two women: a white nude leans on a sofa and supports herself on the shoulder of a partially clad black woman. A drawing in Bazille's sketchbook shows the same conception (RF 5259 fol. 2 recto; fig. 68), with a third figure in the

margin prefiguring the addition of the attendant at right in the final painting. This is *La Toilette*, which Bazille painted between December 1869 and March 1870, and which he describes to his mother in several letters, making reference to "a ravishing model who is going to cost me an arm and a leg"[1] and "a superb black woman."[2] As many commentators have pointed out, the figure at right, whose costume adds a contemporary note to an otherwise exotic scene, bears a strong resemblance to Lise Tréhot, Renoir's companion and model.

Why did Bazille choose this subject? The theme of women at their baths, and the allied subject of nudes of different races in oriental or orientalizing settings, were mainstays of French painting. Bazille approaches the subject rather differently, evidently attempting to bring together several different strands of the old and the modern traditions. If in certain aspects *La Toilette* seems to honor Manet's *Olympia*, the overall effect is very different: the women seem withdrawn into themselves, lost amidst the rich colors and varied textures of the surrounding fabrics — like the women in Delacroix's *Women of Algiers*, of which Bazille would have known both the version of the Louvre and that of the Bruyas collection at the Musée Fabre. He seems also to draw upon paintings of the old masters: a Veronese (see cat. 52) and Rembrandt's *Bathsheba*, given to the Louvre the year before and extensively praised by Bazille's friend Zacharie Astruc.[3] In fact, both the Delacroix and Rembrandt were perceived by many of Bazille's contemporaries as examples of "pure painting," offering an alternative to both the journalistic pictures of the Realists and the anecdotal and pseudo-documentary scenes of the popular orientalists.[4]

Although the artist's friends praised it, and although it ranks among the most conventional of Bazille's paintings in terms of subject matter, *La Toilette* was refused by the jury of the Salon of 1870, which, however, accepted *Summer Scene* (cat. 25). "This is going to annoy you," he wrote to his mother; "as for me, you know what I've thought of the jury for a long time now. I have been in a very bad mood, but I am in no way discouraged."[5] However, he probably found the right explanation: "Self-pride aside, I fear that my other painting [*La Toilette*] was rejected by mistake."[6] D.P.

NOTES
1. Marandel 1978, no. 85, p. 209; correspondence, 1992, no. 130 [between January 13 and 19, 1870].
2. Marandel 1978, no. 83, p. 209; correspondence, 1992, no. 134 [February or early March, 1870].
3. Astruc 1870, May 29, p. 2.
4. Pitman 1989, pp. 124–125; see also the essay by Jean-Patrice Marandel in this catalogue.
5. Marandel 1978, no. 84, p. 209; correspondence, 1992, no. 138 [April 27, 1870].
6. Marandel 1978, no. 84, p. 209; correspondence, 1992, no. 138 [as after May 2, 1870].

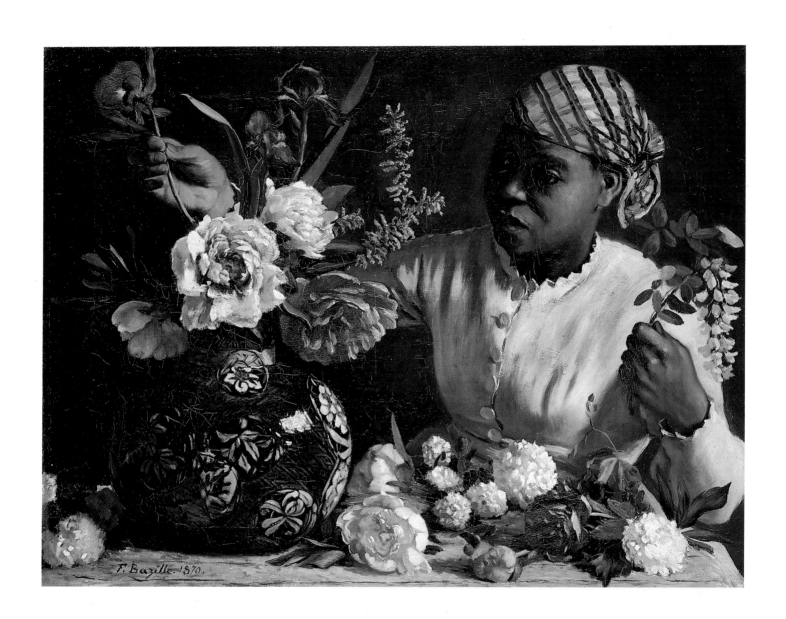

27 AFRICAN WOMAN WITH PEONIES

1870

Négresse aux pivoines

oil on canvas, h. 60; w. 75.

s.d.b.l.: F Bazille 1870

Montpellier, Musée Fabre

inv. 18.1.3

PROVENANCE:

Family of the artist. Collection of Marc Bazille, the artist's brother. Given by Marc Bazille to the Musée Fabre in 1918.

EXHIBITIONS:

1910, Paris, Salon d'Automne, no. 22; 1927, Montpellier, Exposition internationale, no. 29; 1931, Paris, Exposition coloniale; 1939, Paris, Musée de l'Orangerie, no. 6; 1939, Berne, Kunsthalle, no. 6; 1941, Montpellier, Musée Fabre, no. 34; 1950, Paris, Wildenstein Gallery, no. 54; 1959, Montpellier, Musée Fabre, no. 36; 1971, Montpellier, Musée Fabre; 1973, Paris, Musée des Arts Décoratifs; 1974, Bordeaux, Galerie des Beaux-Arts, no. 87; 1978, Chicago, The Art Institute, no. 55; 1979, Paris, Grand-Palais, no. 172; 1990, Osaka, K. Matsushita Foundation Museum, no. 39; 1991, Montpellier, Musée Fabre, no. 46; 1991–92, Montpellier, Musée Fabre.

BIBLIOGRAPHY:

Joubin 1929, no. 365; Poulain 1932, no. 39; Claparède in *Languedoc méditerranéen…*, 1947, p. 237; Sarraute 1950, no. 54; Daulte 1952, p. 188, no. 51; Bezombes 1953, p. 103, no. 303; cat. *Chefs-d'oeuvre du XIXᵉ siècle*, 1955, no. 2, p. 26, fig. 66; Courthion 1964, pl. 27; cat. *Équivoques*, 1973; cat. *1874: naissance de l'impressionisme*, 1974, no. 87; Marandel 1978, no. 55; cat. *The Second Empire 1852–1870…*, Philadelphia, 1978, no. VI–4; cat. *Cent Chefs-d'oeuvre*, 1988, p. 186; Honour 1989, p. 205; Pitman 1989, pp. 135–41; Munck 1990, p. 100, no. 39; Daulte 1991, p. 180, no. 59; Jourdan 1991, no. 46; Jourdan 1991–92, pp. 16–21, fig.16.

A black woman arranges flowers in a vase — no doubt the same woman that Bazille had already depicted the winter before in *La Toilette* (cat. 26). In another painting by Bazille of almost the same subject, known by the same title, the woman turns towards us to offer the flowers she carries in a basket (fig. 69); although long known as the second version, it appears to have been painted first, if one can believe the evidence of the earlier-blooming tulips and narcissi that appear in it.[1] In both versions, the flowers take precedence: their brighter colors and crisper facture cause the subdued tones and smoother forms of the woman to recede into the background. In his letters of the winter and spring of 1870, Bazille says nothing about a painting of a black women, but he does refer several times to the flowers that he plans to paint for Suzanne, the wife of his brother, Marc.[2] Sarraute suggests that the flowers for Suzanne may in fact be one or both of the *African Woman with Peonies* paintings, which came from the collection of the son of Suzanne and Marc Bazille, and which compare favorably in importance with the flowers that Bazille painted for his cousins the Teulons the previous year (cat. 22).[3] Reduced to a support for the flowers, the woman nonetheless retains an unmistakable patient dignity. D.P.

NOTES

1. Pitman 1989, p. 135.
2. Marandel 1978, nos. 78 [May 1870], 84 [May 18, 1870], 85 [January 18, 1870], and 86 [April 27, 1870]; correspondence, 1992, nos. 139, 138, 130, 137.
3. Sarraute 1948, pp. 109–10.

FIG. 69

African Woman with Peonies

(2nd version)

oil on canvas

h. 60; w. 74

s.d.b.l.: F Bazille 1870

Washington, National Gallery of Art, Collection of Mr. and Mrs Paul Mellon

inv. 2881

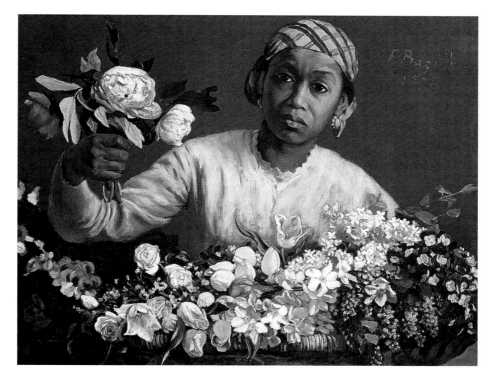

Studies for *Ruth and Boaz*

28 Study of RUTH

1870

Étude pour *Ruth*

Pencil and charcoal

h. 29; w. 36

Private collection

PROVENANCE:

Family of the artist. Collection of Frédéric Bazille.
Private collection

29 HEAD, ARM, AND BUST OF RUTH

1870

Téte, bras et buste de Ruth

charcoal on white paper

h. 60; w. 47

Inscription c.r.: "le bras moins
long" ("the arm less long").

Private collection

PROVENANCE:

Family of the artist. Collection of Frédéric Bazille.
Private collection.

EXHIBITIONS:

1878, Chicago, The Art Institute, no. 58.

BIBLIOGRAPHY:

Daulte 1952, p. 198, no. 31; Daulte 1991, p. 82;
Marandel 1978, no. 58.

30 Study of RUTH

1870

Étude pour *Ruth*

charcoal and pastel on paper

h. 21; w. 39

Private collection

PROVENANCE:

Family of the artist. Collection of Frédéric Bazille.
Private collection.

EXHIBITIONS:

1910, Paris, Salon d'Automne, no. 23; 1927, Mont-
pellier, Exposition internationale (no no.); 1941,
Montpellier, Musée Fabre, no. 33; 1950, Paris,
Wildenstein Gallery, no. 60; 1978, Chicago, The
Art Institute, no. 57.

BIBLIOGRAPHY:

Poulain 1932, p. 222; Sarraute 1950, no. 60;
Daulte 1952, p. 198; Marandel 1978, no. 57.

31 BUST OF RUTH

1870

Buste de Ruth

charcoal on paper

h. 12; w. 17

Private collection

PROVENANCE:

Family of the artist. Collection of Frédéric Bazille.
Private collection.

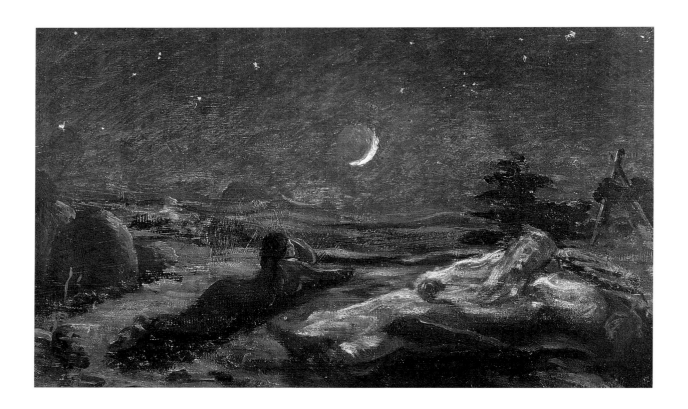

32 Sketch for RUTH AND BOAZ

1870

Équisse pour

Ruth et Booz

oil on wood

h 20; w. 32.5

Private collection

126

PROVENANCE:

Family of the artist. Collection of Frédéric Bazille. Private collection.

EXHIBITIONS:

1950, Paris, Wildenstein Gallery, no. 59.

BIBLIOGRAPHY:

Sarraute 1950, no. 59.

On August 2, 1870, Bazille wrote to Edmond Maître: "This solitude pleases me infinitely; it makes me work very hard, and read a lot. I have almost finished a large landscape, a study of a nude young man, the Ruth and Boaz is about half done"[1] (fig. 70). The subject of Ruth is from the Bible,[2] and it is the only religious theme Bazille painted. It was represented several times by French nineteenth-century painters, and Jean-François Millet probably had it in mind while conceiving his *Harvesters' Meal* (1853, Boston, Museum of Fine Arts). Cabanel, for his *Ruth*

and Boaz in the Musée Fabre (fig. 71), read Victor Hugo's *Légende des siècles*. In the Bible Ruth does not dream, but in Hugo:

> *Ruth dreamed and Boaz slept…*
> *The cedar does not sense*
> *the rose at its base,*
> *And he did not sense*
> *a woman at his feet.*

The "half-done" painting, incomplete at Bazille's death — it was painted in the summer of 1870, a few days before his enlistment (August 16) — is faithful to Hugo; Ruth's expression is consistent with his treatment, as are the prevailing gravity and solemnity, illuminated by a blue moonlight in which the artist has scrupulously represented "the crescent delicate and clear" (fig. 72). D.V.

NOTES

1. Daulte 1952, p. 81
2. *Old Testament*, Ruth, 3: Ruth passes the night at Boaz's feet.

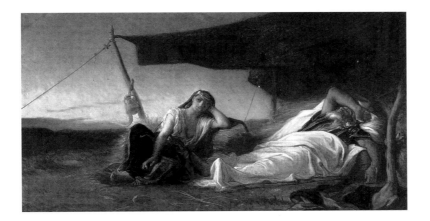

Undated Works

33 ACADEMIC HEAD

Tête académique

charcoal on paper

h. 25.5; w. 16.

Private collection

PROVENANCE:

Family of the artist. Collection of Frédéric Bazille.
Private collection.

This sketch must have been executed between
1862 and 1863 in Gleyre's studio in Paris, or
while the artist was taking courses in drawing
and modeling in Baussan's studio in Montpel-
lier between 1860 and 1862. It is not
mentioned by Daulte, unless it be one of the
"*croquis de plâtre, croquis divers, sujet de compo-
sition*" ("sketches of plasters, various sketches,
subject of composition"; nos. 1 to 4 in his
1952 catalogue). His failure to indicate the di-
mensions of these drawings makes certainty
on this point difficult. Perhaps it is the
"sculpted head" listed by Gabriel Sarraute in
the catalogue of the exhibition held at the
Wildenstein Gallery in Paris in 1950. The di-
mensions are markedly different, but the note
on the back of this work clearly indicates it has
been shown. This could not have been at the
1941 centenary exhibition in Montpellier, for
the notice published by Gaston Poulain on
that occasion makes no mention of it. A.J.

34 MALE NUDE

Académie d'homme

oil on canvas

h. 60; w. 43

Private collection

PROVENANCE:

Family of the artist. Private collection.

EXHIBITIONS:

1941, Montpellier, Musée Fabre, no. 40.

BIBLIOGRAPHY:

Poulain 1932, p. 222; Daulte 1952, p. 194, no. 7.

Bazille recounts that Charles Gleyre came to the studio twice a week and passed in front of each of his students, correcting their drawing and painting. From time to time he assigned a little subject which "everyone executes as best he can."[1] The students worked after the living model as well as after antique sculpture, in accordance with academic custom, in view of preparing themselves for the competitions. Painted studies such as this *académie* allowed the student to perfect his mastery of handling and color.

This rather vapid male nude, attributed to Bazille by Gabriel Sarraute, makes concessions to academic propriety at the expense of a more realist vision such as that of the *Male Nude* dated March 1863 (cat. 1). It bears a certain resemblance to the *académie* hanging on the wall at the upper left in the *Studio on the rue de Furstenberg* (cat. 8). But it would be rash to identify this painting as the one in the studio. The pose of the model is different: the arm is raised in the other direction, the figure holds a baton, and the feet are on the same level of depth. Bazille seems to have duplicated the works on his studio wall in 1865 with considerable accuracy: the portrait of Monet by Séverac (fig. 12) is perfectly recognizable, and it seems reasonable to suppose he would have been equally scrupulous in representing his own paintings. A.J.

NOTE

1. Marandel 1978. no. 4, p. 191; correspondence, 1992, no. 17 [before February 20, 1863].

35 MANET DRAWING

Manet dessinant

charcoal on paper

h. 29.5; w. 21.5

New York, The Metropolitan

Museum of Art

PROVENANCE:

Family of the artist. Collection of André Bazille.
Collection of Mme Rachou-Bazille. Galerie
Charpentier, sale of June 17, 1960, no. 30; The
Metropolitan Museum of Art, Robert Lehman
Collection, 1975.

EXHIBITIONS:

1935, Paris, Association des étudiants protestants,
no. 10; 1941, Montpellier, Musée Fabre, no. 42;
1950, Paris, Wildenstein Gallery, no. 52; 1959,
Montpellier, Musée Fabre, no. 47; 1976, New York,
The Metropolitan Museum of Art, no. 59; 1977,
New York, The Metropolitan Museum of Art; 1978,
Chicago, The Art Institute, no. 35; 1980, New
York, The Metropolitan Museum of Art, no. 3.

BIBLIOGRAPHY:

Poulain 1932, p. 222; Daulte 1952, p. 197, no. 24;
Sérullaz 1963, pl. 65; Sérullaz 1970, fig. 32; Bouil-
lon 1975, pp. 37–44; Marandel 1978, no. 35.

Elegant as always, in top hat and stiff collar,
leaning slightly backward, Manet concentrates
on a drawing on the easel in front of him.
Likewise, in Bazille's *Studio on the rue la Con-
damine* of 1870 (fig. 19), Manet stands in front
of an easel leaning backward slightly, as if sur-
prised by Bazille's painting. In this work, the
emphasized outlines, simplified and slightly
rounded forms, and the hatching and smudg-
ing that replace careful shading offer a good
example of Bazille's drawing style. Daulte as-
signs this drawing, without explanation, to
1869. Although he does not speak of the event
in his letters, Bazille probably met Manet in
the mid-1860s through his cousins the
Lejosnes. The two painters appear in Fantin-
Latour's *A Studio in the Batignolles Quarter* of
1870 (fig. 23), and each painted the portrait of
the other in Bazille's *Studio on the rue La Con-
damine* of the same year. Among Manet's

drawings, on a page with a charming drawing
of a cat, is written the Bazille family's address
in Montpellier.[1] But we have no firm evidence
for dating either their first meeting or this
study. D.P.

NOTE

1. *Manet 1832–1883* (New York: Abrams for The
Metropolitan Museum of Art, 1982), no. 112b.

36 MAN SUBDUING A BULL

Homme maîtrisant

un taureau

pencil and charcoal on paper

h. 11; w. 15

Montpellier, Musée Fabre,

 inv. 68.3.3

PROVENANCE:

Bequeathed by the abbé Vigroux to the Musée Fabre in 1968.

EXHIBITIONS:

1941, Montpellier, Musée Fabre, no. 43; 1978, Chicago, The Art Institute, no. 45.

BIBLIOGRAPHY:

Daulte 1952, p. 199, no. 35; Jourdan 1991–92, pp. 16–21, fig. 24; Marandel 1978, no. 45.

Sometimes referred to as *Corrida*, this drawing depicts a subject that is unexpected in Bazille's work. The original title is the best one, however, because this is not a scene from the bullring but rather an *abrivado*, or the subdu-ing of a young bull prior to its being branded. Bazille surely witnessed this activity at the Saint-Sauveur farm where his father raised cattle. The family was also interested in the Camargue bull races, which took place in the neighboring towns throughout the summer, as Gaston Bazille's correspondence attests. The nervous graphism of this drawing is an at-tempt to capture the impression of the struggle, the tension between man and beast. In one of the artist's sketchbooks (RF 5260) Marandel has identified a study for a farmhand subduing a horse (fol. 38) which is handled very similarly. A.J.

37 STUDY OF TREES

Étude d'arbres

oil on canvas, h. 41; w. 28

Private collection

PROVENANCE:

Family of the artist. Collection of Frédéric Bazille.
Private collection.

EXHIBITIONS:

1950, Paris, Wildenstein Gallery, no. 4; 1978,
Chicago, The Art Institute, no. 4; 1984,
Montpellier, Musée Fabre, no. 1.

BIBLIOGRAPHY:

Sarraute 1950, no. 4; Daulte 1952, p. 167, no. 1;
Marandel 1978, p. 37, no. 4; Daulte 1991, p. 153,
no. 1.

38 THE EDGE OF THE FONTAINEBLEAU FOREST

Lisière de Forêt à Fontainebleau

oil on canvas

h. 60; w. 73.

Paris, Musée d'Orsay, Jeu de Paume

inv. RF 2721

PROVENANCE:

Gift of Frédéric Bazille to Henri Fantin-Latour.
Given by Mme Fantin-Latour to the Musée de Lux-
embourg in 1905. Entered the Musée du Louvre in
1929. Jeu de Paume in 1947. In the Musée d'Orsay
since 1986.

EXHIBITIONS:

1910, Paris, Salon d'Automne, no. 5; 1936, Greno-
ble, Musée des Beaux-Arts, no. 505; 1970, Paris,
Musée Delacroix; 1980, Mont-de-Marsan, no. 23;
1982, Tokyo, Museum of Western Art, no. 30;
1984–85, Los Angeles County Museum of Art, The
Art Institute of Chicago, Paris, Grand Palais, no. 8.

BIBLIOGRAPHY:

Bénédite 1924, p. 226, no. 16; Masson 1927, p.
12; Poulain 1932, no. 9; cat. of the Musée de l'Im-
pressionisme, 1947, no. 22; Daulte 1952, p. 170,
no. 11; Bazin 1958, p. 273; cat. *A Day in the Coun-
try*, 1984–85, pp. 57–58; Pitman 1989, pp. 81–82.

Along with *Landscape at Chailly* (cat. 11), *The Edge of the Fontainebleau Forest* is one of artist's rare depictions of the landscape of the Île-de-France. During the Easter vacation in April 1863 Monet had brought him to the Fontainebleau Forest to paint after nature: "I have just, my dear mother, spent a very agreeable week," wrote Bazille. "As I've already told you, I spent eight days in the little town of Chailly near the Fontainebleau Forest. I was with my friend Monet, from Le Havre, who is rather good at landscape, he gave me some advice that helped me a lot. I worked very hard and I can show you my first paintings come August, there are six or seven of them. Two or

three aren't finished, I'll spend a few Sundays at Chailly to complete them. We stayed in the excellent Hôtel du Cheval Blanc where for 3 fr. 75 a day one is perfectly well fed and lodged. The forest is truly admirable in certain parts; we haven't any idea in Montpellier of such oaks. The rocks are less beautiful despite their great reputation, it isn't difficult to find more grandiose ones in the area around our city. I've promised myself to make an enormous number of studies over the vacation."[1]

The main sites painted in this period by Fontainebleau Forest landscapists staying at Chailly and Barbizon, villages scarcely two kilometers away, were Bas-Préau and the Apremont gorge. In *Edge of the Fontainebleau Forest*, the treatment and compositional structure reveal the influence of the Barbizon painters, particularly Diaz and Rousseau. The palette is dark; the light, so vibrant in *Landscape at Chailly*, is muted here, as is the very pale sky animated by light clouds; and the handling and facture are less rich. While Sarraute and Daulte date this landscape to 1865, when Bazille joined Monet to pose for the *Déjeuner sur l'herbe*, Dianne Pitman has proposed an earlier dating, and her hypothesis should be seriously considered. In 1865, Bazille did indeed go to Chailly to help out Monet, but he was impatient to return to Montpellier. The only documented work from this period is *The Improvised Field Hospital* (cat. 10). The bad weather that interrupted Monet and could hardly have encouraged open-air painting, the posing sessions, the brevity of the artist's sojourn, and the treatment, so different from the landscape securely dated to 1865, all suggest that the work is earlier. Should we then identify it as one of the six or seven landscapes executed during Bazille's first stay at Chailly in April of 1863, when he was full of enthusiasm for this forest "truly admirable in certain parts"? The dating of *Study of Trees* (cat. 37) is also problematic. Sarraute considers this to be one of the artist's earliest works, but does not suggest any specific site. It is perhaps worth noting here that after 1865 Bazille found his inspiration in the Midi, at Méric, the family property on which he painted *en plein air*, and in the surrounding landscape of Languedoc. A.J.

NOTE

1. Marandel 1978, no. 8, pp. 192–93; correspondence, 1992, no. 21 [April 8, 1863].

39,40 Studies for A GRAPE HARVEST

Études pour une Vendange

oil on canvas

h. 38; w. 92 (each).

Montpellier,

Musée Fabre,

inv. 18.1.4 and 18.1.5

PROVENANCE:

Family of the artist. Collection of Marc Bazille, the artist's brother. Given by him to the Musée Fabre in 1918.

EXHIBITIONS:

1910, Paris, Salon d'Automne, no. 16; 1927, Montpellier, Exposition internationale, no. 21; 1939, Paris, Musée de l'Orangerie, no. 5; 1939, Berne, Kunsthalle, no. 5; 1941, Montpellier, Musée Fabre, no. 31; 1950, Paris, Wildenstein Gallery, no. 43; 1959, Montpellier, Musée Fabre, no. 31; 1978, Chicago, The Art Institute, no. 34; 1986, Edinburgh, National Gallery of Scotland, no. 41; 1991, Montpellier, Musée Fabre.

BIBLIOGRAPHY:

Joubin 1926, no. 362; Poulain 1932, no. 35; Poulain in *L'Art et les artistes* 1934, p. 314; Baderou, Faré 1939, p. 19; Sarraute 1948, no. 31; Sarraute 1950, no. 43; Daulte 1952, pp. 181–82, no. 38; Exhibition cat., 1959, p. 19, no. 31; Marandel 1978, no. 34; Dejean 1984, p. 1; Daulte 1991, no. 41; Jourdan 1991, pp. 16–21, fig. 14.

During the fall of 1868, Bazille made several drawings of the grape harvest and began to make studies of vineyards in preparation for a large painting with figures which he was contemplating, thus using the traditional practice of executing small open-air studies in anticipation of a larger work. Judging from the number of active figures included in the preparatory sketches (RF 5259, fols. 6, 12, 17 and 40; figs. 73–76), this composition, which would never be realized, was ambitious. In his

sketchbook, he referred to it as either the "large grape harvest" or the "small grape harvest" (fol. 67 verso). In his correspondence, the artist mentions only one painting, which was at Méric: "I intend to work very hard at Méric, I'm even sketching a painting here so I'll have only to finish it there. Don't forget this. The next time you go to Méric," he wrote to his mother in mid-February 1869, "obtain exact measurements of the canvas on which I've started the grape harvest, and send them to me within a centimeter of accuracy, I need to know this to arrange this painting."[1] Is the sketch in question the second study of vineyards, painted at the beginning of 1869 in Paris? The two studies that are candidates for this identification, identical in format, are now framed together. Or did Bazille begin a larger painting, a "large grape harvest," which is now lost, as Sarraute and then Claparède have supposed? In resolving to treat such a scene, Bazille would certainly have remembered the success that greeted paintings of this theme by Daubigny and Jules Breton in the Salon.[2] But he was also directly inspired by having witnessed similar scenes in the Midi, for Gaston Bazille kept vineyards at Saint-Sauveur and at Méric. Here Bazille represents the slope of the Launac plain, with the la Gardiole mountain in the background as seen from the property of the Tissiés, Marc Bazille's in-laws, at Bionne near Montpellier. Such harvesting scenes would have been sufficiently familiar to the artist for him to have finished the second sketch of vineyards from memory in Paris, between January and February of 1869. Thus Claparède's suggestion that the artist may have painted the two studies one after the other in Montpellier, to capture changes in the landscape under different lighting conditions, should be rejected. A.J.

NOTES

1. Marandel 1978, no. 71, p. 206; correspondence, 1992, no. 115 [mid-February 1869].
2. Cat. *Lighting up the Landscape*, 1986, pp. 47–48.

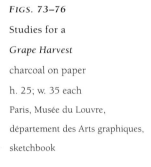

FIGS. 73–76

Studies for a

Grape Harvest

charcoal on paper

h. 25; w. 35 each

Paris, Musée du Louvre,

département des Arts graphiques,

sketchbook

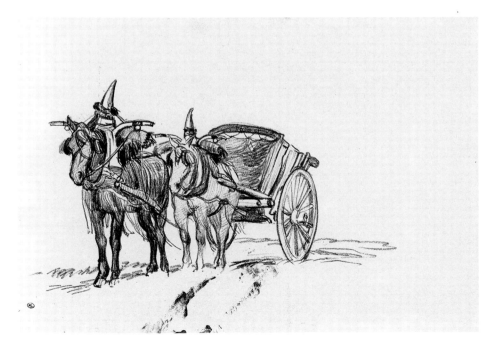

41 FRÉDÉRIC BAZILLE

Frédéric Bazille en chemise

oil on canvas

h. 46; w. 38

Private collection

PROVENANCE:

Family of the artist. Collection of Frédéric Bazille. Private collection.

EXHIBITIONS:

1950, Paris, Wildenstein Gallery, no. 26; 1959, Montpellier, Musée Fabre, no. 15; 1978, Chicago, The Art Institute, no. 24; 1984, Montpellier, Musée Fabre.

BIBLIOGRAPHY:

Sarraute 1950, no. 26; Daulte 1952, p. 189, no. 56; Marandel 1978, no. 24; Dejean 1984, p. 2; Daulte 1991, p. 181, no. 61.

Of all the presumed or authenticated self-portraits by Frédéric Bazille, this one is by far the most attractive. His face is striking in its youth — though it is difficult to date the work with any precision — and is set off against a background which is a mixture of Prussian and cobalt blue, with scattered touches of pink: as Dejean has written, "a veritable underbrush, nocturnal and hot, that makes the face, sparkling with joy, seem happier and more animated."[1] It is the image of a young man who is calm and serene, whose blue eyes fix on the viewer with a seductive appeal. Without his painter's attributes, present in the *Self-Portrait with Pallette* (cat. 42), devoid of the gloomy air in the *Frédéric Bazille at Saint-Sauveur* (cat. 43), Bazille here reveals another aspect of his ingratiating personality. D.V.

NOTES

1. X. Dejean, in the pamphlet for the exhibition held in Montpellier in 1984.

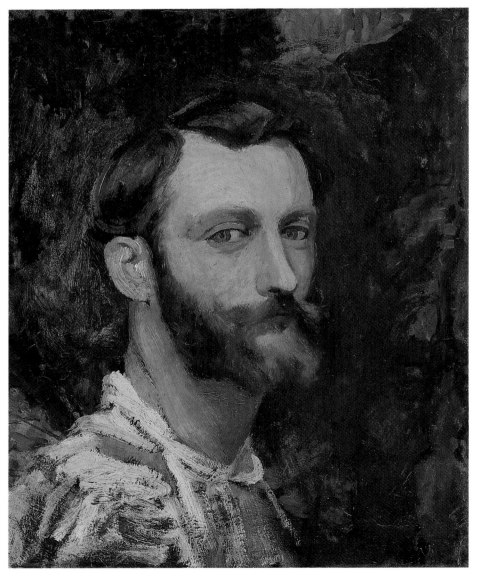

42 SELF-PORTRAIT WITH PALETTE

Frédéric Bazille à la palette

oil on canvas

h. 135; w. 80

Chicago, The Art Institute,

inv. 1962–336

PROVENANCE:

Family of the artist. Collection of André Bazille, then of Mme Rachou-Bazille. Galerie Charpentier, sale of June 17, 1960, no. 54. Wildenstein Collection. The Art Institute of Chicago, The Frank H. and Louise B. Woods Purchase Fund, in Memory of Mrs. Edward Harris Brewer.

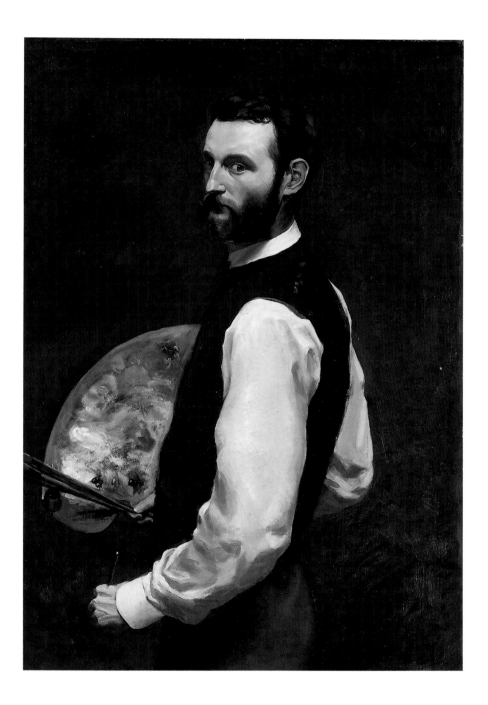

EXHIBITIONS:

1910, Paris, Salon d'Automne, no. 13; 1927, Mont-
pellier, Exposition internationale, no. 18; 1935,
Paris, Association des étudiants protestants, no. 5;
1941, Montpellier, Musée Fabre, no. 18; 1950,
Paris, Wildenstein Gallery, no. 16; 1958, Montpel-
lier, Musée Fabre, no. 3; 1959, Montpellier, Musée
Fabre, no. 9; 1960, Paris, Galerie Charpentier, no.
54; 1978, Chicago, The Art Institute, no. 25; 1980,
Albi, Musée Toulouse-Lautrec, no. 16; 1985, New
York, Wildenstein Gallery.

BIBLIOGRAPHY:

Poulain 1932, no. 17; Sarraute 1950, no. 16;
Daulte 1952, p. 170, no. 10; Maxon in *The Art In-
stitute of Chicago Quarterly*, 1963, vol. 57, pp.
22–24, no. 2; Wildenstein, GBA, February 1963, S.
6, vol. 61, pp. 40–41, no. 1129; Maxon in *Apollo*,
vol. LXXXIV, September 1966, p. 216; Trêves
1969, p. 14, no. 390; Trêves in *le Peintre*, no. 390,
October 1969, pp. 14–17; Sérullaz 1970, fig. 32;
Maxon 1977, p. 79; Fremantle in *Burlington Maga-
zine*, vol. 120, no. 900, September 1978, pp.
608–31; Marandel 1978, no. 13; cat. *100
Masterpieces*, Chicago, 1978, no. 45; Lassaigne,
Gache-Patin 1983, p. 158; Bonafoux 1986, p. 48;
Bretell 1987, pp. 74, 75, 117; Daulte 1991, p. 157,
no. 10.

Dated to 1865 by Sarraute and Daulte, this
self-portrait is puzzling: the sharp features and
receding hairline seem to belong to an older
person than Bazille, who was twenty-four that
year. In fact, it closely approaches his appear-
ance in Fantin-Latour's A *Studio in the
Batignolles Quarter* of 1869–70 (fig. 23). Sar-
raute also noted that both the father and the
brother of the artist dated the painting to
1867, the year retained also by Poulain.[1] That
date, or an even later one, seems more proba-
ble. Daulte underlines the influence on this
painting of Fantin-Latour's self-portrait of
1859 (Grenoble), which shows the artist in a
similar pose.[2] D.P.

137

NOTES

1. Sarraute 1948, no. 10, p. 20.
2. Daulte 1952, no. 10, p. 170.

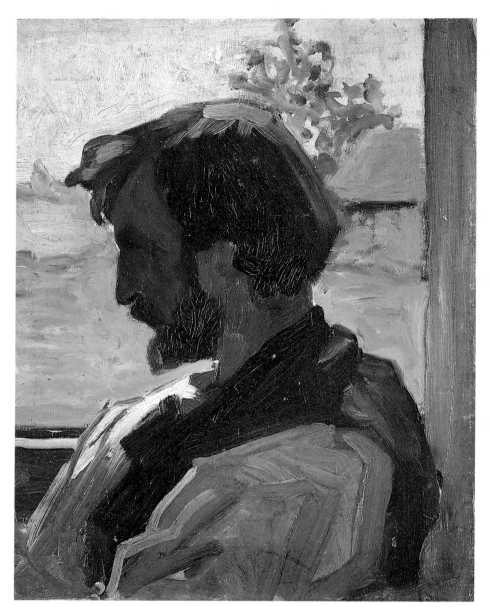

43 FRÉDÉRIC BAZILLE AT SAINT-SAUVEUR

before 1868

oil on wood

h. 40; w. 31

Montpellier, Musée Fabre

inv. 45.8.1

PROVENANCE:

Family of the artist. Collection of Frédéric Bazille, the artist's nephew. Given by Frédéric Bazille to the Musée Fabre in Montpellier in 1945.

EXHIBITIONS:

1950, Paris, Wildenstein Gallery, no. 42; 1959, Montpellier, Musée Fabre, no. 30; 1971, Montpellier, Musée Fabre; 1977, Montpellier, Musée Fabre, no. 57; 1978, Chicago, The Art Institute, no. 36; 1985, Lausanne, Musée Cantonal; 1991, Montpellier, Musée Fabre.

BIBLIOGRAPHY:

Sarraute 1950, no. 42; Daulte 1952, p. 181, no. 37; Dejean 1977, no. 57; Marandel 1978, no. 36; Daulte 1991, pp. 170–71, no. 40; Jourdan 1991, pp. 16–21, fig. 19.

This portrait has traditionally been ascribed to Frédéric Bazille. The family gave it to the Musée Fabre as a work by him in 1945; it was among the works rediscovered in an attic at Méric. Sarraute and Daulte date it to the summer of 1868, placing it at Saint-Sauveur, on the estate in the Lattes whose buildings they claim are recognizable in the background. But everything about this little portrait — the broad brushstrokes, very different from the smooth handling used by Bazille in some of his portraits, and the impossibility of the

artist's depicting himself in such extreme profile, even by means of a complex arrangement of mirrors — suggests that if the model is indeed Frédéric Bazille, it cannot be a self-portrait. Some writers have advanced Monet's name, and, given the close ties between the two men, it is altogether possible that he is the author. In that case, the background would represent not Saint-Sauveur at Lattes but the Saint-Siméon farm near Honfleur, situating this small painting prior to the summer of 1868. A.J.

44 PORTRAIT OF RENOIR

oil on canvas

h. 61; w. 50

Paris, Musée d'Orsay

inv. DL 1970.3

PROVENANCE:

Given by Frédéric Bazille to Auguste Renoir. Collection of Claude Renoir. Sold by him to the Musée des Beaux-Arts in Algiers in 1935. Placed

on deposit at the Louvre by the Algiers museum. At the Musée d'Orsay since 1986.

EXHIBITIONS:

1929, Cannes, Musée des Beaux-Arts, no. 5; 1950, Paris, Wildenstein Gallery, no. 51; 1982–83, Marseille, Musée Cantini, no. 1.

BIBLIOGRAPHY:

Poulain 1932, no. 18; Alazard 1939, p. 29, no. 1707, pl. XXXV; Sarraute 1950, no. 51; Daulte 1952, p. 175, no. 22; Rewald 1961, p. 203; Daulte in *Connaissance des arts*, December 1970, no. 226, p. 90; Champa 1973, p. 86, fig. 119; Bellory-Rewald 1977, p. 31; Daulte in *l'Oeil*, April 1978, no. 273, p. 40; Bazin 1982, p. 23; cat. *L'Orient des Provençaux*, 1982–83, p. 20, no. 1; Bonafoux 1986, p. 150; Daulte 1991, p. 163, no. 24.

This portrait would seem to be a response to *Frédéric Bazille at his Easel*, painted by Auguste Renoir in 1867 (fig. 14), and of which the latter said: "I even made a portrait of Bazille which had the luck to be noticed by Manet, who was however far from admiring what I did."[1] It is executed in cold tones against a blue, black, and white background, and its handling is nondescript. It has generally been dated to the winter of 1867. Seated on a chair, his knees drawn up against his chest, Renoir looks towards the left into the studio, which he scrutinizes intently. Bazille and Renoir both moved into a studio at number 20 on the rue Visconti on July 1, 1866. But Frédéric did not return from his vacation in Montpellier until November, and it was only in February of 1867 that he informed his parents of the presence in his studio of "needy painters." As a reminder, we note that Monet "appeared from out of the blue" a few weeks before the Salon of 1867. D.V.

NOTE

1. Ambroise Vollard, *Auguste Renoir*, 1920

45 PORTRAIT OF ALPHONSE TISSIÉ

oil on canvas

h. 58; w. 47

Montpellier, Musée Fabre

inv. 18.3.1

PROVENANCE:

Collection of Alphonse Tissié. Given by him to the Musée Fabre in 1918.

EXHIBITIONS:

1927, Montpellier, Exposition internationale, no. 22; 1941, Montpellier, Musée Fabre, no. 32; 1959, Montpellier, Musée Fabre, no. 32; 1971, Montpellier, Musée Fabre; 1978, Chicago, The Art Institute, no. 39; 1991–92, Montpellier, Musée Fabre.

BIBLIOGRAPHY:

Joubin 1926, no. 363; Poulain 1932, no. 37; Gillet 1935, p. 241; Sarraute 1948, pp. 4–76; Sarraute 1950, no. 44 bis; Daulte 1952, p. 182, no. 39; exhibition cat., 1959, p. 19, no. 31; Marandel 1978, no. 39; Daulte 1991, p. 171, no. 42; Jourdin 1991, pp. 16–21, fig. 18.

Alphonse Tissié, born on February 1, 1845, was the brother of Suzanne, the wife of Marc Bazille. He was also a childhood friend of the two Bazille brothers. After attending college in Paris, Alphonse pursued a military career. Despite Tissié's barracks life, the two Montpellier natives continued to see one another in Paris: "Sunday morning I was visited by Alphonse Tissié in a cavalryman's uniform, he looked superb and seemed quite content."[1] Such a remark reveals the painter's marked interest in uniforms. This cavalryman's outfit would allow him to elaborate a rich harmony of gray, blue, and red in this canvas.

A note glued to the back of the canvas indicates: "Incomplete sketch of a portrait of Alphonse Tissié by Frédéric Bazille, made in Paris in 1868." It would seem that these words are in the hand of Alphonse himself, who donated the painting to the Musée Fabre in 1918. While a date of 1868 is plausible for this work, it cannot be proven. The stretcher was purchased on April 8, 1863, as a stamp on it attests. Could it have lain unused for several years, or been used again? D.V.

NOTE

1. Marandel, p. 205, no. 65; correspondence, 1992, no. 100 [January 11, 1868].

46 PORTRAIT OF A MAN

Portrait d'homme

oil on canvas, h. 54; w. 46

Minneapolis, The Minneapolis
Institute of Arts (The John R.
Van Derlip Fund)

PROVENANCE:

Family of the artist. Collection of Frédéric Bazille.
Collection of Mme Hérisson. Acquired by
The Minneapolis Institute of Arts (The John
R. Van Derlip Fund).

EXHIBITIONS:

1950, Paris, Wildenstein Gallery, no. 25; 1959,
Montpellier, Musée Fabre, no. 14; 1962, New York,
Finch College Museum of Art, no. 2; 1972, New
York, Wildenstein Gallery; 1978, Chicago, The Art
Institute, no. 29.

BIBLIOGRAPHY:

Daulte 1952, p. 180, no. 34; anon. in *Art
Quarterly*, Spring 1963, vol. XXVI, p. 94; anon. in
GBA, February 1963, vol. LXI, no. 156, p. 40;
Maxon 1963, pp. 141–221; Rewald 1973 (4th ed.),
p. 116; Daulte 1991, p. 169, no. 34.

Dramatically illuminated by a raking light
from behind, a serious young man directs to-
wards us a pensive gaze. This painting has
been treated as a self-portrait by Bazille, but
both the identification and the attribution are
questionable. The features of the face differ
markedly from those of Frédéric Bazille: a
shorter face, a more aquiline nose, curlier hair
parted nearer the center, a different style of
beard, and brown eyes instead of blue. The
painting is unsigned, and the looser and more
angular facture differs noticeably from Bazille's
usual style. Apparently it has been considered
one of his works because it was found among
the paintings recovered from the artist's studio
in Paris after his death. D.P

47 YOUNG WOMAN WITH LOWERED EYES

Jeune Femme

aux yeux baissés

oil on canvas

h. 46; w. 38

s.b.r.: F. Bazille

Private collection

PROVENANCE:

Family of the artist. Collection of André Bazille. Collection of Mme Rachou-Bazille. Private collection. Acquired by the Mitsubishi Trust and Banking Corp., Tokyo, in February 1989. Private collection.

EXHIBITIONS:

1935, Paris, Association des étudiants protestants, no. 7; 1941, Montpellier, Musée Fabre, no. 26; 1950, Paris, Wildenstein Gallery, no. 29; 1959, Montpellier, Musée Fabre, no. 18; 1960, Nice, Galerie des Ponchettes; 1978, Chicago, The Art Institute, no. 48.

BIBLIOGRAPHY:

Poulain 1932, no. 30; Schmidt in *le Semeur*, June 1935; Sarraute 1950, no. 29; Daulte 1952, p. 182, no. 40; Exhibition cat., 1959, p. 16, no. 18; Marandel 1978, no. 48; Daulte 1991, p. 172, no. 44.

In the spring of 1867, Bazille wrote to his father that he was finishing a small studio interior, of the rue Visconti studio which he'd occupied since July 1866 (cat. 13), sharing it with Renoir, then with Monet as well. As in *Studio on the rue de Furstenberg* (cat. 8) and later in his painting of the rue La Condamine studio (fig. 19), the artist represented canvases hanging on the walls. Sarraute has proposed that one of these, a small canvas to the extreme right of the composition, is the enigmatic *Young Woman with Lowered Eyes*. This work is undated, but its presence in the studio occupied by Bazille from July 1866 to December 1867 allows us to propose a date which is confirmed by the artist's letter to his father in May. The painting was undoubtedly executed during the winter of 1867. Sarraute also emphasized the model's resemblance to that used by Renoir in his *Diana* (Washington, National Gallery of Art), dated 1867 and rejected by the Salon jury that year. An X-ray of Bazille's *Studio on the rue La Condamine* reveals a painting just below the *Young Woman* that is a study for the *Diana*, but it has not been possible to determine whether this is a preparatory sketch by Renoir or a work made by Bazille, profiting from the model posing for his friend.[1] In any case, the use of the same model for the two works seems clear, and reveals the intimacy of the two artists at this time. Bazille focuses his attention on the face and bust of the young woman, who is dressed in a simple white sleeveless blouse. She poses with her eyes lowered, her face partly obscured by shadow, and this posture, for which certain critics have suggested Bazille had a particular preference with his female models, is the one chosen by Renoir for his *Diana*. A.J.

NOTE

1. Cat. *Renoir*, 1985, p. 60.

142

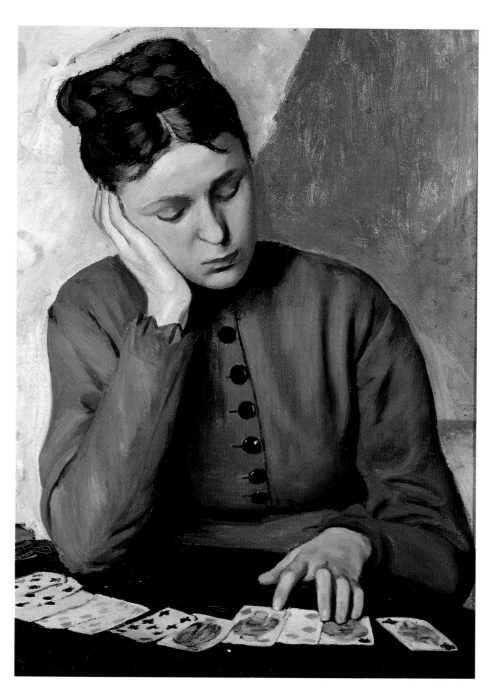

48 THE FORTUNE-TELLER

Tireuse de cartes

oil on canvas

h. 61; w. 46

Private collection

PROVENANCE:

Family of the artist. Meynier de Salinelles collection. Private collection.

EXHIBITIONS:

1927, Montpellier, Exposition internationale, no. 16; 1935, Paris, Association des étudiants protestants, no. 2; 1941, Montpellier, Musée Fabre, no. 27; 1950, Paris, Wildenstein Gallery, no. 30; 1959, Montpellier, Musée Fabre, no. 19; 1972, Paris, Galerie Schmidt, no. 23; 1974, Tokyo, Matsuzakaya Art Museum, no. 1; 1978, Chicago, The Art Institute, no. 46.

BIBLIOGRAPHY:

Poulain 1932, no. 31; Sarraute 1950, no. 30; exhibition cat., 1959, p. 19, no. 19; Daulte 1952, pp. 182–83, no. 41; Marandel 1978, no. 46; Pitman 1989, pp. 132–35; Daulte 1991, p. 173, no. 46.

Under the window in the *Studio on the rue La Condamine* (fig. 19), partly hidden by other canvases, we glimpse a small painting of a woman in red who rests her head on her hand: *The Fortune-Teller*. Several commentators have rightly noted the Cézanne-like character of the woman in this painting:[1] solidly painted, not at all sensual, absorbed in contemplating the cards spread before her, and as inscrutable as they are. But the appearance of the painting in the studio does not help date it: one notes that the *Terrace at Méric* of 1866 (fig. 57; Geneva, Petit-Palais) appears in the same room, over the piano at right. Once again Bazille may have drawn inspiration from the old masters: in this case, Vermeer's *Girl Asleep* (New York, The Metropolitan Museum of Art).[2] If this is so, it is typical of Bazille that he responds to the moods and the poses rather than the iconography or details of the painting that inspired him. D.P

143

NOTES

1. Scheyer 1942, p. 127; Marandel 1978, p. 98.
2. Proposed by Alderman 1972, p. 25. It is not clear where Bazille could have seen this work: see Pitman 1989, pp. 132–34.

49 WOMAN ON THE TERRACE AT MÉRIC

Dame sur la terrasse de Méric

oil on canvas

h. 28; w. 35

Private collection

PROVENANCE:

Family of the artist. Collection of Frédéric Bazille. Private collection.

EXHIBITIONS:

1950, Paris, Wildenstein Gallery, no. 44.

BIBLIOGRAPHY:

Daulte 1952, p. 177, no. 28; Daulte 1991, p. 166, no. 31.

This study of a *Woman on the Terrace at Méric*, which Daulte dates 1867, doubtless because of its connection with paintings executed at Montpellier that year, such as *The Family Gathering* and *Oleanders* (Cincinnati Art Museum), provides us with clear evidence of Bazille's working methods. Without doubt it is a small open-air study preliminary to a projected larger painting. The artist sketched in the woman with the brush, as in the unfinished *Oleanders*, where the figure is also seated on a bench, in the shade of a tree. There are several rough areas, as if the canvas had been scraped with a palette knife, but attentive examination indicates the reworkings were effected with the brush handle when the paint was still wet, an unconventional procedure. The figure has not been identified; some have proposed she is Mme Gaston Bazille, the artist's mother. A.J.

50 TWO HERRINGS

Deux Harengs

oil on canvas

h 41; w. 27

Private collection

PROVENANCE:

Family of the artist. Collection of Jean Thuile.
Private collection.

EXHIBITIONS:

1950, Paris, Wildenstein Gallery, no. 45.

BIBLIOGRAPHY:

Daulte 1952, p. 179, no. 31; Daulte 1991, p. 167,
no. 34; Sarraute 1950, no. 45.

Two smoked herrings, headless, stand out against a gray-green background striped with broad brushstrokes. The light priming is visible, and the thick application of the paint in the fish is broad, nervous, and summary. Re-nouncing all artifice of presentation and arrangement, such as he had used in his still lifes of 1866 and 1867, Bazille chose a subject of extreme simplicity as a pretext for a work of pure painting. The handling and palette of this still life link it with *The Scoter-Duck* (private collection), in which the artist still utilized a trompe-l'oeil effect by painting the bird hanging by a string from a wooden plank. Here the background is uniform and the chosen object presented in isolation, as in the small still lifes painted by Manet in the 1880s. A.J.

51 THE DOG
RITA ASLEEP

Rita, chienne couchée

oil on canvas

h. 38; w. 45

Private collection

PROVENANCE:

Family of the artist. Collection of Frédéric Bazille.
Private collection.

EXHIBITIONS:

1927, Montpellier, Exposition internationale, no.
36; 1941, Montpellier, Musée Fabre, no. 10; 1950,
Paris, Wildenstein Gallery, no. 13; 1959, Montpellier, Musée Fabre, no. 7; 1978, Chicago, The Art
Institute, no. 10; 1984, Montpellier, Musée Fabre.

BIBLIOGRAPHY:

Poulain 1932, no. 4; Sarraute 1950, no. 13; Daulte
1952, p. 168, no. 5; Champa 1973, p. 85, fig. 117;
Marandel 1978, no. 10; Daulte 1991, p. 154, no.5.

One of the artist's sketchbooks (RF 5260) contains several studies of dogs in motion, and
Daulte mentions a preparatory drawing (private collection) for this painting. The dog, a
Gordon setter, its coat black and brown, lies
on a carpet with gray and red decorative motifs. Curled back on herself, she's asleep.

Sarraute dates the painting to 1864, for no apparent reason, save his supposition that Bazille
painted this little work as an homage to
Delacroix, whom he greatly admired and
whose posthumous exhibition he had seen
that year. Champa stresses the success of the
work, whose overall tonality of warm browns
and blacks recalls the restricted palette of
Manet.[1] It is worth noting here that Paul
Guigou painted four panels representing a
hunting dog, one of which, dated 1864, is
close to Bazille's Rita.[2] A.J.

NOTES
1. Marandel 1978, p. 45.
2. Bonnici 1989, cat. 105, p. 155.

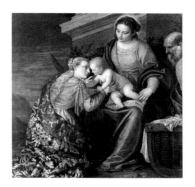

52 THE MYSTIC MARRIAGE OF SAINT CATHERINE

(copy after Veronese), 1863–64

*Le Mariage mystique
de sainte Catherine*

oil on canvas, h. 125; w. 125

s.b.r.: copié par F. Bazille

Beaune-la-Rolande, parish church

PROVENANCE:

Family of the artist. Given by Gaston Bazille, the artist's father, to the church of Beaune-la-Rolande in 1871.

EXHIBITIONS:

1950, Paris, Wildenstein Gallery, no. 67; 1978, Chicago, The Art Institute, no. 7.

BIBLIOGRAPHY:

Poulain 1932, p. 220; Sarraute 1950, no. 67; Daulte 1952, p. 191, no. 59; Marandel 1978, no. 7; Daulte 1991, p. 183, no. 65.

We do not know at what date Bazille set up his easel in the Musée Fabre to paint this copy of the *Mystical Marriage of Saint Catherine* by Veronese (fig. 77). Copying paintings of the old masters was an important part of the training of young painters, and Bazille himself had written to his parents in 1863 that he was copying a painting by Rubens in the Louvre.[1] The rich colors, the concern with the play of light and shadow, and the delicate touches of broken color of the Veronese made him a favorite among the painters of Bazille's circle: Fantin-Latour, Manet, Morisot, and Cézanne also copied his paintings.[2] Bazille's *La Toilette* (cat. 26) recalls the Veronese in several respects[3]: the figure at left kneeling and seen from behind, face in profile; the vertical form of the figure at right; the square format of the whole. One might even say that the absence in *La Toilette* of an equivalent for the Christ child, the iconographic and compositional center of the painting by Veronese, makes itself felt in the curious detachment of Bazille's figures.[4] After Frédéric's death, Gaston Bazille presented this painting to the church of Beaune-la-Rolande, in appreciation of the assistance that its priest had provided in helping him find the body of his beloved son.[5] D.P.

NOTES

1. Marandel 1978, no. 5, p. 192; correspondence, 1992, no. 15.
2. Druick and Hoog 1982, p. 128.
3. Daulte 1952, p. 128, credits the comparison to Jean Claparède.
4. Pitman 1989, pp. 128–29.
5. Sarraute 1950, n.p., no. 67.

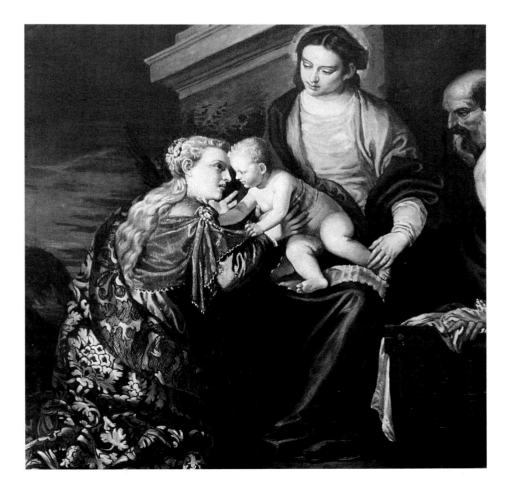

53 PORTRAIT OF PAUL VERLAINE AS A TROUBADOUR

oil on canvas, h. 46; w. 38

s.d.b.r: F. Bazille 1868. s.d.

on the stretcher: F. Bazille

juillet 1868.

Dallas, The Dallas Museum of Art,

inv. 1978.68.Fa.

PROVENANCE:

Collection of Paul Verlaine. Collection of Mme
Verlaine, the poet's mother, until 1886. Private
collection. Collection of Wildenstein and Co. The
Dallas Museum of Art, Foundation for the Arts
Collection, Mrs. John B. O'Hara Fund and Gift
from Colonel C. Michael Paul.

EXHIBITIONS:

1978, Chicago, The Art Institute, no. 38; 1986,
Houston, The Museum of Fine Arts, no. 37.

BIBLIOGRAPHY:

Lepelletier 1907, p. 302; Poulain 1932, p. 141;
Daulte 1952, p. 70; Daulte in *L'Oeil*, 1978, pp.
40–41, no. 273; Marandel 1978, no. 38; Bernier
1985; Daulte 1991, p. 177, no. 53.

Bazille probably met Verlaine through Ed-
mond Maître or the poet François Coppée, a
friend of the Lejosnes.[1] Writing to Maître from
Montpellier in August 1870, Bazille men-
tioned Verlaine along with their other mutual
friends Fantin-Latour, Manet, Monet, Renoir,
and Sisley.[2] A portrait of Verlaine by Bazille
was listed among the poet's belongings in
1871.[3]

This portrait, formerly in the collection of
the family of the poet, depicts him as a min-
strel holding a mandolin and wearing an odd
medieval hat. Acquired by the Dallas Museum
in 1978 and identified as the lost portrait by
Bazille, its attribution nonetheless poses prob-
lems. The signature on the front of the
painting appears to have been added at a later

date. The inscription "F. Bazille juillet 1868,"
which appears on the stretcher, does not help,
as Bazille seems to have spent that month not
in Paris but in Montpellier, where he cele-
brated the birth of Valentine Bazille, daughter
of Marc and Suzanne, on June 29, the same
day that Monet sent from Paris one of his most
desperate appeals for money.[4] More to the
point, the style is uncharacteristic of Bazille, in
both the peculiar choice of costume (perhaps
intended to commemorate a theatrical event)
and the unusual facture. The brushstrokes
form a delicate herringbone pattern, and the

sculptural forms of the face contrast with the
strong curved lines with which Bazille usually
renders noses and chins. Even the remarkable
transparency of the iris of the poet's eye pro-
vides a striking contrast with the usually
rather hard and opaque surfaces of Bazille's
portraits. D.P.

NOTES

1. Daulte 1978, p. 28.
2. Daulte 1952, p. 81, no. 1.
3. Daulte 1952, p. 70.
4. Letter from Monet dated June 29, 1868:
Daniel Wildenstein, vol. I, 1974, no. 40.

54 RELAXATION ON THE GRASS

Repos sur l'herbe

oil on canvas

h. 21; w. 34

s.b.r.: F. Bazille

PROVENANCE:

Collection of M. Barbey. Collection of Edmond H. Ziegler-Viallet. Private collection.

EXHIBITIONS:

1942, Paris, Galerie Charpentier, no. 7.

BIBLIOGRAPHY:

H.Z. de Baugy in *Beaux-Arts*, November 21, 1940; Daulte 1952, p. 173. no. 11; Pitman 1989, p. 262; Daulte 1991, p. 159, no. 14.

In the shade of a tree, at water's edge, seated or reclining in the grass, four figures relax. Daulte, who catalogued this painting for the first time in 1952, proposed the following identifications: Claude Monet, in shirtsleeves and seated against the trunk of a chestnut tree; his mistress, Camille Doncieux, her full skirt spread out around her; to the right, Alfred Sisley reclining, reading a newspaper; and Sisley's own female friend. Daulte indicates the painting would have been executed during the sojourn of Bazille and his friends in the forest of Fontainebleau in 1865, though this is not confirmed at any point by the artist's correspondence. Sarraute, while acknowledging the quality of this small canvas, expresses doubts about its attribution to Bazille. A.J.

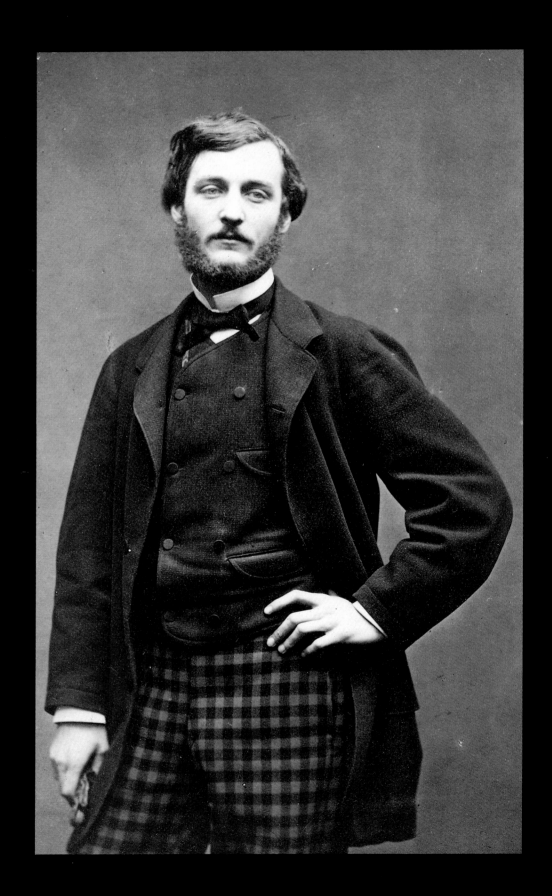

Chronology

Étienne Carjat (Paris)
1828–1906
Frédéric Bazille
photograph
h. 9.4; w. 5.5
Private collection

Notice: This biography makes extensive use of Frédéric Bazille's correspondence with his parents and his brother during his Parisian sojourns. With a few exceptions, these letters are undated, which explains the inconsistency with which they have been employed in the past. In view of correcting previous errors regarding the artist's life and work, the dating of this correspondence has been systematically reviewed and amended by Guy Barral and Didier Vatuone. The Parisian events that Frédéric Bazille relates to his family provide points of reference that have served as the basis for the new dating. A complete edition of the correspondence utilizing the new chronology has recently been published in a separate volume.

The newly established dates appear in brackets. Spelling has been modernized.

1840
September 29, marriage of Gaston Bazille (1819–1894; fig. 78) and Camille-Victorine-Marguérite Vialars (1821–1908; fig. 79).

1841
December 6, birth of Jean Frédéric Bazille, at 11 Grand'Rue (his parents' residence; fig. 80). The birth certificate (fig. 81) was executed December 7, at 11:00 A.M., and signed by his father, Gaston Bazille.

1845
May 9, birth of Claude Marc Bazille (fig. 82).

1849
Bazille's first known letter to his father. On this letter, his brother, Marc, wrote: "1849 during the final illness of Frédéric Vialars, our mother's father."

FIG. 78 (left)

Huguet-Moline (Montpellier)

Gaston Bazille

photograph

h. 8.9; w. 5.4

Private collection

Photo.: F. Jaulmes

FIG. 79 (right)

Huguet-Moline (Montpellier)

Mme Gaston Bazille,

born Camille Vialars

photograph

h. 8.7; w. 5.3

Private collection

Photo: F. Jaulmes

151

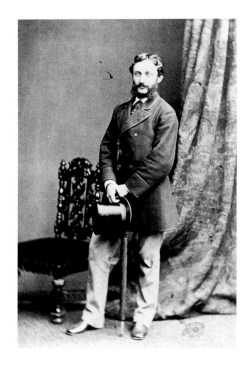

FIG. 80

House in which

Frédéric Bazille

was born

11 Grand'Rue,

in Montpellier

Photo: F. de Richemond

FIG 81

Official record of the

birth of Frédéric Bazille

1841

Montpellier,

Municipal Archives

Photo:

Communications Office

FIG. 82

Mayall (London)

Marc Bazille

photograph

h. 9.1; w. 5.9

Photo: F. Jaulmes

FIG. 83

Frédéric Bazille

The Family Gathering

1867

(detail: Adrienne des Hours)

oil on canvas, h. 152; w. 230

Paris, Musée d'Orsay; Photo: RMN

FIG. 85

Huguet-Moline and

Cairol (Montpellier)

Frédéric Bazille

photograph, h. 13.9; w. 9.9

Montpellier,

Musée Fabre

Photo: F. Jaulmes

FIG. 87

Auguste Baussan

1829–1907

Medallion representing

Frédéric Bazille

bronze. d, 20

s.d.b.r.: A. Baussan 1862

Relief inscription

at left: F. Bazille

Montpellier, Musée Fabre

inv. 32.3.1

Photo: F. Jaulmes

FIG. 84

The Méric property

General view of the family house

Photo: O'Sughrue

FIG. 86

Anonymous

Auguste Baussan in his studio

at work on the sculpture of

Saint Roch whose features

are those of Frédéric Bazille

undated photograph

h. 16.6; w. 11.6

Montpellier, Musée Fabre

Photo: F. Jaulmes

FIG. 88

La Tour de Nesles in

the Gleyre studio

lithograph from

Le Boulevard, 1869

Standing at left: Bazille

After a drawing by

Félix Régamey

Photo: Bibliothèque

Nationale

154

1854

Camille Vialars, married name Grand, bequeaths the Méric property (fig. 84) to the two daughters of her brother Frédéric: Camille Vialars — the painter's mother — and Adrienne, married name des Hours-Farel, who would appear in *The Family Gathering* (fig. 83).

1857

March 14, Frédéric writes to his father, then in Algeria, that he's interested in birds. On May 23, Gaston Bazille is in Paris, after having attended an agricultural competition at Montbrisson.

1859

April 9, Frédéric receives his bachelor of sciences diploma. Trip to the Alps, letter from Grenoble to his father on stationery from the Hôtel des Trois Dauphins. He goes to Grand Saint-Bernard and to the Grande Chartreuse, and collects insects. On July 11, the peace of Villafranca: Frédéric comments on this in a letter. September 1, registers at the medical school in Montpellier (fig. 85). Bazille takes drawing lessons with the Baussans, father and son, sculptors in Montpellier, during the years preceding his departure for Paris (fig. 86).

1860

August 6, first-year medical school examinations: satisfactory.

1861

July 31, second-year medical school examinations: deferred. Takes them again on September 11: mediocre.

1862

August 30, end-of-year examinations: satisfactory (fig. 87).

November 1, departure for Paris; on the 2nd, stopover in Lyon. In Paris he is introduced into the studio of Charles Gleyre — a Swiss painter — by Henri Bouchet-Doumenq, a friend of his cousin the painter Eugène Castelnau. [November]: "In addition to an entry fee at the studio, I have had to pay for my registration and for rental of the piano." Registration at the Paris medical school.

[November 15], to his mother: "Last Monday the medical faculty officially resumed its duties. The solemn opening ceremony was presided over by a new dean named Rayer who was appointed on the minister's own authority, and who was not even

a professor. The students protested against this measure." He resides on the rue Jacob. [Friday, December 26, 1862 or January 2, 1863]: "I never miss the 'concerts populaire' of M. Pasdeloup."

1863

[January 18], to his mother: "We're going to put on La *Tour de nesle* in the studio, I've been assigned a bit part, that of Sire de Pierrefonds, I don't have much to say, but on the other hand I've also been given the role of the grand Seneschal. The entry fee has been fixed at one candle per seat. I'll invite all my friends to come. We spent this week, when the model wasn't posing, making the sets. I was asked to make a medieval stained-glass window that will, I think, be rather amusing. I'll send you an account of the performance. Several former students from the studio who are today well-known painters, Gérôme, Hamon, etc., have asked to attend."

[February 13], to his mother: "Victor must have given you details about our famous performance of Nestle Tower in the studio, what he didn't tell you is that a caricature of us appeared in the little newspaper called the 'Boulevard.'[1] I'll send it to you, you'll see me in it from head to toe. It's the final tableau that's represented, I'm the tall figure on the left" (fig. 88).

Very early on in his first sojourn, he began to discuss with his parents the possibility of renting his own studio. [February]: "I would very much like for you to give me your views about the idea I spoke to you about in my last letter, of my taking a studio of my own. It would be very useful for me, I would have the calm I need to draw after plaster casts, which is utterly impossible in my room or at the studio."

In March, meets Claude Monet and the son of Viscount Lepic — later a friend of Degas — in the Gleyre studio. [March-April]: "I recently made the aquaintance of Monsieur le vicomte Lepic, son of the emperor's aide-de-camp. He's a painter and, though already pretty good, he entered our studio to further perfect himself. He brought me to his rooms in the Louvre itself, where his father has set up a splendid studio for him. This young man, and another one from Le Havre named Monet…" In the same letter he writes of his first effort as a copyist,

which has since been lost: "A few days ago I made my first daub, it's a copy of a painting by Rubens in the Louvre. It's atrocious but I am not discouraged. There are other copyists just as bad as I am." [April 8]: "I have just, my dear mother, passed a very pleasant week. As I've already told you, I spent eight days in the little town of Chailly near the Fontainebleau Forest. I was with my friend Monet, from Le Havre, who is rather good at landscape, he gave me some advice that was very helpful to me." He returned from Chailly before the opening of the Salon. Letter to his mother [June 3]: "I've been to the painting exhibition more than twenty times, I know it inside out, my general opinion is that there are very few painters who are truly in love with their art. Most of them are only out to make money by flattering the taste of the public, which is usually false." It should be noted that Bazille makes no mention in his correspondence of the Salon des Refusés. A letter excerpt published by G. Poulain: "I saw some beautiful things in the fine arts exhibition…. I singled out the portrait of the emperor by Flandrin and the African paintings by M. Fromentin; these are, I think, the most beautiful works this year."

Return to Montpellier after June 23. Paris, late September 1863. He has returned with a letter of recommendation to Gustave Courbet, provided him by Auguste Fajon: "Montpellier, September 25, 1863. My dear Gustave. Monsieur Frédéric Bazille, a friend of mine and of Baussan's, is going to Paris. I am asking him to shake your hand on my behalf. He is very anxious to make your acquaintance and deserves to do so. Best wishes. A. Fajon."

Bazille goes back to work at the Gleyre studio. "I need not tell you that I saw the ascent of Nadar's balloon." Still discussing his rental of a studio with his parents, he seems to have received a satisfactory response on his return from Montpellier. [October 6]: "My dear mother, I have been quite upset since my last letter, concerning the studio of which I spoke to you. The day I received your answer I ran to claim it, it had been rented the previous day. It will be vacant in January." His father tried to convince him that rental of a studio for only a few months entailed considerable expenditure for an activity that had

FIG. 89

H. Lavaud

Portrait of Frédéric Bazille

(center), Marc Bazille (left),

and an unidentified

man (right)

Photograph

h. 8.5; w. 5.4

Private collection

Photo: F. Pervenchon

not yet become essential. [October 12], Gaston to his son: "I think you'd do well to be satisfied with Gleyre's studio, all the more so as this year you must give serious attention to your medical studies and your examinations, you promised me you'd pass the first set between now and January, I count on your keeping your promise: then you can make up for lost time with your painting." [Before November 29]: "Last week, M. Gleyre complimented my work for the whole studio to hear, which he rarely does, I'd had the idea of drawing the model life-size on an immense sheet of paper, and I brought it off." On Monday, December 8, he meets his Lejosne cousins at the Louvre and has "not yet made the acquaintance of Courbet, who is currently at his home in Ornans, I'll go to see him when he returns. On the other hand, I've been introduced to M. Théodore Pelloquet,[2] a good critic of painting whose name is probably not [known] to you, but whose advice has been very useful to me." Bazille cultivates a friendship with Monet, who invites him to spend a few days at Le Havre. The studio prepares to put on a comic parody of Macbeth, with Bazille assuming the small role of a female dancer.

1864

On January 15, rents his first studio with a painter friend, Émile Villa, also from Montpellier and a student of Gleyre, at 119 rue de Vaugirard. Letter to his mother, Tuesday [December 8, 1863]: "We went, my friend Villa and I, to have another look at the studio we'll be moving into on January 15." Monday, January 15, 1864, Gaston to his son: "You are putting a considerable strain on my poor pocketbook, examination fees, furniture for the studio, but you know that this year you have to be careful." Charles Gleyre is in poor health and his studio faces financial difficulties: "M. Gleyre is quite sick, it seems the poor man could lose his sight," wrote Frédéric at the end of January. Registration for his medical examinations, which were postponed several times; he did not take them until April. [Wednesday, January 23]: "I'm going immediately to register at the medical school for my examination... my turn won't come until two weeks from now."

[Late February]: "I didn't cross the Seine to see the Delacroix sketches on sale until yesterday."[3] In the same letter: "I've begun a study of flowers in my studio." In March he writes to his father: "I'll make two small views of Paris, taken from the banks of the Seine under the quays, I'll add one or two studio figures, and I'll send you the lot so you can judge my progress in painting." [April], writes his family that he failed his first attempt at the anatomy examination. In May, he visits the Salon with his brother, Marc, who is in Paris on his way

FIG. 90

Théodule Ribot

1823–1891

The Martyrdom of

Saint Sebastian

1865

oil on canvas

h. 97; w. 130

Paris, Musée d'Orsay

Photo: RMN

FIG. 91
Claude Monet
1840–1926
Sketch for
Le Déjeuner sur l'herbe
oil on canvas
h. 130; w. 181
Moscow, Pushkin Museum,
inv. 3307

FIG. 92
Claude Monet
1840–1926
Le Déjeuner sur l'herbe
Fragment of the
left portion of
the composition
oil on canvas
h. 418; w. 150
Paris, Musée d'Orsay
Photo: RMN

FIG. 93
Claude Monet
1840–1926
Le Déjeuner sur l'herbe
Fragment of the
central portion of
the composition
oil on canvas
h. 248; w. 217
Private collection

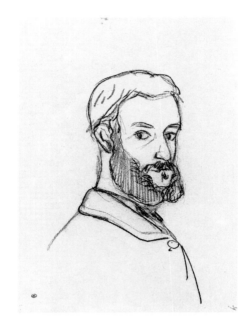

to Hamburg to work in a bank for a year (fig. 89). The parents, having been left alone, take a trip to Draguignan for an agricultural competition, where the father and his "students" receive seventeen awards, including eight first prizes, and continue on to Hyeres and Cannes (letter of May 15, Gaston to his son).

[June 1]: "Honfleur, Wednesday. My dear mother, it was around the middle of last week that I left Paris with my friend Monet. Our trip was charming, it took a day for us to get here with a stopover of several hours in Rouen. We were able to see the Gothic marvels of this large city and the museum, which has an admirable collection of Delacroix." The admired painting is the *Justice of Trajan*. The works completed during this trip were damaged on the way back, except for *Soup Bowl Covers* (cat. 5). In July, having returned to Paris, Bazille prepares for his medical examinations, which he again fails at the end of the month. To obtain "forgiveness," he executes a large canvas, the *Reclining Nude* now in the Musée Fabre (cat. 4). He arrives in Montpellier in the second half of August

("I've almost finished the study I want to show you, and there's nothing else to keep me in Paris"), where Villa sends him the *Reclining Nude*. Letter from Monet, August 26, 1864: "I hope you're working very hard. You have to apply yourself seriously because your parents have given up on your medical career." His career as a painter can really get under way. During his vacation at Méric, he paints *The Pink Dress* (cat. 7), for which his cousin Thérèse des Hours-Farel poses. November, returns to Paris but no longer studies in Gleyre's studio. He has not yet moved out of the studio on the rue Vaugirard, although he often works in Monet's studio to to take advantage of his models. [December 22]: "I work every morning at Monet's." [Around January 1, 1865]: "Rest assured, my dear father, that I'm working very assiduously at the moment, Monet takes the trouble to come wake me up every morning and I spend every day in his studio painting after the live model." A letter from Gaston to Frédéric of December 16, 1864, informs him that the photographer Huguet Molines had retouched his painting *The Pink Dress*. [December 22]: "This

Molines creature has quite messed up my painting, but I'm making other ones to replace it."

1865

Frédéric, along with Monet, moves into a new studio just above Delacroix's. In a letter dated Friday [around January 1]: "All I need to be fully settled in is window curtains, I'll have them on Monday. So from today you can write me at 6 Place Furtenberg [*sic*]." Over the winter he writes a play in collaboration with Édouard Blau, *The Son of Don César*, which, despite their efforts, was never produced. Tuesday, February 28, the father notes once again that his son hasn't written in several weeks. In fact, no letters are known between early January and March 1865.

Bazille probably made a rapid trip to Montpellier between the 10th and the 28th of April. The reason for this remains unknown; perhaps it was the death of his uncle Ernest Pomier. The trip is confirmed in a letter from Gaston, Thursday, 28 December, mentioning: "the marriage of Maurice de Marveille and Mlle de Rouville of Nîmes, announced a few days ago, which

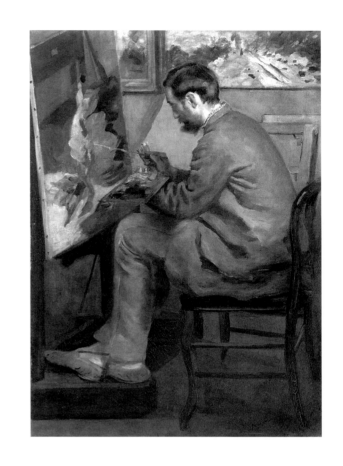

FIG. 95

Auguste Renoir

1841–1919

Frédéric Bazille

at His Easel

oil on canvas

h. 105; w. 73

s.d.b.r.: A. Renoir

1867

Paris, Musée d'Orsay

Photo: RMN

FIG. 96

Anonymous

Luncheon on the

Terrace at Méric

Photograph,

turn of the century

h. 5.7; w. 8.2

Private collection

Photo: F. Jaulmes

159 ·

FIG. 97

Claude Monet

1840–1926

Women in the Garden,

1867

Paris, Musée d'Orsay

you saw in the spring at St Sauveur."

Friday [May 5, 1865], he describes to his father his visit to the Salon: "I also visited the painting exhibition, as you surely expected. There are very few good things, except for a *Saint Sebastian* by Ribot, which you must have read about in the papers (fig. 90). Our compatriot Cabanel has made a very poor portrait of the emperor, which did not prevent him from winning the grand medal of honor. Monet had a much greater success than he'd hoped for." In this rapid overview of the Salon, he makes no mention of Manet's *Olympia*. "He [Monet] is currently at Fontainebleau where I would also like to be, unfortunately I'm wretchedly poor since my return and cannot join him…. The weather has been splendid since I got back, Paris is delicious at this time of year, unfortunately I can't take outings in the surrounding areas." Fragment of a letter [May]: "I'm leaving for Chailly tonight at 6 o'clock. I'm going to work very hard there, I promise to make a study for you." He probably paints the *Landscape at Chailly* (cat. 11). "I've started one of the paintings for my uncle, it will be finished in

two weeks at most if I can get away to make the necessary studies." Monday [July 17, 1865]: "Yesterday I won another sort of victory, through sheer brute strength. Two of my friends and I took the first prize at the Bougival regata, as you'll see in the papers." In this letter, he informs his father that the play he'd been writing with his friend E. Blau had been finished two weeks earlier. In this same period, he completes two paintings commissioned by his uncle Pomier-Layrargues, *Seascape* (cat. 9) and *Saint-Sauveur* (fig. 38), and receives a great many letters from Monet reminding him of his commitment to pose for his painting. In August, he joins Monet at Chailly and poses for the *Déjeuner sur l'herbe* (figs. 13, 91–93). He himself paints *The Improvised Field Hospital* (cat. 10) while Monet is bedridden after being injured. Summer vacation in Montpellier from September to November. Monet: "Paris October 14 [1865]. I write you in great haste… for you'll end up having your effects seized, and, old man, that won't suit me at all, it's enough that you've given notice."

Return to Paris, rue Furstenberg. He has not

told his parents that he's leaving his studio and Monet. He begins work on the lost painting *Young Woman at the Piano*. [November 1865]: "I've started a painting for the Salon, it's a very simple subject and should attract very little attention if it's accepted. A young woman plays the piano and a young man listens to her."[4] Monet joins him again and continues work on his *Déjeuner sur l'herbe*. "Monet has been working a long time; his painting is far advanced and I'm sure it will make a big impression." In a letter [December] he informs his brother: "First of all, I'm working very hard on my painting for the Salon, it won the compliments of master Courbet, who came to visit us to see Monet's painting, which enchanted him." Gaston Bazille, with great lucidity of judgment, December 28, 1865: "I'm sorry about your separation from Monet. It seems he was a real worker who must have made you blush at your own laziness quite often; and when you are alone, I very much fear that you'll pass a great many mornings and even entire days in a *dolce farniente* that won't serve to advance your paintings for the exhibition."

1866

[After January 15]: "I'm at 22 rue Godot de Mauroy since the fifteenth, my studio is most agreeable and the light here is magnificent, but my bedroom is excessively small, I scarcely have room to turn around in it." Parisian life: "I'll also tell you I'm going to a ball tonight given by the baker in the Hôtel du Berri, who's marrying off his daughter. He's invited the finest flower of the pensioners from our table, he's giving a big party at Père Lathuile where there'll be at least five hundred people, it's said in the neighborhood that this wedding will cost ten thousand francs, so you see that bakers aren't exactly wiping their noses on their sleeves in this country called Paris." Sends his works to the jury [March]: "Make a wish that the order will be favorably disposed towards me." Gaston Bazille answers: "I'd very much like your two paintings to be accepted for the exhibition, but in the end I should offer you congratulations just for having finished any paintings to submit to the jury. As you say, it's always difficult to completely finish any kind of work." In fact, his painting *Young Woman at the Piano* was refused, but *Still Life of Fish* (cat. 12), now in Detroit, was accepted.

April 12, Bazille attends the marriage of his cousin Georges in Lyon, then continues on to Montpellier with his mother, not returning to Paris before early May. He is still in Montpellier on the 3rd, when Gaston is in Avignon. May 31, Gaston to his son: "Since you left Paris to go to Lyon and Montpellier I've had to pay, in addition to your pension, including your travel expenses it's true, close to 800 francs — 760 francs, to give you the precise figure." [May]: "I saw Courbet yesterday, he's swimming in gold. That's fashion for you. He'd never in his life sold a painting for more than forty thousand francs. This year he's showing some very beautiful things, it's true, but they're inferior to his *Bathers* and *Demoiselles de la Seine* [sic] etc. The public has gotten it into its head to give him a success, and since the opening of the Salon he's sold a hundred and fifty thousand francs' worth of paintings. His drawers are crammed full of bank notes, he no longer knows what to do with them, all the amateurs run to his house, he turns over lots of old things full of dust and they grab them away from

him. The value of the Bruyas gallery has tripled overnight." Bazille was unaware of the disappointment the Fine Arts administration had in store for Courbet: he would not be awarded a medal. Frédéric outlines his plans to go to Aigues-Mortes to paint, but his parents advise against it because of the various epidemics then ravaging the Camargue. Gaston, Saturday, July 14: "I worry that Aigues-Mortes, in the intense August heat, might be an unpleasant and not altogether healthy place to visit." Gaston again: "I suppose you must, my dear Frédéric, be settled into your new appartment on the rue Visconti." This is a new studio which he shared with Auguste Renoir, whom he knew from the Gleyre studio. Marc has settled in England. Summer vacation after August 7, when Gaston becomes anxious about rumors of a cholera epidemic: "I've begged you, dear Frédéric, to tell me as quickly as possible about your plans to return. The people who come down from Paris and the papers talk about cholera having become a serious problem, and you can understand that we're a bit uneasy." That summer, Bazille worked on a painting, *The Terrace at Méric* (fig. 57), in which are portrayed Mme Gaston Bazille and her sister, Adrienne des Hours-Farel; to the left, Marc Bazille and his fiancée, Suzanne Tissié; a gardener; the three des Hours-Farel daughters; Frédéric's cousins; and the painter himself. This painting would be completed in the course of the winter, in Paris: "I am enchanted by the effect my painting has had on the painters who've seen it, they're all very complimentary and predict that I'll very probably sell it at the exhibition, something I'm not so sure about."

He returns to 20 rue Visconti in November. [Between November 29 and December 15]: "I should have written you sooner to apologize for the rather brusque way I departed.... The only luxury I've permitted myself, a bit expensive it's true, is my subscription to the series of seven concerts at the Conservatoire, for 35 francs, but they continue up until Easter. The first concert is December 15." Aside from this indulgence, over the winter he busies himself with "nude figures" he wants to paint, for which he again solicits money: "Don't condemn me to everlasting still lifes," he writes at

the end of his letter.

1867

Winter. He announces: "I reworked this last (*The Terrace at Méric*). I added two little dogs and I redid the heads of Pauline and Camille, which weren't good." He paints the first *Portrait of Edmond Maître* and plans his paintings for the next Salon. Monday [February 1867]: "I've decided to send to the exhibition the Méric painting and a portrait of one of my friends." And then: "Since my last letter there's news from the rue Visconti. Monet has appeared out of the blue with a collection of magnificent canvases which will be highly successful at the exhibition. He'll be staying with me until the end of the month. With Renoir, that makes two needy painters I'm lodging. It's a veritable infirmary, which I find enchanting. I have enough room, and they're both quite amusing." At the Salon: "My paintings were refused for the exhibition." The works in question are the *Terrace at Méric* and the first *Portrait of Edmond Maître*. With Renoir, Sisley, and others, he signs a petition calling for a new Salon des Refusés and becomes interested in the possibility of a regular exhibition forum: "So we have resolved to rent a large studio each year where we will exhibit as much of our work as we like." During these discussions, he continues to paint: "At the moment I'm working on a painting of two life-size women arranging flowers. I'll finish it by the peony season." During this period, his parents suggest a marriage project to him: "Now it's over, the idea of marriage gave me quite a jolt." The nature of this jolt is unknown. [April 1867]: "By bleeding ourselves as much as we could, we managed to get together a sum of 2500 francs, which isn't enough. So we're obliged to abandon what we wanted to do. We must once again turn to the bosom of the administration." Frédéric writes to Monet's father, attempting to effect a reconciliation between him and his son, who has admitted that Camille Doncieux, the future Mme Monet, is pregnant. Visits "the Ingres exhibition... quite interesting," organized after the artist's death by the École des Beaux-Arts. Comment: "Almost all the portraits are masterpieces, but his subject pictures are very tiresome." The Salon, which that year opens in mid-April, "is the most

mediocre one I've seen, at the Universal Exposition there are twenty or so beautiful canvases by Millet and Corot." "Very soon the private exhibitions of Courbet and Manet, which I long to see, will be opening."

Bazille paints *Studio on the rue Visconti* (cat. 13) in April–May: "I shall leave Paris once I've finished a small interior of my studio." He leaves Paris that year on May 20; for in a letter excerpt (published by Poulain), he regrets not having been there to see the Courbet and Manet exhibitions, which opened respectively on May 29 and May 22–24. In the excerpt published by Poulain, he announces: "My Méric painting is perhaps going to be exhibited for eight days at a picture dealer's who asked me for it." Bazille buys Monet's *Women in the Garden* (figs. 17 and 97) for 2,500 francs, to be paid in monthly installments of 50 francs. Monet asks him: "Try to show it to M. Bruyas, he might like it, don't forget me." Courbet, through Monet, who writes to Bazille the week of May 20, asks him to obtain from Bruyas the loan of works for his exhibition. At the end of May, he goes to Aigues-Mortes, realizing his plans of the preceding year.

Bazille begins to paint *The Family Gathering* (cat. 18) at Méric during the summer. Monet writes to him on June 25 asking for news of the progress of his large painting. During July and August, Monet writes to Bazille often to ask him for money. The son of Camille Doncieux and Monet is born on August 8. On September 18, Frédéric attends the marriage of his brother, Marc, to Suzanne Tissié, the daughter of Louis Tissié, a Montpellier banker and a friend of Bruyas. Tuesday, October 8, he receives Edmond Maître, who is to spend a week with him at Méric. During his stay Maître sees the Bruyas collection, and in a letter to his parents, envisages a trip to Arles and Nîmes with Frédéric. Then, at the beginning of the following week, the two leave for Bordeaux where Bazille is received by the Maître family.

Vacation over, he returns to the rue Visconti studio. Letter of [November 5]: "I arrived in Paris on Sunday. And now I ask that you send me my studies and my painting. I don't know whether my large painting should be sent regular [or express] mail: I worry about its being damaged in transit;

do as you think best." [Late December]: "I am definitely going to change studios. Whatever Mama may say, I don't have enough room in the rue Visconti. I've rented an immense studio in the Batignolles quarter. It costs two hundred francs more.... I won't be moving until the month of January."

1868

[January 11]: "I moved into my new studio, 9 rue de la Paix in the Batignolles quarter, eight days ago. I'm very happy with these lodgings, and I hope never to move again." And he specifies further: "A single family lives in my building, they own it. The cook cleans house for me and makes me lunch, I settle with her at the end of the week, to this point I've spent 11 francs for eight meals. I hope you'll find these precise details about my domestic life [satisfactory]." Over the winter, he spends his evenings with Maître, with whom he develops a deep friendship, "playing whist and making music with Maître, who got me a subscription at the Conservatoire." Despite his move and preoccupation with his own work, he remains very interested in Monet's career, or at least in his finances: "I got M. Lejosne to buy a very beautiful still life by Monet." Frédéric works "on the painting for the Teulons. For it to be completely dry and ready to be sent we must wait until January 15" (*Flowers*, cat. 22), as well as on *The Family Gathering* (cat. 18). "I don't know if I told you that my friends think the Méric painting is very good, especially what I myself thought was best, the figures of Pauline and Émile. I've set to, I'll be finished in a month." [January 19, 1868]: "At present I'm working on my portrait in the Méric painting, it's giving me a great deal of trouble." In March, his father learns he's accumulated a considerable debt, amounting to 1,600 francs. [March 26]: "It is unfortunately quite true that I owe the sum you spoke of. I very much hope to pay it without your help, for I know what a strain this would be for you. It seems my creditor felt obliged to inform you, I'm very sorry about that, and I'd be most grateful if you would answer him that you don't concern yourself with my business affairs and that he should deal directly with me."

April 2, baptism of Jean Monet: his godfather is

Frédéric, his godmother is Julie Velay, Pissarro's companion. From May 1, *The Family Gathering* and *Flower Pots* (private collection) are shown at the Salon; Zola and Castagnary discuss the first work in their reviews.

Friday, April 17, Gaston to Frédéric: "It will suffice for you to be here by the 6th or the 7th of May.... I need to have an artist on hand, to decorate the carts, or at least gild the horns of my steers." Thursday, April 30, Gaston to Frédéric: "I hope, my dear Frédéric, that you have prepared your departure and that, as you indicated to us, you'll be here next Wednesday or Thursday." Frédéric was coming primarily to help out with the Montpellier regional agricultural competition. June 29, birth of Valentine Bazille, Frédéric's niece, the daughter of Marc and Suzanne. July 15, Gaston Bazille collaborates with Jules-Émile Planchon on the commission overseeing research on phylloxera, a parasitic plant that had begun to proliferate in the vineyards of southern France and to destroy large tracts of them.

That summer, Frédéric paints *View of the Village* (cat. 20) and *Fisherman with a Net* (cat. 19). He also begins a series of studies for a *Grape Harvest* (cat. 39–40). In this connection he writes to his mother in [mid-February]: "The next time you go to Méric obtain exact measurements of the canvas on which I started the grape harvest." Monet sends him a series of utterly despairing letters about his financial situation, which is not improving. Renoir, who is not staying at the studio over the summer but visits it regularly, is anxious because in August the paintings Frédéric exhibited at the Salon have still not been returned. On September 14, Alfred Bruyas gives the bulk of his collection to the city of Montpellier and asks to be named curator of its collection in the Musée Fabre. Gaston Bazille, then an adjunct to the mayor, sits on the commission that accepts his proposal and acknowledges his gift on October 22. November 21: "My dear mother, though it has already been eight days since I left, I don't have much that's important to tell you unless it be that I'm feeling very well. Our trip to Dijon was a great success, we found a good hotel full of magistrates and an interesting city. There are beautiful churches, one or two beautiful paintings in

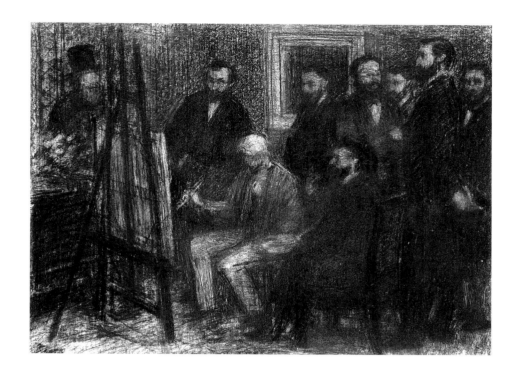

the museum, and the tombs of the Dukes of Burgundy, which are magnificent." He and Renoir make themselves more comfortable in their studio: "I found my studio very dirty, but nothing was missing. Now everything's in order. I bought a large chest of drawers for 75 francs. I had the walls of my bedroom covered with an inexpensive wallpaper, Renoir and I repainted the doors ourselves, now I'm quite settled in."

At the end of December, Gaston is in Paris to serve as a vintner's representative at the first meeting of the Société des Agriculteurs de France. He writes his wife: "I see Frédéric almost every day, but I've not yet been able to visit his studio." And Frédéric to his mother [January 1, 1869]: "Papa will have told you how I live in Paris." Gaston takes the *Still Life with Heron* (cat. 14) back with him to Montpellier.

1869

Over the winter, Bazille paints the second *Portrait of Edmond Maître* (cat. 23) and the *Mauresque* (fig. 30). "I've started to do another portrait of Maître to replace the one I gave him two years ago, and which I find simply too bad." [Mid-February]: "I have some excellent news to give you. The painting of the little Italian girl, which you seemed to think was so bad, is having an enormous success with lots of painters to whom I've shown it recently. Someone else is brought to me every day. Some prefer the Italian girl, and others the male nude…. I work like a slave, I have a model every day." In this period he reworks *View of the Village* (cat. 20) and *Fisherman with a Net* (cat. 19). In March, Mme Lejosne organizes a performance of Ruy Blas in which Édouard Blau, Alfred Stevens, et al., participate. The same Stevens "told me my paintings had to be well hung, and to that end he is going to bring me members of the jury he thinks will like my work. Thus, as soon as everything is varnished and framed, I'll be visited by Messieurs Fromentin and Daubigny." In 1869, the jury is elected by painters whose works have previously been

selected for exhibition. "I won't vote at all, because I wouldn't want there to be any jury, and because for years the one there is has represented perfectly the majority of painters…. My quality as a voter has led to my being approached by some of painting's bigwigs. Daubigny pretended to come see me by chance, and Stevens, whom I often see at Manet's, has invited me to evening parties: how curious they should so covet such a small thing!" On April 6, he attends the Paris premiere of Wagner's *Rienzi*. Only the *View of the Village* is accepted for the Salon. He is astonished to learn that Cabanel supported him in the jury deliberations. [May 2]: "I've received some compliments I found very flattering, from M. Puvis de Chavannes, among others." Before his departure, he visits the exhibition, and sends his father the following account: "Overall the Salon is deplorably weak. There's nothing really beautiful except the paintings by Millet and [Jean-Baptiste] Corot. Courbet's paintings, which are very weak for him,

163

ACTE D'ENGAGEMENT VOLONTAIRE
POUR LA DURÉE DE LA GUERRE

FIG. 99

Register of voluntary enlistees

1870

Série H.13

Montpellier, Municipal Archives

Photo: Communications Office

164

seem like masterpieces in the midst of the universal platitude. Manet is beginning to be a bit more appreciated by the public."

Vacation in Montpellier from May to November. That summer he paints *Summer Scene* (cat. 25). In a letter to Edmond Maître: "I have migraines that are almost constant, complicated by all sorts of pains. What's more, at the moment I am deeply discouraged. I've just begun a painting I'd expected would give me intense pleasure, and I don't have the models I need. It's not going well, and I don't know who to be angry with. If I'm obliged to stop, I'll arrive in Paris with a single painting which you may find atrocious; I don't know where it's going. This is my nude men." From August to September, Renoir stays with his parents in Voisins-Louveciennes. From there, almost every day he goes to Monet's at Saint-Michel, near Bougival, where they both paint at la Grenouillère. Monet writes to Bazille several times asking for money.

Having returned to his Batignolles studio, Frédéric writes in [December]: "I've set to work, I'm doing firstly the interior of my studio, secondly a portrait of Blau, and thirdly a female nude for the Salon. I have everything I need for the winter. Since yesterday it's cold." [Late December]: "Not long ago we took a loge in the top balcony at the Italiens, to hear *Fidelio* — with Maître, Renoir, etc. — we indulged in a sauerkraut debauch after the performance and enjoyed ourselves immensely."

1870

[January 1], to his mother: "In two weeks Wagner's *Lohengrin* is being performed in Brussels. A friend of the composer has already set aside a seat for me, I may also be obtaining free passage on the train. In the latter case, you can well imagine I won't hesitate to spend a couple of days in Brabant." Still this desire to move: "I've rented a new studio with a small bedroom that I'm very happy with, on the rue des Beaux-Arts at the rate of 1,100 francs. I'll leave the one I'm in now on April 15 and I think I could even move early, for the current tenant on the rue des Beaux-Arts will be leaving soon." He makes a painting of this studio with, as he announces in a letter of December, some precious assistance: "I've amused myself till now painting the interior of my studio with my friends. Manet did me in it, I'll send it to the Montpellier

FIG. 101

Envelope with

autograph text by

Marc Bazille, the

painter's brother

Montpellier, Musée Fabre

Photo: F. Jaulmes

FIG. 100

Zouave uniform worn by Frédéric Bazille the day of his death: jacket and scarf, wallet, blank map of France. Letters from the artist.

Montpellier, Musée Fabre

Photo: F. Jaulmes

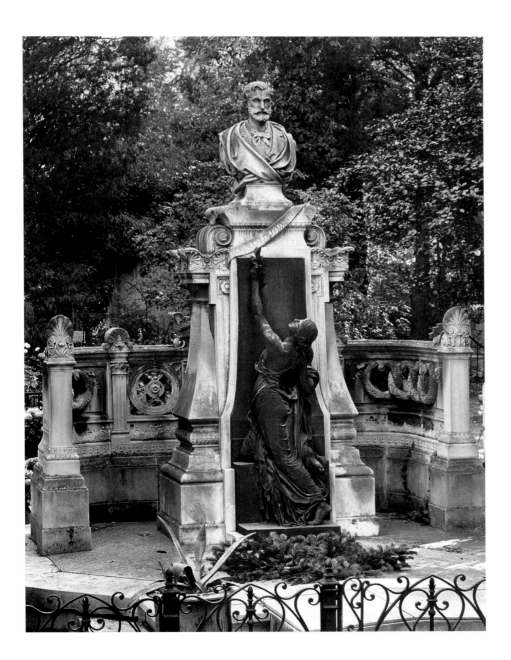

FIG. 103

Monument erected at
Beaune-la-Rolande
at the spot where the body of
Frédéric Bazille was found.

FIG. 102

Auguste Baussan
Monument erected in
memory of Frédéric
Bazille in the Protestant
cemetery in Montpellier
Photo: O'Sughrue

exhibition." [January 24] he informs his parents: "I was unable to attend the burial of Victor Noir [which took place on January 12], because of the pouring rain that fell that day and because I was posing for the painting by Fantin, one of my friends [fig. 98]. Last evening I wanted to get a close-up view of just what this populace of Paris is, and I went with some friends to the Place de la Roquette where a crowd waits every day for the execution of Troppmann [who was executed January 19]. You couldn't imagine a more hideous spectacle."

[Late February]: "I've just finished my work day, my model is leaving the studio, and I'm preparing to dine at the Lejosnes. I work all day, every day. Thus I'll be ready eight days before March 20.... I'm happy enough with my painting, for the moment: my friends pay me compliments but, more than the other times, I confess that this time I'll be quite discouraged if I don't meet with some success at the exhibition." Concerning the same painting, *La Toilette* (cat. 26), which he will submit to the jury: "I've been ruined by my models, a hundred francs are indispensable, take them out of one of the upcoming months if you must. I was lucky, there are three women in my painting." Despite the commitment made to his father, he decides in the spring not to show any paintings at the Montpellier exhibition, judging that it would not be advantageous for him.

In mid-April Bazille moves into the studio about which he'd already written in January, at 8 rue des Beaux-Arts. He lived there alone. Renoir nonetheless used this address when registering for the Salon. This studio was in the same building in which Fantin-Latour had lived since November 1867. During the spring Bazille paints the two versions of *African Woman with Peonies*, one of which is intended for his sister-in-law, Suzanne (cat. 27): "I'll need a good month to finish the flowers I've started and to make drawings for a painting I intend to execute at Méric." The Salon: "You rejoice that my two paintings were accepted for the exhibition, when in fact only one of them was accepted: the *Bathers*. There would seem to have been a mistake, and I was misinformed. This is going to annoy you; as for me you know what I've

thought of the jury for a long time now. I have been in a very bad mood, but I am in no way discouraged. Tomorrow I'll go see what effect I make, Sunday the public will be admitted.... It is absolutely impossible for me to be in Montpellier before the fifteenth, however much I'd like to. I must finish the paintings I'm working on, the flowers for Suzanne that are under way, and some drawings for a painting I'm going to do at Méric."

Bazille's nephew André is born on Monday, May 2. In a letter addressed to his brother the same day: "You're a lucky bloke. Give Suzanne a big hug for me. I didn't say anything, but I was very much hoping for a boy." He arrives in Montpellier towards the middle of May.

[June]: "My dear father, nothing of particular interest is happening in Montpellier, and I'm not well placed to obtain news, as I've been living at Méric for eight days. Yesterday I spent the night in the city to try and find some models. I've started a large landscape that's beginning to take shape."

France declares war against Prussia on July 19, 1870. Frédéric learns this at Méric. On August 16, he enlists in the Third Regiment of Zouaves (figs. 99, 100). On August 30, he sets sail from Philippeville. On September 27, his regiment leaves Algeria.

November 25, Bazille's last letter to his parents: "I still have a little money. I only spend it on tobacco and at our mess, but it won't last forever. I've bought various hosiery, underwear, socks, etc. that suit me quite well."

On November 28, Frédéric Bazille is killed at the battle of Beaune-la-Rolande. On Wednesday, December 14, Eugène Castelnau notes in his journal: "Gaston Bazille arrived this morning with the body of his son Frédéric, killed in the battle of Beaune-la-Rolande. A tall handsome boy full of spirit. He enlisted at the beginning of the war in the Third Zouaves. After a short tour in Africa, he returned to France with his regiment, having been made a quartermaster-sergeant. He took two bullets in the stomach. His father was looking for him for eight days, showing, in his determination to reach the side of his son, already dead and buried on the field of battle, invincible courage and energy, having obtained a Prussian safe-conduct.

After a thousand difficulties and hardships, a thousand dangers, he obtained the melancholy satisfaction of rescuing from an unmarked grave the remains dear to himself and to France. For myself, I weep for this brave boy killed fighting for us. Connected by a common taste, that for painting, to which he devoted himself after having studied medicine, I followed his progress with joy and I hoped to see us become increasingly close. Now he's a victim of this deplorable war of which I haven't yet had the courage to speak in these notes" (figs. 101–103).

NOTES

1. By Félix Régamey.
2. Théodore Pelloquet was a pseudonym of Frédéric Bernard. This wide-ranging author was given the task of writing pieces to counterbalance Zola's reviews of the Salon. But he fought a duel over the *Olympia*, and was generally favorable to the "Refusés."
3. The Delacroix sale took place from February 17 to 29, 1864, after exhibitions on the 10th, 11th, and 12th at the studio in the rue de Furstenberg and on the 16th at the Hôtel Drouot.
4. Manuscript note added by Marc: "Renoir says that my brother did not remove this painting" ("n'a pas retiré ce tableau").

Exhibitions

This list includes monographic exhibitions devoted to Frédéric Bazille as well as all exhibitions in which one or more works by the artist were shown.

1866–Paris, Palais de l'industrie, Salon of 1866.

1868–Paris, Palais de l'industrie, Salon of 1868.

1869–Paris, Palais de l'industrie, Salon of 1869.

1870–Paris, Palais de l'industrie, Salon of 1870.

1900–Paris, Grand Palais, Exposition universelle de 1900, *Centennale de l'art française de 1800 à 1889.*

1910–Paris, Salon d'automne, *Rétrospective Bazille,* October 15–November 15.

1922–Paris, Musée des Arts Décoratifs, *Le Décor de la vie sous le Second Empire.*

1922–Malmaison, palace of Malmaison, *Le Second Empire.*

1923–Paris, Salon d'automne, *Rétrospective des rétrospectives, 1904–1922.*

1927–Montpellier, Exposition internationale, *Rétrospective Bazille,* May–June.

1929–Cannes, Musée des Beaux-Arts, *La Provence et ses peintres au XIX^e siècle.*

1931–Paris, Exposition coloniale, *Rétrospective de la section de synthése des Beaux-Arts.*

1935–Paris, Association des étudiants protestants, *Exposition Frédéric Bazille.*

1936–Grenoble, Musée des Beaux-Arts, *Fantin-Latour et ses amis.*

1937–Paris, Galerie des Beaux-Arts, *La Naissance de l'impressionisme.*

1937–Paris, Musée d'Art Moderne, *Chefs-d'oeuvre de l'art français.*

1937–Boston, Museum of Fine Arts, *Modern French Painting.*

1939–Paris, Musée de l'Orangerie and Berne, Kunsthalle, *Les Chefs-d'oeuvre du musée de Montpellier.*

1939–Liège, *Exposition internationale de l'eau.*

1940–New York, *World's Fair.*

1941–Montpellier, Musée Fabre, *Centenaire de Frédéric Bazille,* May–June.

1942–Paris, Galerie Charpentier, *Le Paysage français de Corot à nos jours.*

1947–48–Brussels, Palais des Beaux-Arts, *De David à Cézanne.*

1948–Berne, Kunsthalle, *Dessins français du Louvre.*

1949–50–London, Royal Academy of Arts, *Landscape in French Art, 1500–1900.*

1950–Paris, Wildenstein Gallery, *Rétrospective Frédéric Bazille.*

1952–Paris, Galerie Charpentier, *Cent Portraits d'hommes.*

1953–Compiègne, Chateau de Compiègne, *Le Temps des crinolines.*

1954–London, The Arts Council of Great Britain, *Manet and His Circle.*

1954–London, Tate Gallery, *Impressionist Paintings from the Louvre.*

1954–Detroit, Institute of Modern Art, *From Cézanne to the Present.*

1954–New Orleans, Isaac Delgado Museum of Art, *Masterpieces of French Painting through Five Centuries.*

1954–55–New York, The Museum of Modern Art, *Fifteen Paintings by French Masters of the Nineteenth Century.*

1955–Marseille, Musée Cantini and Nice, Galerie des Ponchettes, *Exposition impressioniste.*

1955–Paris, Musée du Louvre, Cabinet des Dessins, *Donations et Nouvelles Acquisitions.*

1957–Paris, Musée Jacquemart-André, *Le Second Empire.*

1957–Caracas, Museum of Fine Arts, *Cien Años de pintura moderna 1840–1940.*

1958–Montpellier, Musée Fabre, *Des primitifs à Nicolas de Staël.*

1959–Montpellier, Musée Fabre, *Exposition Frédéric Bazille,* organized on the occasion of the XVIIth Congress of the Association des pédiatres de langue française, October 13–31.

1960–Paris, Galerie Charpentier, sale of important modern paintings.

1960–Nice, Galerie des Ponchettes, *Centenaire de la réunion du comte de Nice à la France.*

1960–Columbia University, Museum of Art, New York, *Impressionism.*

1961–London, Tate Gallery, *The John Hay Whitney Collection.*

1961–Tokyo and Kyoto, *French Art 1840–1940.*

1962–New York, Finch College Museum of Art, *Nineteenth and Twentieth Century French Masters.*

1962–Mexico City, Museo de Ciencias y Arte, *100 Años de dibujos franceses 1850–1950.*

1963–Lausanne, Musée Cantonal, *Dessins français.*

1963–Aarau, Zeichenkunst Aarau, Aangauerkunsthaus, *Handzeichnungen und Aquarelle aus den Museen Frankreichs, Drei Jahrhunderte französischer Zeichnungen.*

1965–Lisbon, Gulbenkian Foundation, *A Century of French Painting 1850–1950.*

1965–Moscow and Leningrad, *Paintings from French Museums.*

1966–Washington, National Gallery of Art, *French Paintings from the Collection of Mr. and Mrs. Paul Mellon and Mrs. Mellon Bruce.*

1967–Paris, Musée de l'Orangerie, *Vingt Ans d'acquisitions au musée du Louvre.*

1969–Troyes, Musée des Beaux-Arts, *Renoir et ses amis.*

1969–Minneapolis, The Minneapolis Institute of Arts, *The Past Rediscovered: French Paintings 1800–1900.*

1970–Paris, Musée Delacroix, *Delacroix et l'impressionisme.*

1971–Montpellier, Musée Fabre, *Hommage à Frédéric Bazille,* November 28, 1970–January 31, 1971.

1971–Madrid, Prado Museum, *Les Impressionistes français.*

1972–New York, Wildenstein Gallery, *Facco from the World of Impressionism.*

1972–Paris, Galerie Schmidt, *Les Impressionistes et leur précurseurs.*

1973–Paris, Musée des Arts Decoratifs, *Equivoques.*

1973–Turin, Galleria Civica d'Arte Moderna, *Art and Photography.*

1973–Tokyo, Wildenstein Gallery, *The Impressionists.*

1973–San Francisco, The California Palace of the Legion of Honor, *Three Centuries of French Art: Selections from the Norton Simon Museum of Art and the Norton Simon Foundation.*

1974–New York, the Bronx Court House, *Paris: Places and People.*

1974–Bordeaux, Galerie des Beaux-Arts, *Naissance de l'impressionisme.*

1974–Paris, Grand Palais, and New York, The Metropolitan Museum of Art, *Impressionism: A Centenary Exhibition.*

1974–Paris, Galerie Durand-Ruel, *Hommage à Paul Durand-Ruel, Cent ans d'impressionisme.*

1974–Tokyo, Matsuzakaya and Yamaguchi Gallery,

Prefectoral Museum, *Impressionism: A Centenary Exhibition.*

1975–New York, Wildenstein Gallery, *The Object as Subject.*

1976–New York, The Metropolitan Museum of Art, *Tricolor: 17th Century Dutch, 18th Century English, and 19th Century French Drawings from the Robert Lehman Collection.*

1976–Paris, Musée du Louvre, *Technique de la peinture.*

1976–77–Houston, The Museum of Fine Arts, *Caillebotte: A Retrospective Exhibition.*

1977–Montpellier, Musée Fabre, *Exposition Eugène Castelnau.*

1977–New York, The Metropolitan Museum of Art, *Degas in the Metropolitan Museum.*

1978–Chicago, The Art Institute, *European Portraits 1600–1900.*

1978–Montpellier, Musée Fabre, *Le Portrait.*

1978–Chicago, The Art Institute, *Bazille and Early Impressionism.*

1979–Paris, Musée du Petit-Palais, *Peintres de fleurs in France du XVIIIe et XIXe siècle.*

1980–Mont-de-Marsan, *Le Second Empire dans les Landes.*

1980–Albi, Musée Toulouse-Lautrec, *Tresors impressionistes du musée de Chicago.*

1980–New York, The Metropolitan Museum of Art, *French Drawings of the 19th Century from the Robert Lehman Collection.*

1982–Saint-Tropez, Musée de l'Anonciade, *Fleurs de Fantin-Latour à Marquet.*

1982–Tokyo, Museum of Western Art, *Realist Tendencies in France.*

1982–83–Dijon, Musée des Beaux-Arts, *La Peinture dans la peinture.*

1982–83–Marseille, Musée Cantini, *L'Orient des Provençaux, chefs-d'oeuvre du musée d'Alger.*

1984–Lausanne, Fondation de l'Hermitage, *L'Impressionisme dans les collections romandes.*

1984–Montpellier, Musée Fabre, *Bazille pour la dernière fois à Montpellier.*

1984–85–Los Angeles County Museum of Art, The Art Institute of Chicago, and Grand Palais, *Paris, A Day in the Country: Impressionism and the French Landscape.*

1985–New York, Wildenstein Gallery, *Paris Cafés.*

1985–Montpellier, Musée Fabre, *Courbet à Montpellier.*

1985–86–Paris, Grand Palais, *Choix d'oeuvres acquises par l'État ou avec sa participation de 1981 à 1985.*

1986–Edinburgh, National Gallery of Scotland, *Lighting up the Landscape.*

1986–Paris, Musée d'Orsay, *La Vie de bohème.*

1986–Houston, The Museum of Fine Arts, *The Portrait in France 1700–1900.*

1987–Paris, Musée d'Orsay, *Portraits d'artiste.*

1989–Montpellier, Musée Fabre, *Dix Ans d'acquisitions au musée Fabre.*

1990–Osaka, K. Matsushita Foundation Museum, *Human Shape and Flower.*

1991–Bordeaux, Musée des Beaux-Arts, *Trophées de chasse.*

1991–Montpellier, Musée Fabre, *Musée noir.*

1991–Montpellier, Musée Fabre, *Frédéric Bazille, 150e anniversaire.*

1991–Manchester, Currier Gallery of Art, *The Rise of Landscape Painting in France: Corot to Monet.*

1992–Montpellier, Musée Fabre, *Traces et Lieux de la création.*

1992–Montpellier, Musée Fabre, *Frédéric Bazille et ses amis impressionistes.*

1992–The Brooklyn Museum, and Memphis, The Dixon Gallery and Gardens, *Frédéric Bazille: Prophet of Impressionism.*

Bibliography

General References

Adhémar, Hélène. "Modifications apportées par Monet à son *Déjeuner sur l'herbe de 1865 à 1866*," Bulletin du laboratoire du musée du Louvre, June 1958, no. 3, pp. 37–41.

_____. *Musée du Jeu de paume*. Paris, Réunion des Musées Nationaux, 1979.

Alexandre, Arsène. "Renoir," in exhibition catalogue *A. Renoir*. Paris, Durand-Ruel, 1892.

Astruc, Zacharie. "La caverne enchantée ou visite à l'exposition," *Le Salon*, May 1863.

Bailly-Herzberg, Janine. *Dictionnaire de l'estampe en France: 1830–1950*. Paris, Arts et métiers graphiques, 1985.

Bazin, Germain, and Leymarie, Jean. "L'Impressionisme," *L'Amour de l'art*, nos. III and IV, Paris, 1947.

Bertall (Charles-Albert d'Arnoux, known as). "Promenade au Salon de 1869," *Journal amusant*, May–June 1869.

_____. "Promenade au Salon de 1870," *Journal amusant*, May–June 1870.

Bellory-Rewald, Alice. *Le Monde retrouvé des impressionistes*. Paris, Seghers, 1977.

Blunden, Maria and Godfrey. *Journal de l'impressionisme*. Paris, Skira, 1970.

Boime, Albert. "The Instruction of Charles Gleyre and the Evolution of Painting in the Nineteenth Century," *Charles Gleyre ou les illusions perdues*. Zurich, Schweizerisches Institut für Kunstwissenschaft, 1974.

Bonafoux, Pascal. *Les Impressionistes: portraits, lettres et témoignages*. Geneva, 1986.

Bonnici, Claude-Jeanne. *Paul Guigou: 1834–1871*. Paris, Edisud, 1989.

Borel, Pierre. "Un mécène romantique au XIXe siècle: Alfred Bruyas," *Pro Arte*, no. 6, October 1942.

_____. *Lettres de Gustave Courbet à Alfred Bruyas*. Geneva, Cailler, 1951.

Bouillon, Jean-Paul. "Manet vu par Bracquemond," *Revue de l'art*, no. 37, 1975.

_____ et al., *La Promenade du critique influent*. Paris, Hazan, 1990.

Bouret, Jean. *L'École de Barbizon et le paysage français au XIXe siècle*. Paris, bibliothèque des arts, Neuchatel, Ides et Calendes, 1972.

Brettell, Richard R. *French Salon Artists 1800–1900*. Chicago, The Art Institute of Chicago; New York, Abrams, 1987.

Bruyas, Alfred. *Art moderne: documents relatifs à la galerie Bruyas*. Montpellier, Hamelin, 1872.

_____. *La Galerie Bruyas*, introduction by Théophile Sylvestre. Paris, Quentin, 1876.

_____. *Salons de peinture*. Montpellier, Boehm, 1852.

Callen, Anthea. *Les Peintres impressionistes et leur technique*. Paris, 1983.

Castagnary, Jules Antoine. *Salons: volume I, 1857–1870*. Paris, Charpentier, 1892.

Champa, Kermit S. *Studies in Early Impressionism*. New Haven and London, Yale University Press, 1973.

Chamson, André. "Languedoc," *Beaux-Arts*, no. 37, 1933.

Chefs-d'oeuvre de la peinture, "De Jean Cousin à Degas, 100 Masterpieces," Musée Fabre, Montpellier, 1988.

Claparède, Jean. *Dessins de la collection Alfred Bruyas et autres dessins du XIXe et XXe siècles*. Paris, 1962.

_____. "Inventory of French Public Collections: Montpellier, Drawings of the XIXth and XXth centuries," *The Art Bulletin*, vol. XLV, no. 2, p. 167.

_____. *Les Peintres du Languedoc méditerranéen de 1610 à 1870. Languedoc méditerranéen et Roussillon d'hier et d'aujourd'hui*. Nice, Dainville, 1947.

Cogniat, Raymond, and Joubin, André. Prefaces and entries in the catalogue of the exhibition *Naissance de l'impressionisme. Gazette des beaux-arts*, Paris, 1937.

Columbier, Pierre du. "Montpellier à Paris," *Candide*, April 4, 1935.

Crespelle, Jean-Paul. *La Vie quotidienne des impressionistes du Salon des refusés à la mort de Manet*. Paris, Hachette, 1981.

Crouzet, Marcel. *Un méconnu du réalisme: Duranty (1833–1880)*. Paris, Nizet, 1964.

Cunningham, Charles C. *Jongkind and the Pre-Impressionists: Painters of École Saint Siméon*. Northampton, 1976.

Daulte, François. *Catalogue raisonné de l'oeuvre peint de Sisley*. Lausanne, Durand-Ruel, 1959.

Denvir, Bernard and Macintosh, Alistair. *Histoire de l'art moderne: de l'impressionisme à nos jours*. Paris, Flammarion, 1989.

Descossy, Camille. *Sur vingt tableaux du musée Fabre*. Montpellier, Causse, Graille et Castelnau, 1938.

Distel, Anne. *Le Collectionneurs des impressionistes*, catalogue of an exhibition held in Dudingen. Paris, La Bibliothèque des Arts, 1989.

Druick, Douglas, and Hoog, Michel. *Fantin-Latour*. Paris, Réunion des Musées Nationaux, 1982.

Duranty, Edmond. "Salon de 1870," *Paris-Journal*, May–June 1870.

_____. "La simple vie du peintre Louis Martin," *Le Siècle*, 13–16 November, 1872.

Duret, Théodore. *Histoire des peintres impressionistes*. Paris, H. Floury, 1919.

Escuret, Louis. *Vieilles Rues de Montpellier*, 2 vols. Montpellier, Escuret, 1956–64; new edition Montpellier, Presses du Languedoc, 1984.

Flescher, Sharon. *Zacharie Astruc, Critic, Artist, and Japonist*. Ann Arbor, UMI Research Press, 1980.

Fliche, Augustin, and Jourda, Pierre. *Languedoc*. Montpellier, Editions des Arceaux, 1948.

Focillon, Henri. *La Peinture au XIX^e et XX^e siècles*. Paris, Laurens, 1928.

Francastel, Pierre. *L'Impressionisme*. Paris, Belles-Lettres, 1937.

Fried, Michael. "Painting Memories: On the Containment of the Past in Baudelaire and Manet," *Critical Inquiry*, March 1984, pp. 510–42.

Gache-Patin, Sylvie."L'Impressionisme et le paysage français," *La Revue du Louvre*, no. 1, 1985.

Georgel, Pierre, and Lecoq, Anne-Marie. *La Peinture dans la peinture*, catalogue of an exhibition held at the Musée des Beaux-Arts, Dijon, 1982–1983.

Gill, André (Louis-Alexandre Gosset, known as). "Le Salon de 1869," *La Parodie*, no. 1, June 4, 1869, pp. 4–14.

Gillet, Louis. *Le Musée de Montpellier*. Paris, Firmin-Didot, 1935.

Hauptman, William. "Delaroche's and Gleyre's Teaching Ateliers and Their Group Portraits," *Studies in the History of Art*, no. 18, 1985.

Hautecoeur, Louis. *Littérature et peinture en France du XVII^e au XX^e siècles*. Paris, Armand Colin, 1942.

Higonnet, Anne. *Berthe Morisot: une biographie*. Paris, Adam Biro, 1989.

Honour, Hugh. *L'Image du Noire dans l'art occidental*. Paris, Gallimard, 1988.

Huyghe, René. *La Relève du réel*. Paris, Flammarion, 1974.

Isaacson, Joel. "The Early Paintings of Claude Monet." University of California at Berkeley, Ph. D. dissertation, 1967.

_____. *Monet: le Déjeuner sur l'herbe*. New York, Viking, 1972.

Johnson, Lee. *The Paintings of Eugène Delacroix: A Critical Catalogue*, 4 vols. Oxford, Clarendon, 1981–86.

Le Journal de Montpellier: judiciaire, artistique, littéraire et industriel. Montpellier, 1841–70, Martel.

Langdon, Helen. *Impressionist Seasons*. Oxford, Phaidon, n.d.

Laver, J. *French Painting in the Nineteenth Century*. London, 1937.

Leenhardt, Albert. *Quelques Belles Résidences des environs de Montpellier* (1er série). Montpellier, Causse, Graille et Castelnau, 1931.

_____. *Vieux Hôtels de Montpellier*. Bellegare, Sadag de France, 1935.

Letheve, Jacques. *La Vie quotidienne des artistes français au XIX^e siècle*. Paris, Hachette, 1968.

Lhéte, André.*Traité du paysage*. Paris, Floury, 1939. *La Liberté: journal démocratique quotidien de l'Hérault et du Gard*. Montpellier, 1869–71, Boehm.

Marx, Roger. "Études sur l'École français," *Gazette des beaux-arts*, Paris, 1903.

Mathieu, Caroline. *Musée d'Orsay: Guide*. Paris, Réunion des Musées Nationaux, 1986.

Le Messager du Midi (daily newspaper). Montpellier, 1848–92, Boehm.

Monet, Claude. "Correspondence: 1844–1925, 4th set, 51 letters written between 1865 and 1925. Preliminary Guide to the Collection," *Archives of the History of Art*, The Getty Center for the Arts and the Humanities, Fall 1985.

Monneret, Sophie. *L'Impressionisme et son époque*. Paris, Denoël, 1980.

Mouso, John. *Monet, Nature into Art*. New Haven and London, Yale University Press, 1986.

Morisot, Berthe. *Correspondence de Berthe Morisot avec sa famille et ses amis*, Denis Rouart, ed. Paris, Quatre-Chemins, 1950.

Pool, Phoebe. *Impressionism*. London and New York, Oxford University Press, 1967.

Poulain, Gaston. "Le Pré-impressionisme," *Formes*, no. 19, 1931.

_____. "Le visage des pays de France vus par nos artistes, VII, le Languedoc," *Art et les artistes*, no. 148, 1934, pp. 315–18.

_____. "Paul Valéry au Musée Fabre," *Itinéraires*, November 1942.

Rewald, John. *The History of Impressionism*, New York, The Museum of Modern Art, 1946.

_____. *Histoire de L'Impressionisme*. Paris, Albin Michel, new ed., 1986.

Riout, Denys. *Les Écrivains devant l'impressionisme*. Paris, Macula, 1989.

Robiquet, Jean. *L'Impressionisme vécu*. Paris, Julliard, 1948.

Romane-Musculus, Paul. *La Prière des mains: l'Église réformée et l'art*. Paris, Je sers, 1938.

Rossi-Bortollotto, Luigina. *Tout l'oeuvre peint de Delacroix*. Paris, Flammarion, 1975.

Sarraute, Gabriel. "Contribution à l'étude du Déjeuner sur l'herbe de Monet," *Bulletin du laboratoire du musée du Louvre*, June 1958, no. 3.

Sérullaz, Maurice. *L'Impressionisme*. Paris, P.U.F., series Que sais-je?

_____. *I Disegni di maestri: l'Ottocento francese*. Milan, 1970.

Shiff, Richard. *Cézanne and the End of Impressionism: A Study of the Theory, Technique, and Critical Evaluation of Modern Art*. Chicago and London, University of Chicago Press, 1984.

Signac, Paul. *De Delacroix au néo-impressionisme*. Paris, Floury, 1939.

Silvestre, Théophile. "Les Quatre portraits de Bruyas," *Les Artistes français*. Vol. II, Paris, G. Crés, 1936.

Tabarant, Adolphe. *La Vie artistique au temps de Baudelaire*. Paris, Mercure de France, 1942.

Thomas, Louis J. *Les Fondateurs du Musée de Montpellier: une femme, son roi, son poète et son peintre*. Montpellier, Dubois et Poulain, 1928.

_____, and Gaston Pastre, J.-L. *Montpellier, ville inconnue*. Montpellier, Dubois et Poulain, 1930.

Thoré, Théophile. *Salons de W. Burger: 1861–1868*. Paris, Renouard, 1870.

Thuile, Jean. *Défense du Peyrou*. Montpellier, Causse, Graille et Castelnau, 1945.

_____. *Entrée au Peyrou*. Montpellier, Dubois et Poulain, 1945.

Tietze, Hans. "Earliest and Latest Works of Great Artists," *Gazette des beaux-arts*, July–December 1944.

L'Union nationale (daily newspaper). 1868–71, Montpellier.

Venturi, Lionello. *Les Archives de l'impressionisme*, 2 vols. Paris and New York, Durand-Ruel, 1939.

Vollard, Ambroise. *Auguste Renoir*. Paris, G. Cres, 1920.

_____. *En écoutant Cézanne, Degas, Renoir*. Paris, Grasset, 1938.

Wildenstein, Daniel. *Claude Monet, biographie et catalogue raisonné, t. I, 1840–1881*. Paris and Lausanne, Bibliothèque des Arts, 1974.

Zafran, Eric H. *European Art in the High Museum*. Atlanta, 1984.

Zola, Émile. "Mon Salon," *L'Événement illustré*, May 2–June 16, 1868.

_____. *Correspondance*, 4 vols. Montreal, Presses de l'université de Montréal, and Paris, Éditions du Centre national de la recherche scientifique, 1978–83.

Books and articles about Frédéric Bazille

Anonymous. "A Painting by Bazille," *Bulletin of the Fogg Art Museum*, vol. VII, 1937, p. 15.

Anonymous. "Bazille Paintings for Fogg," *Art Digest*, June 1, 1938.

Adlow, Dorothy. "Lady in the Garden: A Painting by Frédéric Bazille…," *Christian Science Monitor*, April 24, 1945.

Alderman, John Robert. "Sources in Bazille's Late Works." Ph. D. dissertation, Department of Fine Arts, Harvard University, 1972.

Barral, Guy. "Bazille et Montpellier," in catalogue *Traces et Lieux de la création*. Montpellier, 1992.

Bazille, J. Frédéric. *Correspondance*, Didier Vituone and Guy Barral, eds. (forthcoming).

Bazille, album published on the occasion of the retrospective exhibition organized by the Association des étudiants protestants de Paris, n.d. (1935).

Bernat, Monique. "Frédéric Bazille et le mouvement pré-impressioniste," *Journal des Arts*, October 1959.

Champa, Kermit. "Frédéric Bazille: the 1978 Retrospective Exhibition," *Arts Magazine*, no. 10, June 1978.

Charensol, Georges. "Frédéric Bazille et les débuts de l'impressionisme," *l'Amour de l'art*, no. 1, January 1927.

Claparède, Jean. "Bazille à Montpellier," *Réforme*, June 24, 1950.

Colombier, Pierre de. "La place de Frédéric Bazille," *Candide*, April 4, 1935.

Dabit, Eugène. "Quelques impressions à propos d'une exposition Bazille à l'Association des étudiants protestants," *Europe*, no. 149, May 15, 1935.

Daulte, François. *Frédéric Bazille et son temps*. Geneva, Callier, 1952.

_____. *Frédéric Bazille et les débuts de l'impressionisme: catalogue raisonné de l'oeuvre peint*. Paris, Bibliothèque des arts, 1991.

_____. "Le peintre de portraits: à propos de la rétrospective," *Arts*, June 9, 1950.

_____. "A True Friendship: Edmond Maître and Frédéric Bazille," in *Frédéric Bazille and Early Impressionism*, Chicago, 1978.

_____. "Le peintre raconté par lui-même et par ses amis," *Reforme*, June 24, 1950.

_____. "Bazille, son oeuvre s'achève en 1870," *Connaissance des arts*, December 1970.

_____. "Une grande amitié: Edmond Maître et Frédéric Bazille," *l'Oeil*, April 1978.

Day, Holly. "Frédéric Bazille and Early Impressionism," *New Art Examiner*, April 1978.

Dejean, Xavier. *Frédéric Bazille: Petit journal d'exposition*. Montpellier, 1984.

Descossy, Camille. *Montpellier, berceau de l'impressionisme: Corot, Courbet, Bazille et la campagne montpelliéraine*. Montpellier, Cros, 1933.

Dolan, Thérèse. "Frédéric Bazille and the Goncourt Brothers' Manette Salomon," *Gazette des beaux-arts*, February 1990.

Dorival, Bernard. "La scène d'été de Bazille et de Cézanne," *Musées de France*, 1949, no. 4.

F.A. "Frédéric Bazille," in *l'Union nationale*. Montpellier, La Renaissance du Livre, 1932.

Fierens, Paul. "Frédéric Bazille," *Journal des débats*, July 22, 1932.

Gauthier, Maximilien. "Jean Frédéric Bazille, peintre né à Montpellier," *Larousse mensuel*, no. 328, June 1934.

_____, and de Laprade, Jean. "Jean Frédéric Bazille," *Beaux-Arts*, 1935, no. 117.

Gourg, Jean-Louis. "Le souvenir de Frédéric Bazille mort il y a cent ans," *Vision sur les arts*, 1970, no. 66.

Grasset, Jacques de, and Jourdan, Aleth. "La Vue de village. Forme, couleur, matière," in catalogue *Frédéric Bazille: 150ᵉ anniversaire*. Montpellier, 1992.

Huyghe, René. "The Louvre Museum and the Problem of Cleaning Old Pictures," *Museum*, 3, 1950.

Joubin, André. "Frédéric Bazille et ses tableaux legués aux musées nationaux," *Beaux-Arts*, April 15, 1924.

Jourdan, Aleth. "Bazille dans les collections du musée Fabre," in catalogue *Frédéric Bazille: 150ᵉ anniversaire*. Montpellier, 1992.

——, and Vatuone, Didier. "Traces," in catalogue *Traces et Lieux de la création*. Montpellier, 1992.

——, and Vatuone, Didier. "Les Lieux de la création," in catalogue *Traces et Lieux de la création*. Montpellier, 1992.

Kind, Joshua. "Mad About Museums by Thick Tungue," *New Art Examiner*, July 1978.

Lacave, Mireille. "Une famille montpelliéraine," in catalogue *Frédéric Bazille: 150ᵉ anniversaire.* Montpellier, 1992.

Laprade, Jacques. "Frédéric Bazille," *Beaux- Arts,* no. 117, March 29, 1935.

Marandel, J.-Patrice. *Frédéric Bazille and Early Impressionism.* Exhibition catalogue, Chicago, 1978.

Maxon, John. "Bazille," *Art Institute of Chicago Quarterly,* vol. 57, no. 2, 1963.

Michel, Francois-Bernard. *Frédéric Bazille: réflexions sur la peinture, la médecine, le paysage et le portrait....* Paris, Grasset, 1992.

Pinéay, Robert. "Frédéric Bazille au Jeu de paume," *Cahiers du Sud,* 2ᵉ semestre, 1947.

Pitman, Dianne. "The Art of Frédéric Bazille: 1841–1870," Ph. D. dissertation, Johns Hopkins University, 1989.

Poulain, Gaston. "L'Amitié de Bazille et de Claude Monet," *ABC Magazine d'art,* no. 3, 1927.

_____. "Un Languedocien, Frédéric Bazille," *La Renaissance,* April 1927.

_____. "Une oeuvre inconnue de Frédéric Bazille," *Art de France,* nos. 17–18, 1947.

_____. *Bazille et ses amis.* Paris, La Renaissance du livre, 1932.

_____. "L'origine des *Femmes au jardin* de Claude Monet," *L'Amour de l'art,* March 1937.

_____. "À propos du tableaux sur Claude Monet blessé," *Comoedia illustré,* January 4, 1927.

Romane-Musculus, Paul. "Ce que Bazille a de protestant," *Réforme,* June 24, 1950.

_____. "Baptêmes de peintres: Degas, Sisley, Bazille," *Bulletin de la Société de l'histoire du protestantisme français,* no. 112, 1966.

_____. "Généologie de la famille Bazille," *Bulletin historique de la ville de Montpellier,* no. 8, 1987.

Rouaud, Jean. "Frédéric Bazille: lieux et non-lieux," in catalogue *Traces et Lieux de la création.* Montpellier, 1992.

Sabatier, Pierre. "Un pré-impressionniste languedocien: Frédéric Bazille 1841–1870," *Bulletin de l'académie des sciences et lettres de Montpellier,* 1978.

Santenac, Paul. "Sur le peintre méridional Frédéric Bazille," *Sud,* no. 90, December 1, 1932.

Sarraute, Gabriel. "Catalogue de l'oeuvre de Frédéric Bazille." Thesis, École du Louvre, Paris, 1948.

_____. "Catalogue de l'oeuvre de Frédéric Bazille: résumé de thèse," *Musées de France,* May 1949.

_____. "Peintre de l'été," *Arts,* June 1950.

_____, and Dorival, Bernard. "Deux dessins de Frédéric Bazille au musée du Louvre," *Musées de France,* May 1949.

Schabaker, Peter. "Frédéric Bazille's *Summer Scene* and its Relation to the Early History of Impressionism," unpublished paper, Archives of the Fogg Art Museum, Harvard University.

Scheyer, E. "Jean Frédéric Bazille: the Beginning of Impressionism," *The Art Quarterly,* Spring 1942.

Schmidt, Albert-Marie. "L'exposition Frédéric Bazille à l'Association des étudiants protestants," *Le Semeur,* June 1935.

Schulze, Franz. "Frédéric Bazille, 'Lost' Impressionist," *Art in America,* no. 66, 1978.

Segondy, Jean. "Les peintres Fabre, Cabanel et Bazille," *Montpellier, ville contemporaine. t. I, 1789–1870.* Bibliothèque municipale de Montpellier, 1970.

Sterling, Charles. "De Brueghel à Bazille," *L'Amour de l'art,* June 1931.

Thouvenot, France. "La mort du peintre Bazille au combat de Beaune-la-Rolande: 28 novembre 1870," *Bulletin de la Société d'émulation de l'arrondissement de Montargis,* March 1983.

Tinterow, Gary. "Porte de la Reine at Aigues-Mortes," *The Metropolitan Museum of Art Bulletin.* 47, Fall 1989.

Vatuone, Didier. "Frédéric Bazille: repères chronologiques," in catalogue *Frédéric Bazille: 150ᵉ anniversaire.* Montpellier, 1992.

_____. "Mon cher père," in catalogue *Traces et Lieux de la création.* Montpellier, 1992.

Wildenstein, Daniel, and Huisman, Philippe. "Bazille," *Arts,* June 1950.

Zeiger-Viallet, Edmond-H. "À propos du *Repos sur l'herbe* de J.F. Bazille," *Beaux-Arts,* November 21, 1940.

_____. "Le centenaire de la naissance de Jean Frédéric Bazille: 1841–1870," *Beaux-Arts, le journal des arts,* nouvelle serie, no. 48, December 1941.

Catalogues

Anciens et Nouveaux: choix d'oeuvres acquises par l'État ou avec sa participation de 1981 à 1985, cat. of an exhibition held at the Grand Palais in Paris, 1985–86.

Bazille: Exposition organisée au profit du musée du Montpellier by Gabriel Sarraute and Jean Claparède. Paris, Wildenstein Gallery, 1950.

Berthe Morisot. New York, 1987.

Peintures et sculptures exposées dans les galeries du musée Fabre de la ville de Montpellier, by André Joubin. Paris, Blondel, 1926.

Tableaux modernes, aquarelles, dessins et pastels par Boilly... composant la collection de M. Pierre Leenhardt (ancienne collection Louis Bazille, de Montpellier).

Tableaux, pastels, dessins, aquarelles par Bazille... faisant partie de la collection Roger Marx, sale catalogue. Paris, Galerie Manzi, May 11–12, 1914.

Catalogue of the Musée Fabre, by Jean Claparède. Volumes IV to XI, *l'École française.* Montpellier, 1965.

Catalogue sommaire illustré des peintures du musée du Louvre et du musée d'Orsay. III, IV, V: École française, by Isabelle Compin and Anne Roquebert. Vol. III, Paris, 1986.

Cézanne, The Early Years, 1859–1872, cat., written by Lawrence Gowing, of an exhibition held at the Royal Academy of Arts in London, the Musée d'Orsay in Paris, and the National Gallery of Art in Washington, 1988.

Chefs-d'oeuvre du XIXᵉ siècle français, by Albert Châtelet. Florence, Milan, Rome, De Luca, 1955.

Courbet à Montpellier, cat. of an exhibition held

at the Musée Fabre in Montpellier, 1985.

A Day in the Country: Impressionism and the French Landscape, cat. of an exhibition held at the Los Angeles County Museum of Art, The Art Institute of Chicago, and the Grand Palais in Paris, 1984–85.

Degas, cat. of an exhibition held at the Grand Palais in Paris, The Museum of Fine Arts in Ottawa, and The Metropolitan Museum of Art in New York, 1988–89.

1874: Naissance de l'impressionisme, cat. of an exhibition held in the Galerie des Beaux-Arts in Bordeaux, 1974.

Eugène Castelnau: 1827–1894, cat. of an exhibition held at the Musée Fabre in Montpellier, 1977.

Frédéric Bazille: 150ᵉ anniversaire, cat. of an exhibition held at the Musée Fabre in Montpellier, 1991–92.

Frédéric Bazille: exposition organisée en l'honneur du XVIIᵉ Congrès de l'association des pédiatres de langue française. , Montpellier, Musée Fabre, October 13–31, 1955.

Frédéric Bazille. Traces et Lieux de la création, cat. of an exhibition held at the Musée Fabre, 1992.

Frédéric Bazille and Early Impressionism, cat. of an exhibition held at The Art Institute of Chicago; entries by J.-Patrice Marandel, essay by François Daulte, correspondence selected and translated into English by Paula Prokopoff-Gianini. Chicago, 1978.

La Gloire de Victor Hugo, cat. of an exhibition held at the Grand Palais in Paris, 1985–86.

Hommage à Claude Monet, cat. of an exhibition held at the Grand Palais in Paris, 1980.

Impressionism: A Centenary Exhibition, cat. of an exhibition held at the Grand Palais in Paris and The Metropolitan Museum of Art in New York, 1974–75; cat. entries by Anne Dayez, Michel Hoog, and Charles S. Moffett.

Lettres autographes de F. Bazille, Monet, Manet. Livres d'heures…, sale catalogue. Paris, J.-P. Couturier, Drouot, 1982.

Livret explicatif des ouvrages de peinture, sculpture, dessin, architecture, etc., admis à la première (second, troisième) exposition annuelle de Montpellier., Société artistique de l'Hérault, 1868 (1869, 1870).

Manet: 1832–1883, cat. of an exhibition held at the Grand Palais in Paris and The Metropolitan Museum of Art in New York, 1983.

Monet and His Circle, The Arts Council of Great Britain, London, 1954.

Notice des objets d'art anciens et modernes exposés au Salon de Montpellier le 1er mai 1860. , Montpellier, Gras, 1860.

Orsay avant Orsay, cat. of an exhibition held in Antibes, Toulouse, and Lyon, 1985–86.

Le Paysage français du XVIᵉ au XIXᵉ siècle, by Bernard Dorival. London, 1949–50.

Paris Cafés, cat. of an exhibition held at the Wildenstein Gallery in New York, 1985.

Renoir, cat. of an exhibition held at the Hayward Gallery in London, the Grand Palais in Paris, and The Museum of Fine Arts in Boston, 1985–86.

Sale catalogue, Paris, Gallerie Petit, May 4, 1922.

Salon d'automne. Aux sources de l'impressionisme, art contemporain, cat. of an exhibition held at the Grand Palais in Paris, 1985–86.

The Second Empire: Art in France under Napoleon III, cat. of an exhibition held at The Philadelphia Museum of Art, The Detroit Institute of Arts, and the Grand Palais in Paris, 1978–79.

Trophées de chasse, cat., written by Bernadette de Boysson and Olivier Le Bihan, of an exhibition held at the Musée des Beaux-Arts in Bordeaux, 1991.

Van Gogh à Paris, cat. of an exhibition held at the Musée d'Orsay in Paris, 1988.

Works in the Exhibition

All works are by Frédéric Bazille unless otherwise stated. Dimensions are given in centimeters; height preceeds width. Works are listed alphabetically within chronological order, undated works last.

MALE NUDE

1863

Académie d'homme

conté crayon and

charcoal on paper, 62 x 47

Montpellier, Musée Fabre

(cat. 1)

SAINT-SAUVEUR

1863

oil on canvas, 75 x 120

New York, Private collection

(not in catalogue)

THE MYSTIC MARRIAGE OF ST. CATHERINE

(copy after Veronese)

1863–64

Le Mariage mystique de

sainte Catherine

oil on canvas, 125 x 125

Beaune-la-Rolande,

parish church

(cat. 52)

THE PINK DRESS

1864

La Robe rose

oil on canvas, 145 x 110

Paris, Musée d'Orsay

(cat. 7)

RECLINING NUDE

1864

Nu couché

oil on canvas, 70 x 180

Montpellier, Musée Fabre

(cat. 4)

THE SCOTER-DUCK

1864

La Macreuse

oil on canvas, 45 x 37

New York, Private collection

(not in catalogue)

SOUP BOWL COVERS

1864

Couvercles de bouillon

oil on canvas, 22 x 35

Private collection

(cat. 5)

RECTO: *Study for* RECLINING NUDE/

VERSO: PORTRAIT OF A MAN

1864

Recto: Étude pour le Nu couché/

Verso: Portrait de Villa

charcoal on paper

R: 42 x 57; V: 57 x 42

Montpellier, Musée Fabre

(cats. 2, 3)

WOMAN VIEWED FROM BEHIND

1864

Femme vue de dos

oil on canvas, 63 x 48

Paris, Private collection

(not in catalogue)

THE EDGE OF THE FONTAINEBLEAU FOREST

Lisière de Forêt à

Fontainebleau

oil on canvas, 60 x 73

Paris, Musée d'Orsay

(cat. 38)

THE FARM AT SAINT-SAUVEUR

1865

Saint-Sauveur

oil on canvas, 60 x 140

Paris, Private collection

(fig. 38)

THE IMPROVISED FIELD HOSPITAL

(Monet after his accident

at the Inn of Chailly)

1865

L'Ambulance improvisée

oil on canvas, 47 x 62

Paris, Musée d'Orsay

(cat. 10)

LANDSCAPE AT CHAILLY

1865

Paysage à Chailly

oil on canvas, 82 x 105

Chicago, The Art Institute

of Chicago

(cat. 11)

SEASCAPE (THE BEACH AT SAINTE-ADRESSE)

1865

Marine

oil on canvas, 50 x 140

Atlanta, The High Museum of Art

(cat. 9)

STUDIO ON THE RUE FURSTENBERG
1865
Atelier de la rue de Furstenberg
oil on canvas, 80 x 65
Montpellier, Musée Fabre
(cat. 8)

STILL LIFE OF FISH
1866
Poissons
oil on canvas, 63 x 83
Detroit, The Detroit Institute of Arts
(cat. 12)

TWO HERRINGS
1866–67
Deux Harengs
oil on canvas, 41 x 27
Private collection
(cat. 50)

AIGUES-MORTES
1867
oil on canvas, 46 x 55
Montpellier, Musée Fabre
(cat. 16)

PORTE DE LA REINE À AIGUES-MORTES
1867
oil on canvas, 80.6 x 99.7
New York, The Metropolitan
Museum of Art
(cat. 15)

PORTRAIT OF RENOIR
1867
oil on canvas, 61 x 50
Algiers, Musée National des
Beaux-Arts
(cat. 44)

THE ROSE LAURELS (THE TERRACE AT MÉRIC)
1867
Les Lauriers
oil on canvas, 55.9 x 99.1
Cincinnati, Cincinnati Art Museum

STILL LIFE WITH HERON
1867
Le Héron
oil on canvas, 100 x 79
Montpellier, Musée Fabre
(cat. 14)

STUDIO ON THE RUE VISCONTI
1867
Atelier de la rue Visconti
oil on canvas, 64 x 49
Richmond, Virginia
Museum of Fine Arts
(cat. 13)

Study for THE FAMILY GATHERING
1867
Étude pour la
Réunion de famille
charcoal and pencil
on paper, 30 x 30
Paris, Musée du Louvre
(cat. 17)

YOUNG WOMAN WITH LOWERED EYES
1867
*Jeune Femme aux
yeux baissés*
oil on canvas, 46 x 38
Private collection
(cat. 47)

FRÉDÉRIC BAZILLE AT SAINT-SAUVEUR
before 1868
oil on canvas, 40 x 31
Montpellier, Musée Fabre
(cat. 43)

FISHERMAN WITH A NET
1868
Le Pêcheur à l'épervier
oil on canvas, 134 x 83
Rau Foundation for
the Third World
(cat. 19)

FLOWERS
1868
Fleurs
oil on canvas, 130 x 97
Grenoble, Musée de Peinture
et de Sculpture
(cat. 22)

PORTRAIT OF ALPHONSE TISSIÉ
1868
oil on canvas, 58 x 47
Montpellier, Musée Fabre
(cat. 45)

VIEW OF THE VILLAGE
1868
La Vue de village
oil on canvas, 130 x 89
Montpellier, Musée Fabre
(cat. 20)

VIEW OF THE VILLAGE
1868
La Vue de village
etching, 24 x 16.2
Montpellier, Musée Fabre
(cat. 21)

Studies for a GRAPE HARVEST
1868–69
Études pour une Vendage
38 x 92 (each)
Montpellier, Musée Fabre
(cat. 39, 40)

PORTRAIT OF EDMOND MAÎTRE

1869

oil on canvas, 84 x 65

Washington, National Gallery of Art

(cat. 23)

SUMMER SCENE (BATHERS)

1869

Scène d'été

oil on canvas, 158.2 x 158.8

Cambridge, Harvard

University Art Museums,

The Fogg Art Museum

(cat. 25)

AFRICAN WOMAN WITH PEONIES

1870

Négresse aux pivoines

oil on canvas, 60 x 75

Montpellier, Musée Fabre

(cat. 27)

BUST OF RUTH

1870

Buste de Ruth

charcoal on paper, 12 x 17

Private collection

(cat. 31)

HEAD, ARM, AND BUST OF RUTH

1870

Tête, bras et buste de Ruth

charcoal on white paper, 60 x 47

Private collection

(cat. 29)

LANDSCAPE ON THE BANKS OF THE LEZ

1870

Paysage au bord du Lez

oil on canvas, 137.2 x 203.2

Minneapolis, The Minneapolis

Institute of Arts

(fig. 1)

LOUIS AURIOL FISHING

circa 1870

Louis Auriol pêchant

à la ligne

oil on canvas, 103 x 55

New York, Private collection

(not in catalogue)

Study of RUTH

1870

Étude pour Ruth

charcoal and pastel on paper

21 x 39

Private collection

(cat. 30)

LA TOILETTE

1870

oil on canvas, 132 x 127

Montpellier, Musée Fabre

(cat. 26)

THE FORTUNE-TELLER

Tireuse de cartes

oil on canvas, 61 x 46

Private collection

(cat. 48)

MALE NUDE

Académie d'homme

oil on canvas, 60 x 43

Private collection

(cat. 34)

MAN SUBDUING A BULL

Homme maîtrisant un taureau

charcoal and pencil on paper

11 x 15

Montpellier, Musée Fabre

(cat. 36)

MANET DRAWING

Manet dessinant

charcoal on paper, 29.5 x 21.5

New York, The Metropolitan

Museum of Art

(cat. 35)

PORTRAIT OF A MAN

Portrait d'homme

oil on canvas, 54 x 46

Minneapolis, The Minneapolis

Institute of Arts

(cat. 46)

PORTRAIT OF PAUL VERLAINE

AS A TROUBADOUR

oil on canvas, 46 x 38

Dallas, The Dallas

Museum of Art

(cat. 53)

SELF-PORTRAIT WITH PALETTE

Frédéric Bazille à la palette

oil on canvas, 135 x 80

Chicago, The Art Institute

of Chicago

(cat. 42)

PORTRAIT DE BAZILLE

By Pierre-Auguste Renoir

(1841–1919)

1867

Portrait de Bazille

oil on canvas, 106 x 74

Paris, Musée d'Orsay

(fig. 14, fig. 96)